Beautiful
BRIDE

from

Every

Angle

Beautiful BRIDE

from

Every Angle

Look Great in Every Photo . . . and in Life!

Barbara Wallace	*planner*
Annie Withers	*stylist*
Lars Wanberg	*photographer*

ZINGIBER
PUBLISHING

CORONA DEL MAR, CALIFORNIA

Copyright © 2011 ZinGiBer Publishing
ISBN 978-1-935108-00-9

Published by ZinGiBer Publishing

P.O. Box 84
Corona del Mar, California 92625-0084
949.640.7843
www.zingiberpublishing.com

www.beautifulbridefromeveryangle.com

Publishing Consulting and Product Development:
BookStudio, LLC
www.bookstudiobooks.com

Jacket and Interior Design:
Charles McStravick, Artichoke Design

Copyediting: Lisa Wolff
Proofreading: Laurie Gibson

Publishers Cataloging-in-Publication Data

 Beautiful bride from every angle : look great in every photo ... and in
 life! / Barbara Wallace, planner; Annie Withers, stylist; Lars
 Wanberg, photographer. -- Corona Del Mar, Calif. : Zingiber Pub.,
 c2011.

 p. ; cm.

 ISBN: 978-1-935108-00-9
 Includes index.

 1. Weddings--Planning. 2. Brides--Life skills guides. 3. Beauty,
 Personal. 4. Wedding etiquette. 5. Wedding photography.
 I. Withers, Annie. II. Wanberg, Lars. III. Title.

HQ745 .W353 2011 2010934542
395.2/2--dc22 1102

PRINTED IN CHINA

PHOTO CREDITS

All photography by
Withers Wanberg Pictures
www.witherswanbergpictures.com
except as listed below:

Aaron Delesie
20, 24 right, 26, 27, 87

James Johnson
30 upper left, 30 lower right, 64, 67, 69

Jennifer Gilmore Photography
82, 83, 97 lower left

John L. Blom Custom Photography
30 lower left, 93 left

Jon Barber, Barber Photography
31 lower right, 77 upper right, 277

Jon Nickson
31 upper left, 60, 61, 73, 96 upper right, 97 lower right

Lauren Hillary Photographic Artist
15, 28, 31 lower left, 41, 62, 66, 96 lower right

Tony Florez Photography
17, 268

Dedications

Barbara

To the memory of my beloved daughter, Heather Annette Henry, a beautiful
young woman of wit and humor whose honest opinions I sought and valued.
Her suggestion that I become a wedding planner inspired me to pursue the
wonderful career that has deeply fulfilled me for many years.

To Ed Whitehouse, the unsung hero who is the rock that keeps me grounded.

Annie

To those who have been with us in spirit and inspiration:
My parents, William K. Withers and Joanna Withers, whose *joie de vivre* has shown me
how to see and create beauty in my life, inspired my imagination, and loved me well.

To Harrison Piele, who was the one who said I would write and who
had an unwavering passion for books, photography, and us.

Lars

To my father, Larrie Wanberg, whose intelligence,
persistence, and sense of story has always inspired me,
and my mother, Bjørg Lahlum Wanberg, whose early passing taught me to
value what is truly important in life—to honor those who we love every day.

To the memory of John Stein, a remarkable surgeon
and compassionate man who left us too early.

Lars and Annie

To our children, Katrin, Nils, and Erland, who once played among
the light stands and seamless background paper of our home studio,
and now explore their own worlds as a writer, photographer, and musician.

To our families, without whom we would not have
weathered the storm or celebrated the journey.

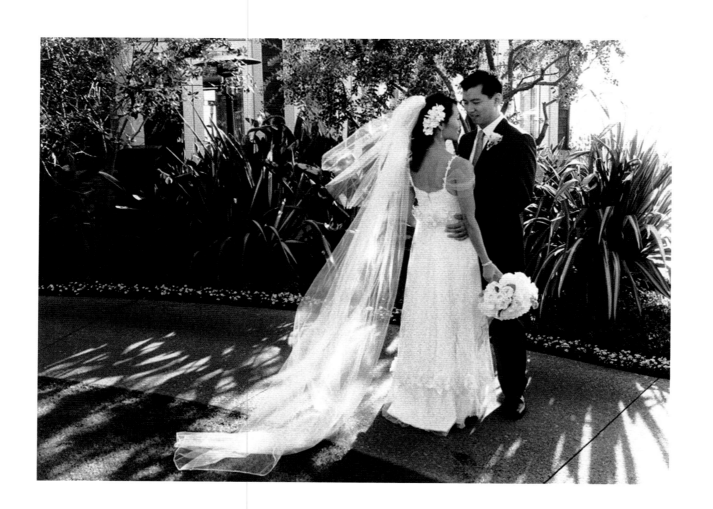

CONTENTS

The glow of candlelight always sets a romantic mood.

The PLANNER

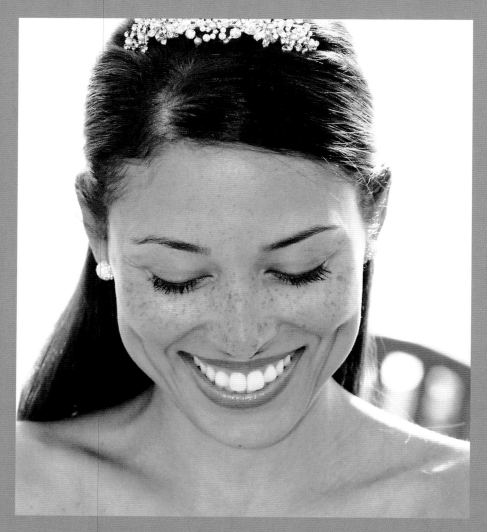

A beautiful bride—fresh, natural, blissful, and radiant—awaits her moment to walk down the aisle.

BARBARA'S *Philosophy*

No woman is more beautiful than on her wedding day,

when she is glowing with love and excitement. However, what does it really

mean to be a "beautiful bride"? Most people, I believe, think beauty is made

up of physical attributes, such as a pretty face, a nice figure, gorgeous hair,

and a nice wardrobe. However, as I have learned after dealing with hundreds

of brides, true beauty is much more than skin deep. It encompasses gracious

behavior, awareness of others' feelings, generosity, and high self-esteem without conceit. All these are far more important than physical looks. We've all known someone who is stunning to look at but once you get acquainted, you find she is self-absorbed or cares only about what you can do for her. She becomes far less attractive when you see through the outer beauty. Thankfully, the reverse is true as well; someone not generally considered beautiful becomes very attractive when the warmth of her being shines through.

As you prepare to be a bride, you will spend a lot of time in front of the mirror—trying on a multitude of wedding gowns, having hair and makeup previews, and selecting all types of clothes for your time in the limelight. It will be tons of fun, though nerve-wracking at times. You might be critical of your looks or, conversely, get a little big-headed from all the attention. I just want to remind you to listen to your heart and your inner voice of reason. That should help you stay on an even keel and put all of this activity into perspective. Remember the old axiom, "Beauty is as beauty does."

You'll hear over and over, "It's your day, so do what you want to do." I agree that is important but caution you to remember that it's also your groom's day; he's probably just as excited and perhaps just as nervous as you are about this whole marriage prospect. Remember that he has emotions, too. He just might not express them the way you and your bridesmaids do.

It's also your mom's day. After all, she's been dreaming of this day far longer than you have. And probably so has your dad—and other members of your family and your groom's family—so be sure to consider their feelings, too. They'll love you all the more for that.

Here's an example of taking the "it's your day" thing too far. I once interviewed a bride who vociferously stated that she didn't see why she had to go from table to table at the reception to thank every guest for coming. After all, she said, she was feeding them an expensive dinner and they'd darn well better bring her a gift equal to the value of what she spent on each of them. And her band was going to cost a lot and she wanted to party the whole time. With a bridezilla in the making, you can understand why I refused to take that wedding.

As you embark on this new adventure called marriage, you might feel as if you are at a crossroads in your life. After all, you are making a huge commitment for all the world to see. Perhaps this is a good time to make some other personal commitments, too. Taking on the mantle of "wife," you're now going to be perceived as more mature and responsible. Perhaps

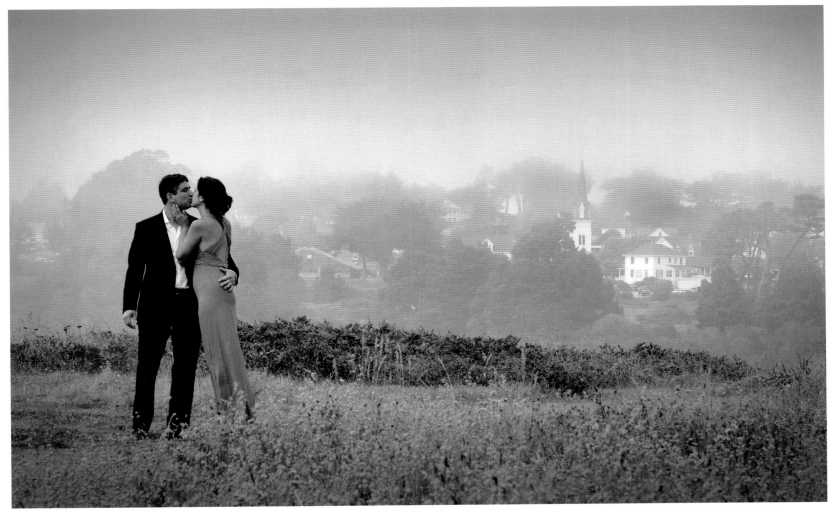

Where is it written that the bride's gown must be white? This bride expressed herself with a gorgeous emerald green dress. Be who you are on your wedding day and your day will be as romantic as this image.

you're even thinking about becoming a parent in the future. With this comes certain responsibilities that you can start preparing for now.

One way to begin is to refine your personal beliefs. These will likely change as you are exposed to various life experiences, people, and incidents, and as long as you are getting better and striving for new heights, it's a good thing. Your youth is a time to sample life and learn who you are. I think that the main framework of anyone's philosophy should be one's personal ethics.

And if you use these as your yardstick to measure all of your actions, it will not be difficult to define and live your philosophy. One of my own goals is to stay open to new ideas and experiences within the parameters of my defined belief system.

Here are some tips to help you define and refine your own philosophy:

• Look inward. Ask, "Who am I?" "Where do I fit in this world?" Talk to friends and family, read books by great thinkers, and see where their ideas land in relation to your own. Continue to formulate your belief system by questioning your own values and those of others. Develop and trust your instincts, but don't be afraid to change. It's not easy to reinvent yourself, but if you feel you need to make some real changes in your life, it might be necessary to make a paradigm shift to become who you really want to be. If necessary, seek professional help.

• Aim to be who you are every minute of every day. It won't likely happen, as we are all human and have distractions, failings and, among other things, moments of laziness. But if you strive for new accomplishments, you're far more likely to succeed than if you have no clear goals. Each morning I look at a piece of paper and quickly ponder three questions that enable "power thinking": "How will I make this day most powerful for my business?" "How will I

make this day most powerful to my health and well-being?" "How will I make this day contribute to my best image?" I mentally answer these questions with such thoughts as "I will work on this book," "I will go to the spin class at the gym," and "I will dress nicely even when I go to the market." These thoughts then become self-fulfilling and remind me of my day's purpose. Your perspective will most likely be different, but I suggest doing something similar.

• Strive to be wise in words and deeds. Think of the consequences of every action before you undertake it. I guarantee you will make mistakes of all sizes and will continue to do so—you're human, remember. Learn to forgive yourself and others for mistakes, but learn from them and don't repeat them. Wisdom comes from those mistakes. As that great philosopher Jimi Hendrix said, "Knowledge speaks, but wisdom listens."

• Take on challenges both big and small. You might have fear, but strive to work past it. No one ever grew by staying within his or her comfort level. You have to stretch. There's a great book about this, *Feel the Fear and Do It Anyway,* by Susan Jeffers, Ph.D. The title says it all.

• Find a mentor. In a perfect world, this would be someone willing to spend time counseling you and helping you achieve your goals. Of course, it's a lot to ask someone to do this for you out of the goodness of his or her heart, especially if that person doesn't know you very well. So

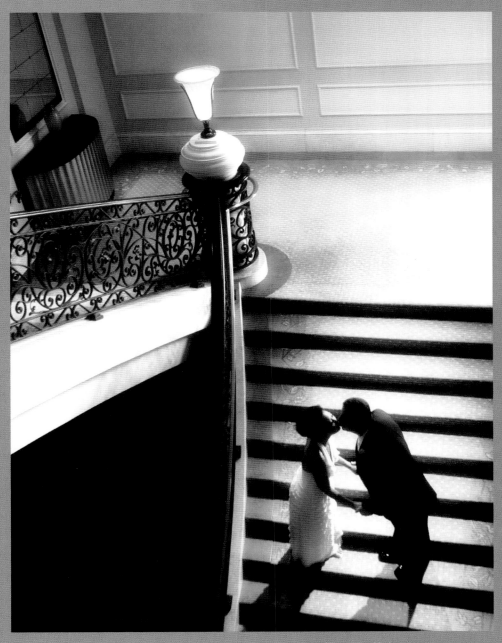

The architectural features of this lovely staircase and the natural light
pouring through an adjacent window lend a warm glow to this stolen kiss.

be realistic with your requests and be prepared to offer something back. And *always* pay it forward. If you can't find a person to mentor you, you can hire a life or business coach or be your own mentor by observing traits in successful people you admire and patterning yourself after them. Not just copying them, but watching how they handle themselves in various situations—instances where you can learn from and be inspired by their behavior.

A word of caution: as you become more successful or sure of yourself, keep your ego in check and don't let it run the show. We've all seen "celebrities" who start to believe their own press and go off the deep end thinking they are more special than the rest of the billions of people on Earth. Humility is a wonderful trait. Practice it daily.

I wish you a very happy marriage filled with all the good things life has to offer.

Traditional and simple rings are so much more than mere bands of gold. They signify that a lifetime commitment starts here.

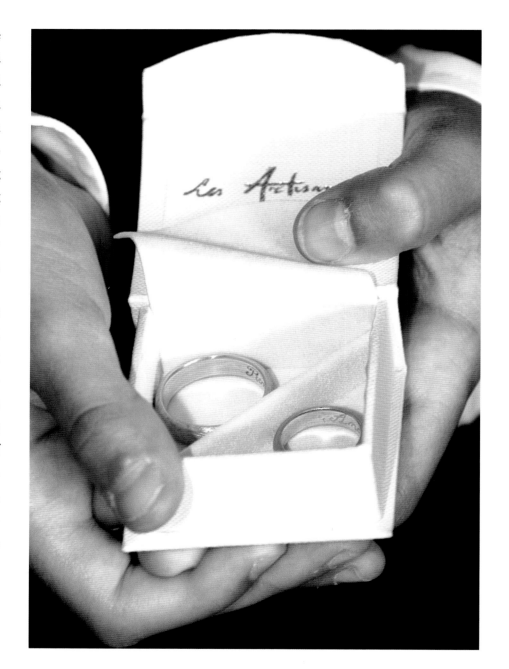

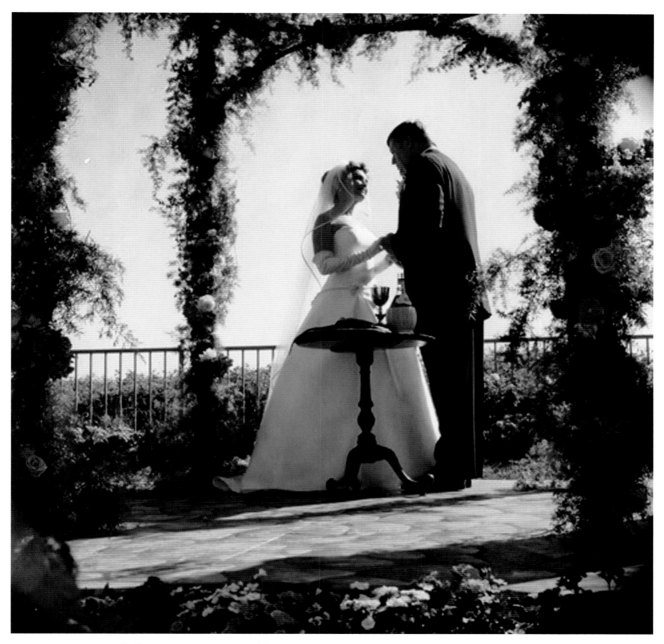

Many couples do a unity ceremony as part of their ceremony. It can be with candles, sand or wine and often mothers take part.
This couple with an Italian themed wedding had a lovely, heartfelt wine and bread sharing ceremony that just the two of them took part in.

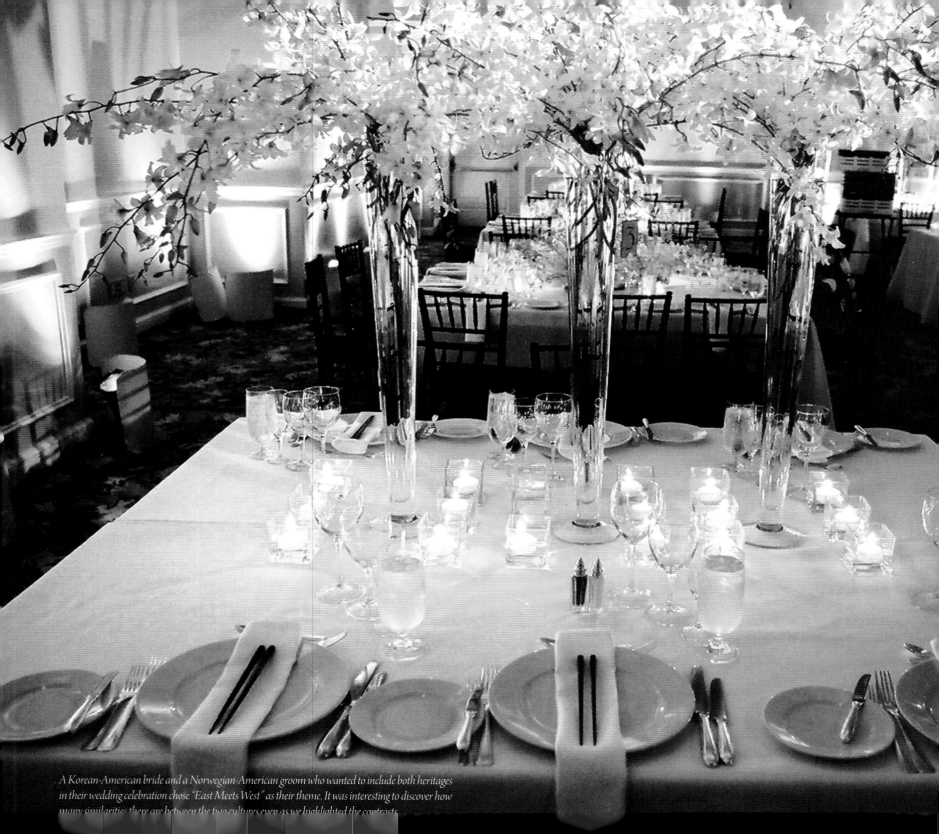

A Korean-American bride and a Norwegian-American groom who wanted to include both heritages in their wedding celebration chose "East Meets West" as their theme. It was interesting to discover how many similarities there are between the two cultures even as we highlighted the contrasts.

Chapter One

YOUR WEDDING
Your Way

The day you got engaged or decided to get married

was probably one of the most exciting days of your life. Take a

moment to bask in the fabulous feeling of knowing that you've

just committed to sharing the rest of your life with someone

you love so much, for in just a moment you will realize,

"Yikes! We have a wedding to plan!" The wheels turning in

your mind might seem to be going in ten directions at once.

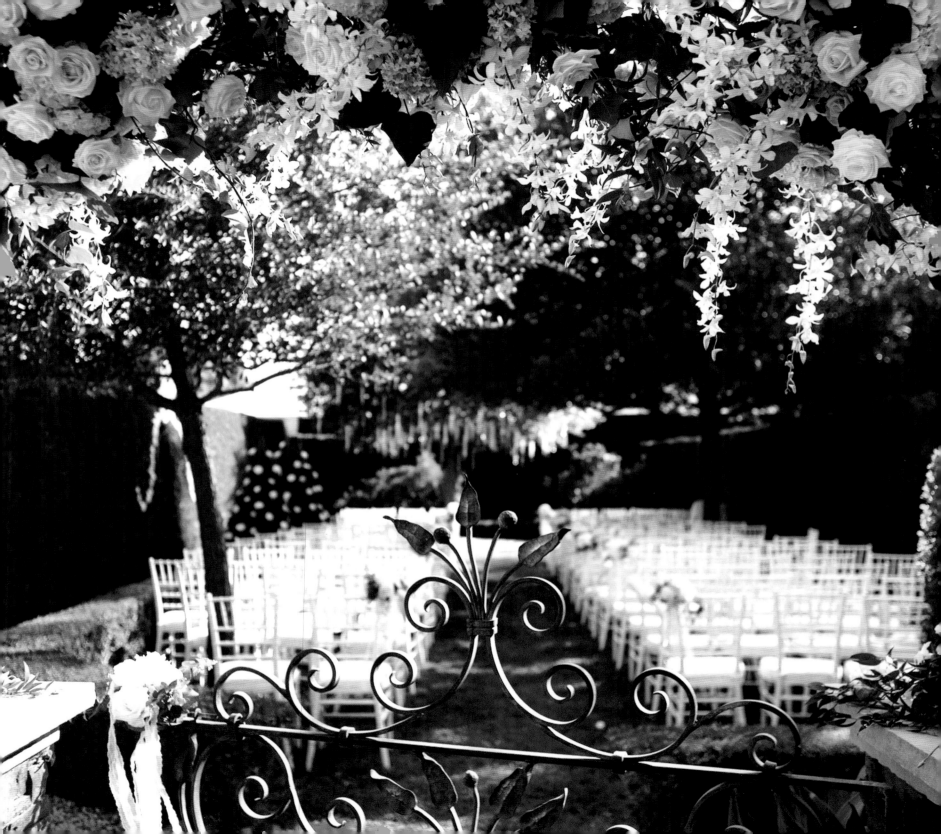

With its famous yellow label, this Champagne says "luxury."

Where to start? Take a deep breath, close your eyes, and envision yourself having a wonderful time from now until the big day. Know that you'll get through the process and the end result will be worth all the time and energy (and money) you invest. Come along with Lars, Annie, and me. We have lots of experience, and we will share lots of ways to allay your concerns and create a really amazing wedding day—and beyond. Congratulations! Now, let's get to work!

Designing Your Wedding

First, determine what kind of feeling you want your wedding to have. Will it be casual, formal, or in-between? Will you have it in your hometown or his, or maybe in your college town? Or perhaps you'd prefer a romantic destination you both love or have dreamed of visiting. Will you limit the guest list to family and close friends, or will you open it up

Left: This intimate ceremony site provided a secret garden feel to this home wedding. Note that we used no side aisles in order to maximize the number of chairs so we could realize the bride's dream of having the ceremony surrounded by the lovely green hedges. See the image on page 26 for a surprise repurpose of this site.

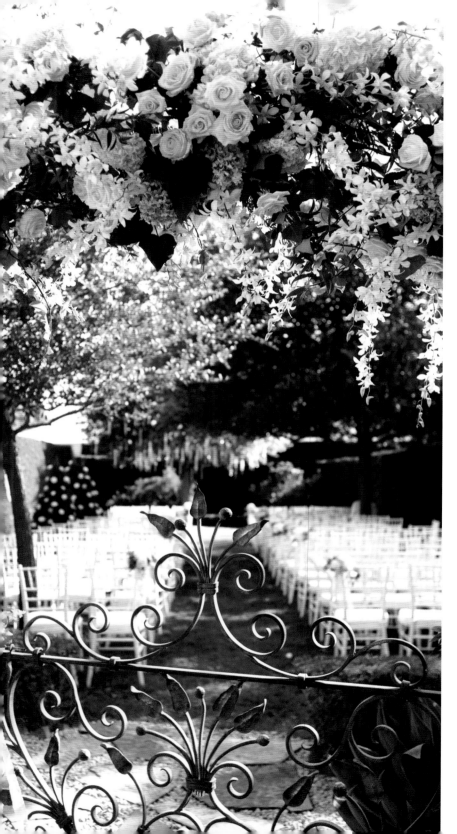

to extended family, friends from all stages of your lives, and business associates of you and your groom and both sets of parents? There are so many questions to answer, but by approaching them one at a time and discussing each one with your fiancé and whoever else will have input, you'll arrive at the answers you need. Just remember to breathe deeply.

Like most brides, you most likely want to avoid anything that even slightly resembles a cookie-cutter wedding. Even if you have limited funds for your special day, you and your groom can put your thumbprints on your wedding by incorporating little touches (or big ones) so your guests will leave with memories that clearly demonstrate whose wedding they attended. For example, one of my couples was known for their love of French fries, so we had a French-fry station with an array of sauces. When you do something like that, your guests will talk about it for months after the wedding.

It's really fun to look at wedding magazines and TV shows to get some great ideas. By the time the wedding planning process is over, most brides have acquired a pile of books and magazines as tall as they are. As you see things you like in magazines, note the pages and what is attractive to you. Maybe it's just the way a bouquet is wrapped, a color scheme, a napkin fold, or the lighting; or perhaps it's the entire ambiance of the room. Seeing these pictures will help your planner, florist, and the entire design team (and you and your groom, too) see your vision. It may take a while to actually focus in on that vision. It's very enjoyable to see how a wedding evolves as you go from those tear sheets and ideas to your final photos.

A romantic moment captured just as the bride and groom were getting ready to walk up the aisle as husband and wife.

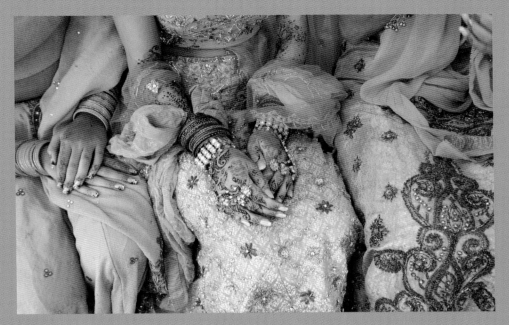

Indian tradition calls for copious amounts of gold jewelry as a couple's lifetime commitment begins. This Indian-American bride and friends show the intricate henna hand-painting called mehndi. If you look closely, you may see the groom's name hidden in the design.

for new things. Use their ideas as inspiration and adapt them to your own situation and budget. You can end up with a beautifully designed wedding that is all your own.

Remember, too, that some magazines do not separate their editorial content from their advertising content. In other words, the companies that buy the most advertising get the most coverage elsewhere in the magazine. So just because someone buys a big ad, it does not make that a fabulous (or even good) vendor or product. Here's where you need to learn to trust your instincts, ask the right questions, and listen carefully to the answers.

Many of the photos you see in magazines are not of real weddings and are clearly not feasible from either a financial or practical standpoint unless you have an unlimited budget and/or care nothing about the comfort of your guests. Think of these design photos as similar to runway clothing designs. Often, the clothing is deliberately outrageous to get your and the media's attention and to show the designers' creativity. The designers don't actually expect people to walk down the street in many of their designs. It's the same with wedding designers. They get bored doing the same things over and over again, so as much as anyone else, they are all looking

This book is different, though. Almost all the photos in this book were taken at real weddings put on by real people. The bride on the cover is a not a model but a beautiful woman on her wedding day. Some of these weddings had enormous budgets, and others had much more modest ones. Look carefully at the photos and find things that feel great to you, that reflect the kind of feeling you want for your day. Share those with your planner (if you have one) or note them in a book. It will be fun to see your vision come into focus!

Special details for a special day.

Pick a Color, Pick a Theme

Good design is good design no matter how much or how little the cost. Just because something costs a lot does not ensure good design or even good taste.

"Less is more" is a phrase recited daily in art schools and designer workrooms the world over. The famed twentieth-century architect Ludwig Mies van der Rohe aphorized what has become a guiding light for designers. Keep it in mind as you design your wedding. It's tempting to incorporate all of the things that you've seen in magazines, on TV wedding shows, in shops,

or at other weddings. But do be careful that you don't have so much going on that it looks like a mishmash or a three-ring circus. In her section, Annie discusses not mixing metaphors in your dress and makeup. That's very important in your wedding design, too, if you want to have a cohesive and well-thought-out look.

Choosing a theme and color scheme early on is important. When I use the term "theme," I don't mean taking an idea and running it into the ground, like at a child's birthday party. I mean having one idea that runs as a thread through the invitations to the décor to the menu and through the end of the wedding event. It might be a color scheme and/or a style, such as contemporary,

traditional, Italian, Old Hollywood, or whatever. This becomes a road map to follow and can help you contain your ideas as you measure each against your vision. It might influence your choice of venue or music. Certainly it will affect your choice of gown, menu, and décor.

It's easier to talk to florists and designers when you have a clear vision and parameters. As you go through the design process, picking and choosing wonderful and coordinated elements, pretty soon you'll realize you've come up with a dynamite wedding. This is what I mean by the wedding evolving. First and foremost, it's your wedding and should be an expression of you.

Sometimes a clear theme idea is hard to come by. One of my brides was a business professional with no hobbies or interests that she thought translated well to her wedding day. We brainstormed all kinds of things, but nothing hit the mark. As we dug a little deeper, she revealed that she loved reading Jane Austen novels and liked the fashions of that period. She especially loved silk tassels and braid and the grandeur they evoked on curtains and clothing. *Voilà!* We had our theme and decided to use tassels as the main design element. The color scheme of gold and cream grew out of this, and we tastefully included tassels on the invitations, on the flowers lining the ceremony aisle, hanging from the table centerpieces, and around the napkins at each place setting. It was a simple addition but a very personal one.

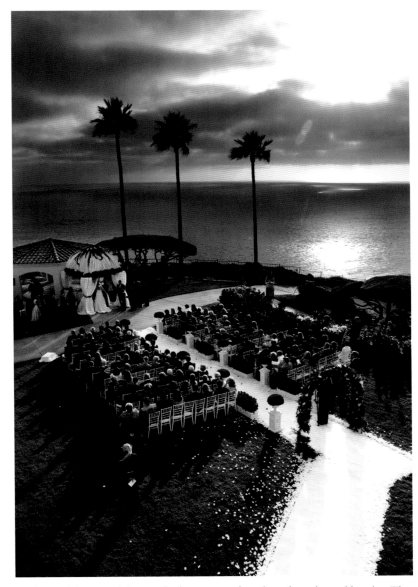

We featured dozens and dozens of red roses everywhere throughout this wedding day. They were the bride's late mother's favorite flower and this was a wonderful way to pay tribute to her memory. All in attendance felt the mom's presence during this gorgeous sunset. If there is a balcony or other high spot overlooking your ceremony site, ask your photographer if a second photographer could be stationed there to get this kind of coverage.

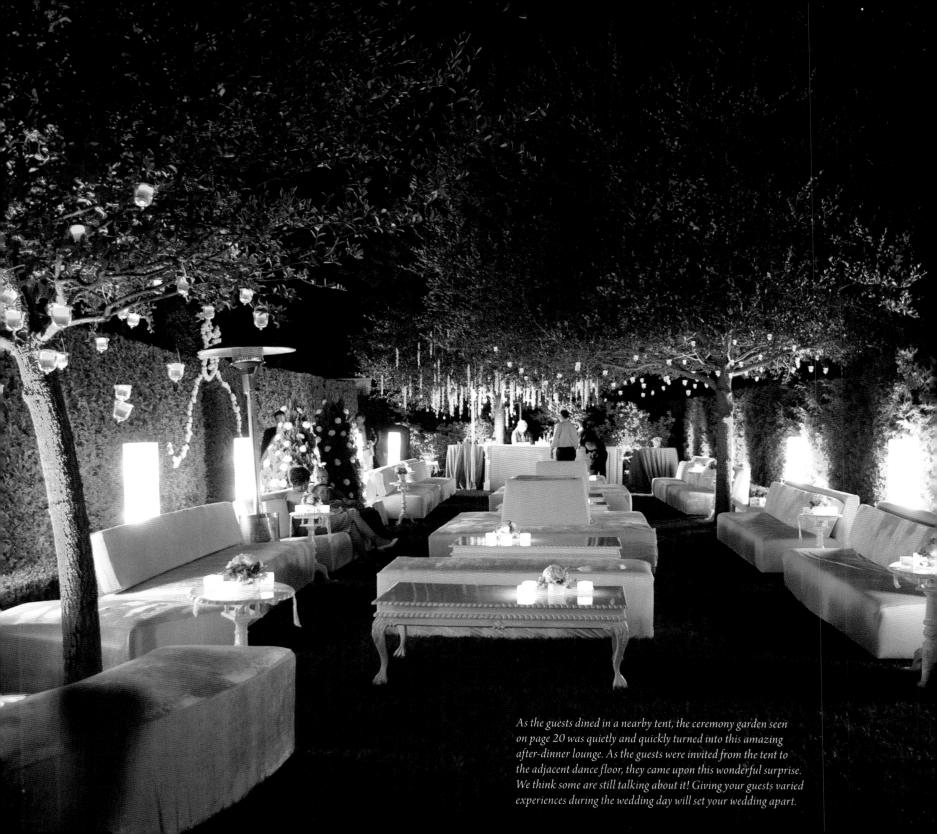

As the guests dined in a nearby tent, the ceremony garden seen on page 20 was quietly and quickly turned into this amazing after-dinner lounge. As the guests were invited from the tent to the adjacent dance floor, they came upon this wonderful surprise. We think some are still talking about it! Giving your guests varied experiences during the wedding day will set your wedding apart.

A lovely detail of the surprise lounge.

Know Your Own Mind

While it might be tempting to ask your friends and family for input during your wedding planning (and some might even give input without being asked), be careful not to let others coerce you into choosing something you don't care for or cannot really afford. This is your and your groom's wedding, not that of a committee of bridesmaids or aunts or anyone else. You should be fulfilling your own dream for your wedding day, not one that someone else has for you or—worse yet—for herself for a wedding she never

had. This makes a case for having your wedding vision fairly well defined at the beginning so that you can more easily stay on the path you've chosen.

You might need to learn some assertive behavior to express and stick to your opinions, especially with people who are used to having the upper hand with you. (Note to potential bridezillas: There is a big difference between assertive and aggressive, so please don't get high-handed with people and try to intimidate them or order them around.) There is, of course, a balance here. It's good to remember to pick your battles. Some things are just not worth turning into a big deal.

Rank the Elements of Your Wedding

Very early in the process, it's essential to rank how important each element of the wedding is to you and your groom. This will help you choose what you want to emphasize at the wedding and what you can simply live without. Some of your answers will be a surprise to one another, so this form [next page] becomes a really good way for the two of you to learn more about each other's taste and priorities.

Copy the form (or you can find it at www. beautifulbridefromeveryangle.com), then list all the wedding elements, from invitations to the music and everything in-between such as flowers, size of the guest list, favors, et cetera. Put a column for your ranking, another for your groom's ranking, and a third column for a compromise ranking, which is what the two of you agree upon once you've discussed any differences in your columns. I suggest using a scale of 1 to 3. Refer to this form periodically to keep focused as you plan. It will help you stay on track if you get bogged down with decisions. Do use the compromise column—after all, it's good practice for your marriage. You're sure to encounter many decisions over the years that require a compromise.

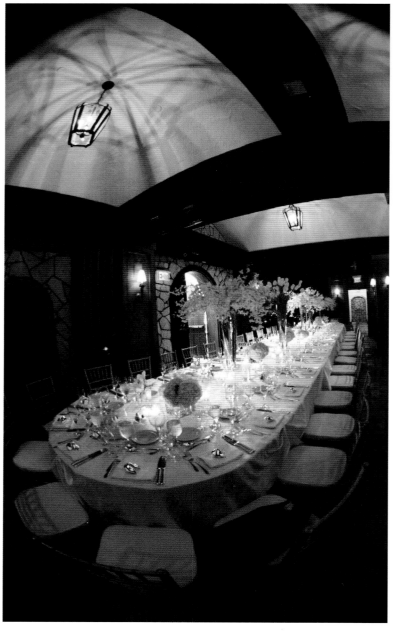

For a small wedding like this one in a wine room, a large table where all guests are seated gives a lovely intimacy that is missing with separate tables. Some people say that you can only talk to the person next to you with this kind of setup, but I've found that is the case with any table. I encourage this type of configuration so everyone can sit with the bride and groom.

Barbara Wallace Weddings

BRIDE AND GROOM'S PRIORITY LIST

PLEASE RANK EACH ITEM IN ORDER OF IMPORTANCE

1 = very important 2 = moderately important 3 = not important

WEDDING ELEMENT	BRIDE'S RANK	GROOM'S RANK	COMPROMISE RANK
Ceremony Location			
Reception Location			
Ceremony Décor			
Reception Décor			
Flowers			
Invitations/Stationery			
Size of Guest List			
Food			
Beverage			
Service Staff/Style			
Bride/Groom Attire			
Attendants' Attire			
Size of Bridal Party			
Photography			
Videography			
Wedding Cake			
Music/Entertainment at Reception			
Music at Ceremony			
Traditions			
Favors/Souvenirs			
Rehearsal Dinner			

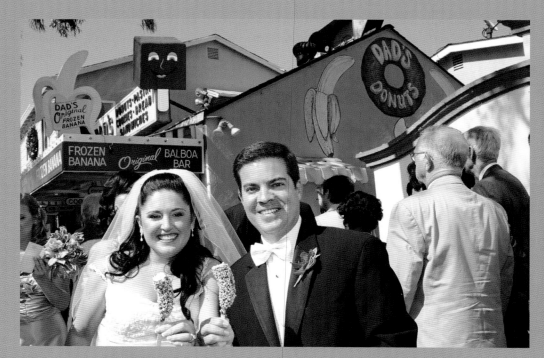

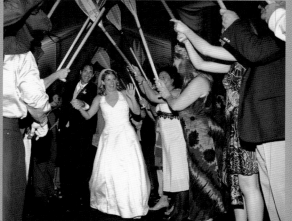

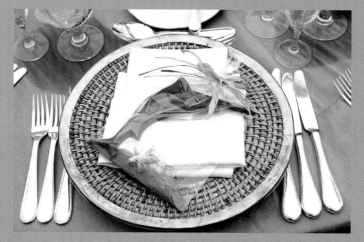

Wedding guests—and the groom—were surprised after the ceremony with a chocolate-covered frozen banana from the stand next door to the chapel on Balboa Island, California (upper left). The bride had tickets printed so all guests could enjoy the treat. A custom-light gobo (upper right) shows how much the bride and groom appreciated their guests. It was fitting for this bride and groom (lower left), who met at a paddling club, to make their grand entrance through an arch of paddles. In lieu of favors, this couple (lower middle) donated to a group that provides assistance dogs for disabled people. A note and cookie shaped like their yellow lab—who was also in the wedding—was tied to each guest's chair. The groom loves deep-sea fishing and even makes his own lures, so a custom-designed chocolate in the shape of a marlin (lower right) was the perfect favor for this wedding.

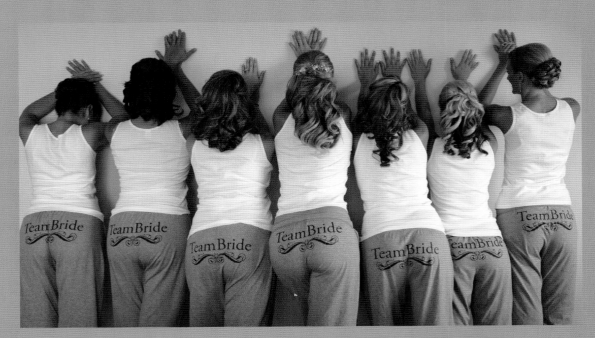

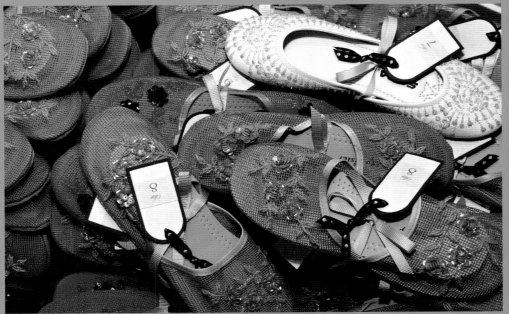

All the bridesmaids had fun being part of Team Bride (upper left). A note that started "In the highly likely event of too much fun . . ." was tied to little Hangover Kits (upper right) that each guest was offered as they departed this reception. For a forty-guest wedding (lower left), this bride wrote a personalized fortune for each guest and inserted it into a silver fortune cookie that served as a place card. The guests were thrilled. All the ladies were delighted when these darling dancing slippers (lower right) were available when the serious dancing began. Be sure to get a variety of sizes and tie a size tag on each pair.

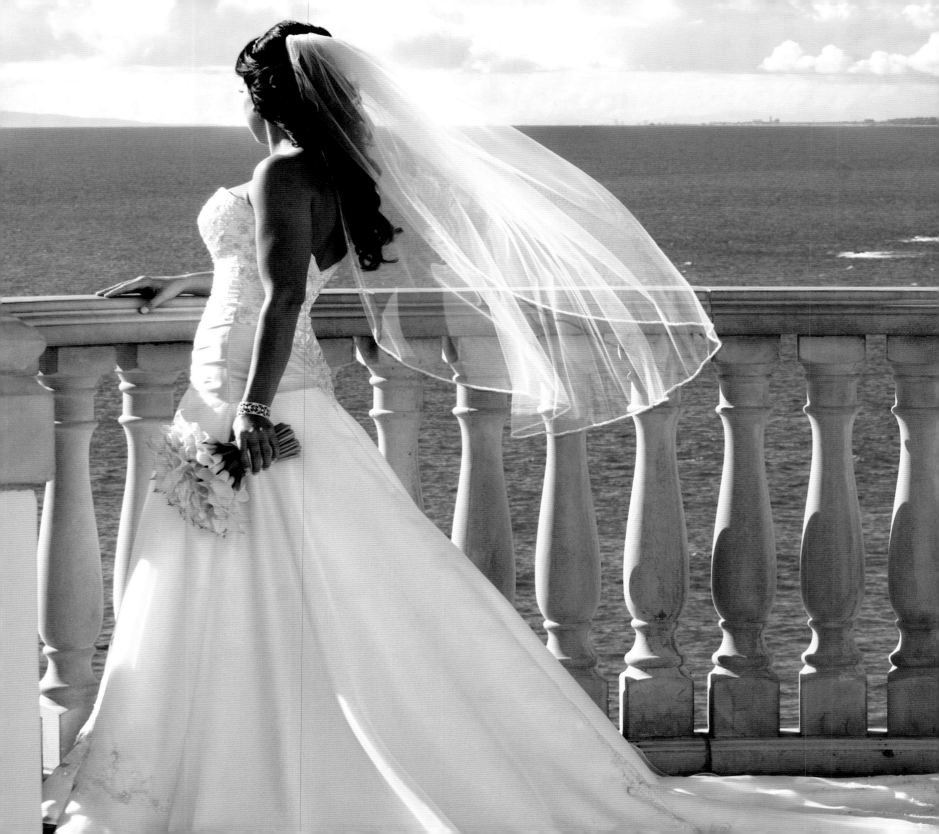

Enjoy the Process

Above all, please let yourself enjoy planning your wedding. While it is a huge party and a huge expense, try at all times to stay focused on the main reason you're having the wedding. It's all about marrying the person you love and having the people you care most about there to witness the ceremony and celebrate with you. If you keep that thought as your beacon, the planning process can be kept in perspective and you'll enjoy it more.

As this bride knew, it's important to take some time alone amidst all the wedding day excitement to reflect for a few moments about your upcoming commitment.

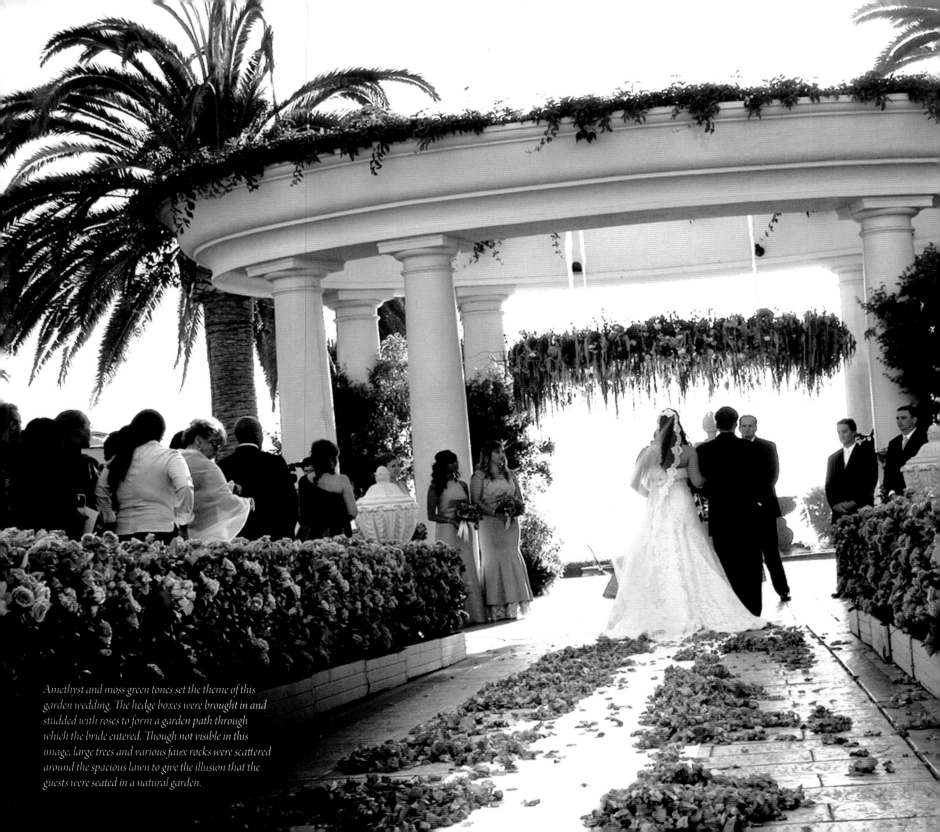

Amethyst and moss green tones set the theme of this garden wedding. The hedge boxes were brought in and studded with roses to form a garden path through which the bride entered. Though not visible in this image, large trees and various faux rocks were scattered around the spacious lawn to give the illusion that the guests were seated in a natural garden.

Chapter Two

MONEY, MONEY, *Money!*

Well, I guess it's time to discuss the dreaded

B-word—budget. I know that's not the most romantic

part of wedding planning but it is *imperative* that you

know exactly how much you have to spend *before*

you spend one penny on the wedding. To illustrate

how important this is I offer this vivid example:

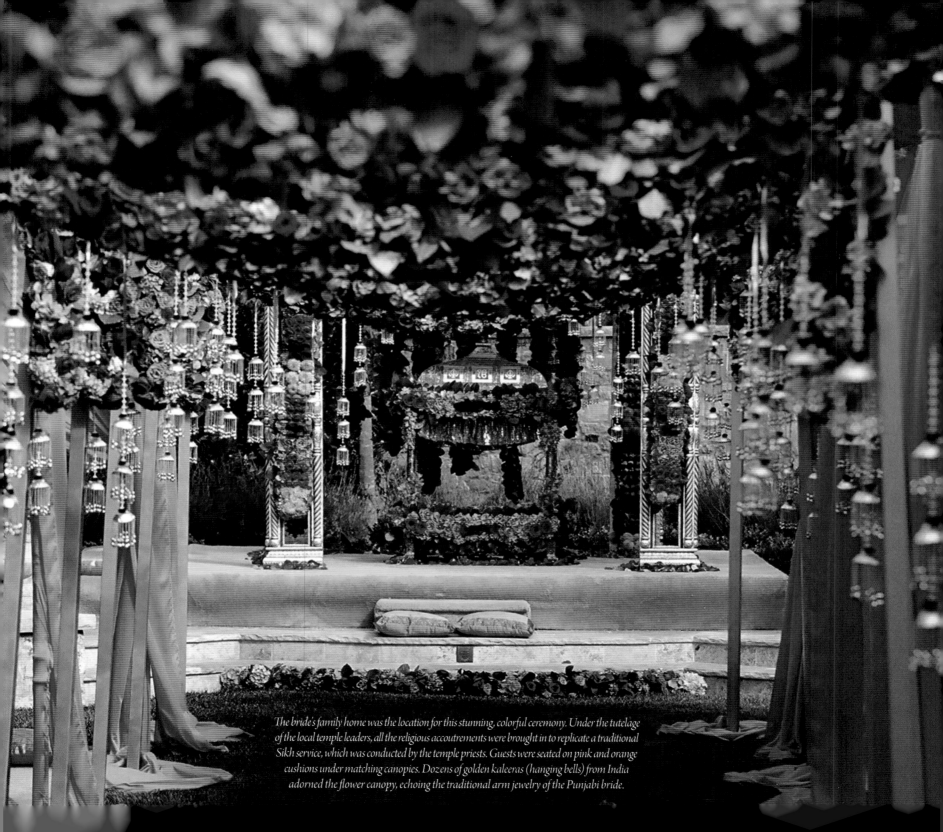

The bride's family home was the location for this stunning, colorful ceremony. Under the tutelage of the local temple leaders, all the religious accoutrements were brought in to replicate a traditional Sikh service, which was conducted by the temple priests. Guests were seated on pink and orange cushions under matching canopies. Dozens of golden kaleeras (hanging bells) from India adorned the flower canopy, echoing the traditional arm jewelry of the Punjabi bride.

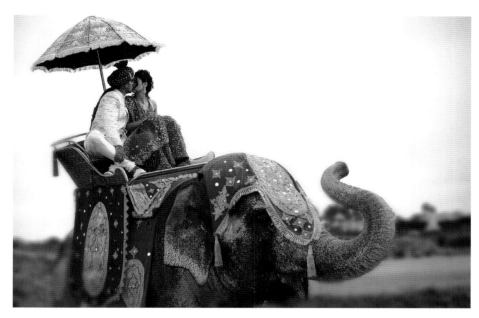

A real Grand Entrance! Having been married a week before in the bride's hometown in the eastern United States, this couple could enter their California reception together and wanted to do so with panache. They did!

I was once hired by a bride and groom with a strict (and rather tight) budget. Before hiring me they booked a high-end venue with a considerable minimum. The next thing the bride did was to spend over 12 percent of the total budget on her wedding gown. It was a gorgeous dress, of course, but this purchase affected the entire wedding planning process. Once she hired me, we had to stretch in many places and simply cut in others to make sure there were funds for the rest of the wedding and that the design and food measured up to the fancy style of the gown and venue. We came up with a lovely wedding for them, of course, but it was a real challenge. The bride realized her error once we were into the planning, but by then it was too late.

As a general rule, I suggest allowing 50 percent of the total wedding budget for the food (including the cake) and beverages, service charge and tax, the rental of the ceremony and reception sites, and any setup charges, which might include the chairs, tables, and other standard décor. I refer to this collectively as the venue charges. (Many people forget to factor in the service charge and tax when they see a catering menu, not realizing that "++" after the price of the entrée means "plus service charge" and "plus local tax." Those two little plus signs usually add another 25 to 30 percent on top of the meal price.) The remaining 50 percent of the budget is broken out this way: about 8 to 10 percent for flowers, 8 to 10 percent

for photography and videography, 5 to 10 percent for music, 5 to 10 percent for the wedding planner's fee, and the remainder for the invitations, attire, transportation, favors, and other items.

Of course, if you choose very elaborate décor or substantially upgrade any other element, you will need to adjust these percentages—e.g., the venue charges portion will be smaller—or add more money to your overall budget. You can see that these percentages are only general guidelines. Let your personal priorities, as specified by the rank you gave each element in Chapter One, be the driving force for how much you actually spend on each element.

A note about food and beverage (F&B) minimums: If you don't absolutely understand this concept, please ask the venue catering manager or your planner to explain the venue's policies related to minimums. Briefly, an F&B minimum is the amount of money (*before* service charge and tax: the ++) that you *must* spend to book a particular room or venue. Let's say you book a room for 150 guests and the F&B minimum is $15,000++. (This is $100++ per guest. With a 21 percent service charge and 7 percent local tax, that is actually $129 per guest.) So you are agreeing to pay $15,000 *plus* the service charge and local tax, which is a total of $19,420. Once you have signed the contract you are committed to that amount, even if your guest count goes down. So, if you go to 100, this would effectively take your price per guest to $150++ ($194 with the ++), and you might have to add more food or upgrade the alcohol selection just to spend up to the minimum. If you do not meet the minimum, most venues will characterize the additional as "room rental," and you are still obligated to pay it, no matter what it's called.

To help you choose your venue, it is very important to accurately estimate your guest count *before* you sign the contract. Be careful to choose the size room that will best accommodate your expected guest count. Either too large or too small can cause challenges in the long run. If I knew I had to err, I'd choose a space that is a bit

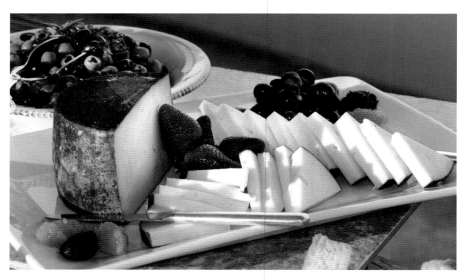

Cocktail reception food can be presented as a display or tray passed by serving staff. A cheese display is always popular but I also suggest tray passing so guests can grab a bite without leaving their conversation.

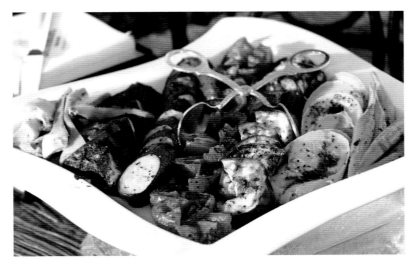

It's thoughtful to have a varied selection of hors d'oeuvres including items for guests who might be on diets, vegan or omnivorous.
These grilled vegetables were part of a lovely display while the mini-sliders were tray passed.

too large; you can always use the extra space, but you cannot push out walls.

I've talked to brides who committed—signed the contract, so they could not cancel it—almost 85 percent of their budget to food and beverages. There is no way to do the rest of the wedding for the remaining 15 percent. Here is a frightening example: A bride had $75,000 for her wedding. She picked a venue that cost her $64,000. How was she going to afford a gown, a photographer, music, and all the rest for $11,000? It was pretty much impossible.

Trying to squeeze the funds that way will likely result in settling for lower-end—and in some cases, poor-quality—vendors or eliminating certain elements of the wedding entirely. This can be like wearing tennis shoes with an Armani evening gown—it just doesn't work! While many people would like to have their wedding at a four- or five-star property, it's not feasible for every budget. So be realistic. Scale down

the guest list or find a less expensive location, but please don't turn your dream wedding into a nightmare just to impress your friends as they walk into the location.

Where Is the Money Coming From?

Be clear from the start about who is paying for the wedding and how much they are contributing. Are you and your groom footing the entire bill yourselves? Will it be your parents? A combination of his parents and your parents? His parents only? Are all of you chipping in? Nowadays there are no strict rules about who pays for what part of the wedding. Over the years I've seen every combination imaginable, and they all worked just fine. But you must spell it out before you embark on your journey—both to avoid any

misunderstandings and to have the funds when you need them for deposits and final payments.

Also, make sure you know when and how the contributors are actually going to give the money. Do they want to pay a certain bill directly? By credit card or with cash? (Note: some wedding vendors do not accept credit cards.) Will the contributor give you a lump sum to manage? Do you have to show an accounting? It might be wise to have a separate checking account for the wedding expenses. Here again, there is no right or wrong. Just ask what will work for you and your families. A frank discussion in the beginning helps all concerned and avoids hurt feelings, misunderstandings, and family rifts.

There is something I call the Golden Rule of Weddings: "The one who has the gold makes the rules." So if you are taking money from others to finance your wedding, they might require some input. Diplomacy is very important here. Of course, in this as in all other areas of life, you will often need to make compromises during the planning process.

Your Financial Plan

It is extremely important that you have a written financial plan. This becomes your financial road map. You wouldn't take off on a trip across the United States without a map, so please don't embark on such an important undertaking as planning your wedding without a financial map. Remember, this will likely be the largest party you'll ever throw, so you must make it as easy on yourself as possible.

I recommend that you make a spreadsheet of all the elements of the wedding, then apportion the funds you've set aside and plug in the numbers. Be sure to remember all the small things that add up (especially at the last minute), such as your undergarments, gifts for your attendants, gratuities to vendors, and welcome gifts for out-of-towners. Especially if you have a strict budget, be sure to consider the delivery and pickup charges as well as sales tax on vendor contracts. Some vendors do not include these costs when they are quoting prices, so make sure you ask for at least an estimate of the final total or you'll have some unwelcome surprises at the end.

Once your spreadsheet is complete and your estimates are within your budget, you can move funds around as things change. Be sure to keep it current, especially if you have to show your accounting to your parents or the "committee" of contributors. Have the figures for each element firmly in mind as you visit vendors so that you can stay within your budget or, if you are lucky, so you can lobby for additional funds from one of the contributors who might be willing and able to toss a little more into the pot.

I've noticed that dads in particular are usually very interested in the bottom line and love the spreadsheet, so I'm sure you'll impress yours if you have this all together to present.

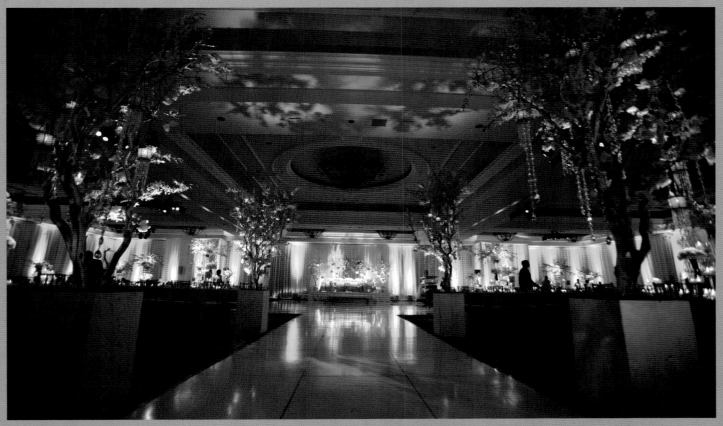

The color theme of this wedding was primarily aqua and silver. However, by using LED lights we were able to change the entire room color with the flick of a switch. What looks like three different weddings in the above photos was actually the same one with the lights changed for various effects throughout the evening. For example, we used green for the salad course and red when we wanted to get the energy up for dancing.

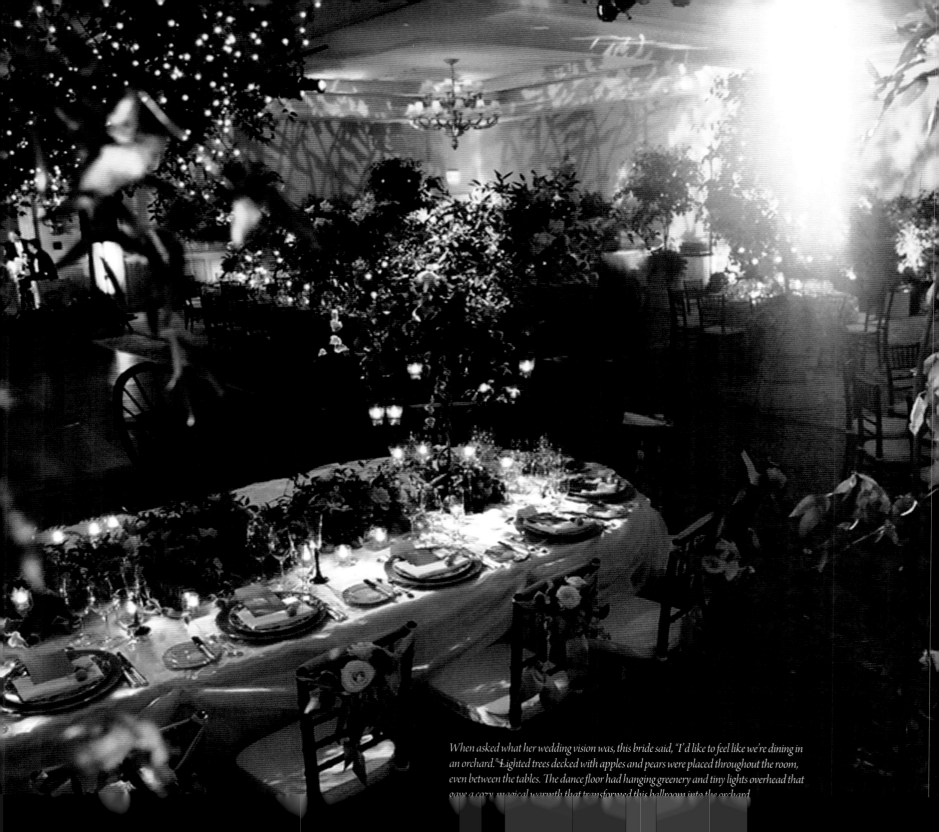

When asked what her wedding vision was, this bride said, "I'd like to feel like we're dining in an orchard." Lighted trees decked with apples and pears were placed throughout the room, even between the tables. The dance floor had hanging greenery and tiny lights overhead that gave a cozy, magical warmth that transformed this ballroom into the orchard.

Hiring Wedding Vendors

Assembling a team of wonderful vendors is essential for a fabulous wedding. As a planner, I have a community of favored vendors. Since I know they will do a great job and that they will do it with professionalism and a positive attitude, I draw from that group first when I am making referrals to my clients. All the best vendors know the value of being part of the team, and none is a prima donna.

If you are assembling your own set of vendors, during the interview process make sure that they are amenable to working with the other vendors you are considering. If they aren't, take note; there may be a reason. They may know something that gives them pause. For example, a band or DJ may try to take over the reception because they think the party isn't good unless the dance floor is filled the entire evening. What about conversation during dinner? Guests don't want to shout to be heard.

A Word about Discounts and Bargaining

While I have no issue with asking a vendor if they can do a bit better on the price they quote by either cutting something or adding some value, many vendors are put off by the suggestion of a discount—especially from a client who has chosen an expensive venue or is incorporating other showy or costly elements.

Reputable vendors base their pricing and service on their years of experience, their professional reputation, and their many satisfied clients. The vast majority deserve what they charge. They are not sure why some clients—total strangers to the vendor—deserve a discount. More than one vendor has asked, "If the client can't afford the wedding they want, why are they having it?" Good question!

Some vendors tell me that if they do consent to cut the price, they will simply give exactly what the couple contracted for. On the other hand, if the couple agrees to pay the full price, they give much more than what was contracted for—without being asked. This is another example of "you get what you pay for."

Trying to get a discount or bargaining with a vendor or supplier is a game some consumers enjoy playing. Most high-quality vendors, however, consider this game an insult and often think of the client as simply a tightwad. I know some vendors who will walk away from the job rather than be subjected to the bargaining process.

Trust the Vendors, Or Don't Hire Them

It's pretty overwhelming to interview wedding vendors when it's not something you've done before. If you are doing the planning yourself, pre-screen them by visiting their websites or having a chat on the phone before you meet in person. During this pre-screening you can get a feel for the type of clientele they cater to and whether you feel they are right for your style and finances—even your personality.

Tell the vendors how much you can spend and how strict you will have to be with your budget. Trust your instinct and your gut on who is best for you, and don't be up-sold or talked into something you really don't want, can't afford, or don't need. If you feel uncomfortable for any reason with a prospective vendor, end the meeting and move on.

Some vendors, such as florists, have minimums, which they'll most likely share with you when you meet. They do need to know what your budget is when you meet so they can show you options that are realistic for you. Describe your vision and listen to what they see as the best way to fulfill that vision with the money you have. They won't waste your time or theirs proposing centerpieces that are $500 each when you really can't go over $100 each. Many vendors are pretty good at pouring

beer into a champagne glass, so to speak. But they are not magicians, so you do have to be realistic and work as a team.

I suggest meeting with a maximum of three or four vendors per category; otherwise you risk burning out, exhausting yourself, and spending too much time on each task. This is why the pre-screening is so important. You have every right to ask to speak to some of their former clients for a reference, but remember that they aren't likely to give you a name that would give them a poor reference.

Wedding planning is like life—there are trade-offs throughout—so keep an open mind. Remember, you are the employer and the vendors are working for you. Also remember that you get what you pay for. If something sounds too good to be true, it probably is. Don't decide on a vendor merely because they offer the lowest price or you've seen their ad many times. You must also consider the quality and the way in which the service will be delivered. For example, there are huge variations in the quality of a stringed instrument group for your ceremony. The lowest-priced ones might be composed of average musicians who seldom play together, while a higher-priced ensemble will likely have better musicians who often play as a group and perhaps offer some specially arranged numbers.

One thing I like to tell my brides is that you are selecting certain details with you and your most discerning guests in mind. Think of it like a pyramid, with you and your groom

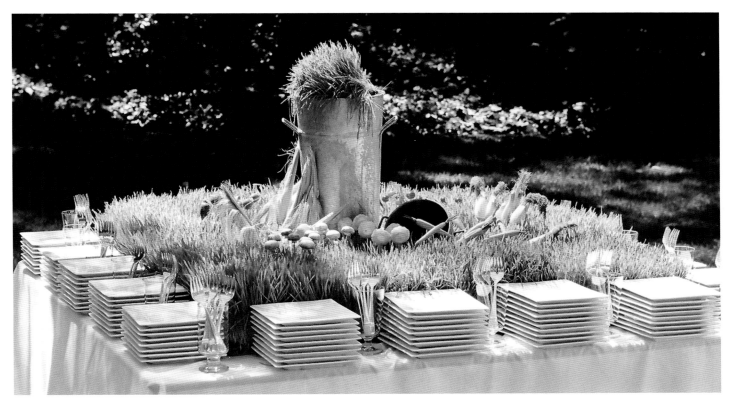

At a wedding the bride called Picnic in the Park, guests were delighted with this unique display of fresh vegetable hors d'oeuvres.

at the top and your most discerning guests on the next level. They may be few, but they will notice details and understand why you selected the vendors and materials, and they will appreciate them. Those lower down the pyramid may or may not notice and will still have a great time. An example is renting chairs from the least expensive vendor. They might have chipped paint or slightly mismatched colors and may even be a little rickety, albeit serviceable. But the higher-priced rental chairs will likely all be well maintained and put forth a far better overall look. Plus they will be delivered right on time by a courteous and professional crew.

Your wedding is a little like a building project, with you as the general contractor. You'll probably get several bids in each vendor category (these are like your subcontractors). To make an informed decision, be sure to compare apples to apples as you consider the proposals. You'll need to ask each vendor in each category the same questions and give them the same budget and vision of what you want. Please, NEVER show a vendor another proposal to see if they can beat the price. This is not ethical, and I would be leery of any vendor who would study another vendor's proposal. The first vendor has generously given you their time and

creativity in preparing that proposal, and it should be respected by both you and the competing vendor.

Try to stay calm, cool, and collected as you go through the vendor-hiring phase. The most important thing is to keep your financial spreadsheet current so you always know where you are. That way it won't overwhelm you, and if you have to show it to your financial contributors, you'll demonstrate you are in control.

Once you start to hire vendors, make another spreadsheet that shows the name and job of each vendor you've booked, all their contact information, the date you sent them the signed contract, the amount and date of the deposit made, and the amount(s) and date(s) of the upcoming payments. Again, you'll be on top of things and know at a glance what's due when, and you need to share the information with anyone who needs to know it. This also helps you avoid missing payments or having surprises when the money gets tighter as the wedding day nears.

Contracts and Deposits

Contracts vary from vendor to vendor. Some have one-page agreements, while others have long documents that address every issue that could possibly arise. I tend to favor the longer ones simply because they make clear up front what is expected of both parties. Fortunately, the vast majority of weddings go off without a hitch, but it's safer to be clear—just in case. Over the years I've heard from vendors that the points they include in their contracts are the result of their worst experiences, situations they never want to be in again. The good thing is that clients and vendors alike who play fair and within the contract provisions never have to worry about disputing any of the provisions, and they end the relationship happy and satisfied.

Most vendors take a 30 to 50 percent deposit when you sign their contract. This effectively buys the date for you. The balance is then due anywhere from the day of the event to thirty days prior to the wedding. Be sure to discuss the final payment with them before you sign the contract. If you prefer to spread your payments out over several months instead of waiting until the end to pay the bulk, you can certainly propose that to a vendor.

Also note the vendor's cancellation policy. As much as we hate to think about it, for a variety of reasons weddings are occasionally canceled. Many vendors charge full price for a cancelled date, especially if it's cancelled a very short time before the wedding day. After they sold you the date, they might have turned other business away and be unable to sell that date to someone else. If the cancellation is farther from

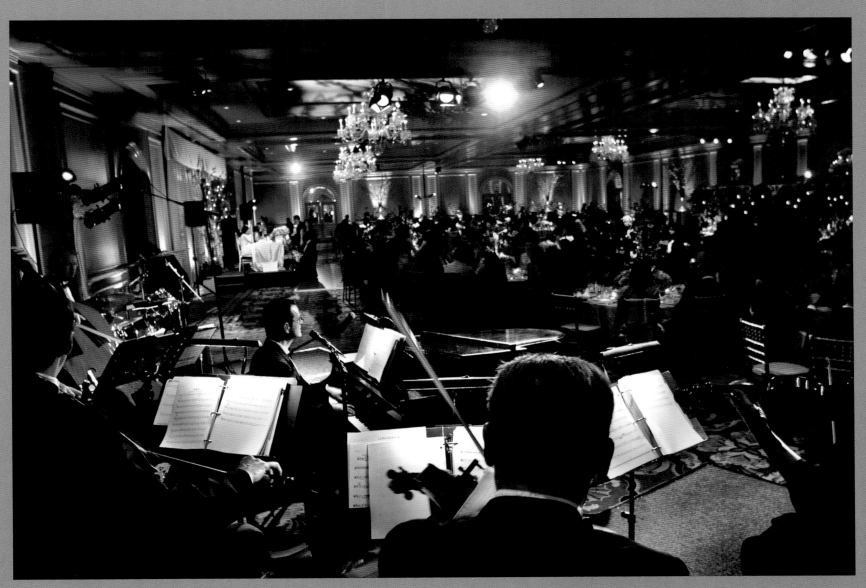

A beautiful ballroom shot from the perspective of the chamber orchestra, which provided lovely music for dining. Later a DJ took over and amped up the music for dancing.

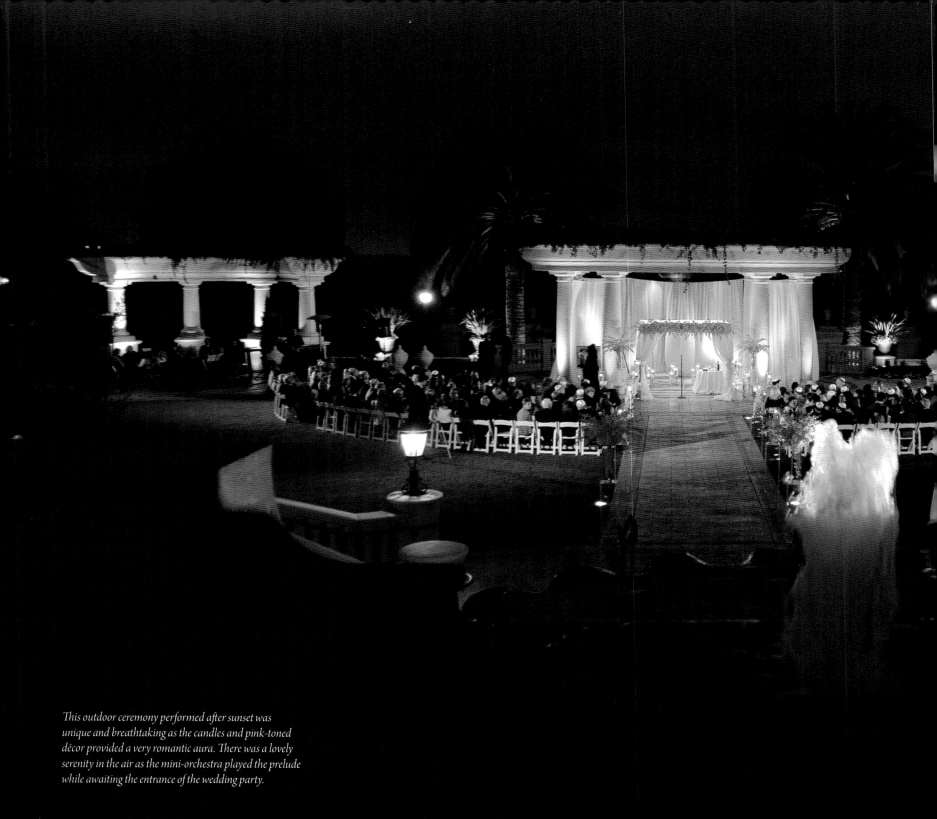

This outdoor ceremony performed after sunset was unique and breathtaking as the candles and pink-toned décor provided a very romantic aura. There was a lovely serenity in the air as the mini-orchestra played the prelude while awaiting the entrance of the wedding party.

the wedding date, some vendors will give you a partial refund and charge you only for the work they have completed. Others might give a full refund if they can fill the date you cancel. Because each set of circumstances is different, there is no hard-and-fast rule that all vendors follow, and some are more empathetic while others take a harder line.

One last thing: Make sure that all the vendors you hire carry ample liability insurance. Ask them to give (or at least show) you a copy of their current certificate from their insurance company. Again, the vast majority of weddings come off without a hitch, but you certainly would be relieved to know that if anything untoward did happen, your vendor would have insurance to cover it.

There is such a thing as personal wedding insurance, so you might consider purchasing that as it will add an extra layer of protection in case something unforeseen happens, such as a family emergency or a natural disaster.

None of the above is meant to alarm you— it's meant to help you be a savvy bride. As I've often said, "Brides don't like surprises unless they come in Tiffany boxes!"

I wish you wise spending!

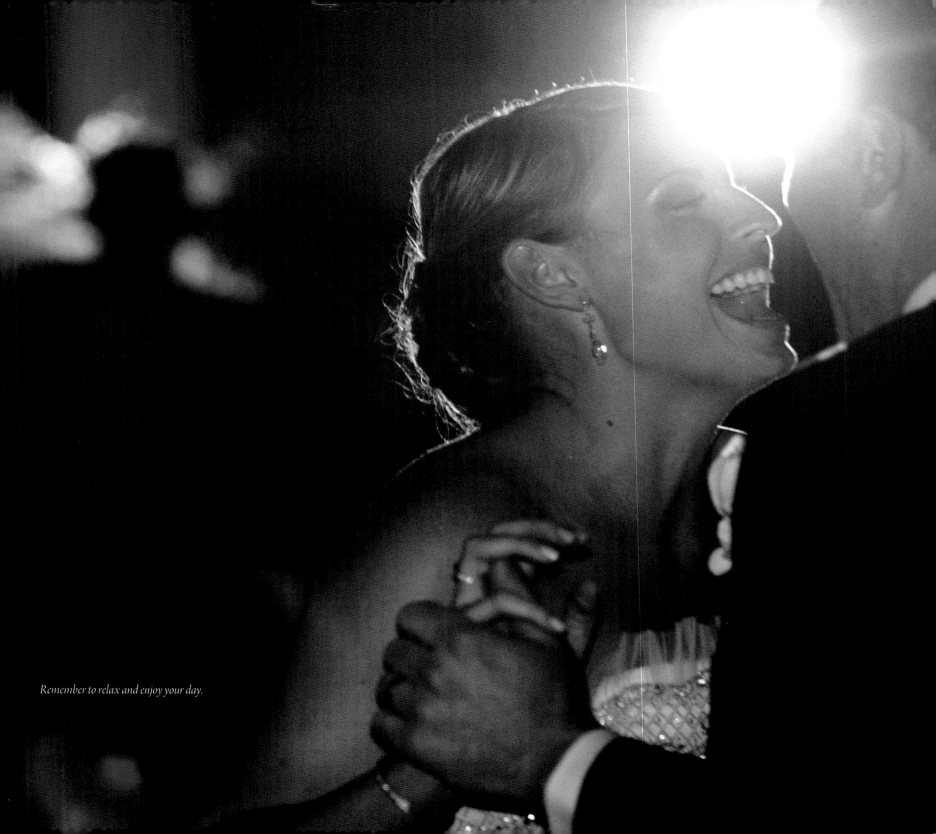

Remember to relax and enjoy your day.

Chapter Three

PLANNING FOR YOUR

Wedding Day

After doing more than two hundred thirty high-end weddings and events with budgets ranging from $40,000 to $2 million, I have learned a good many tricks and lessons about getting the best results. Even after all that, I believe there is always more to learn and I am open to learning something at every wedding—and I do. This applies to everything in life and makes for a great adventure. I hope you'll stay open, too. It's more fun.

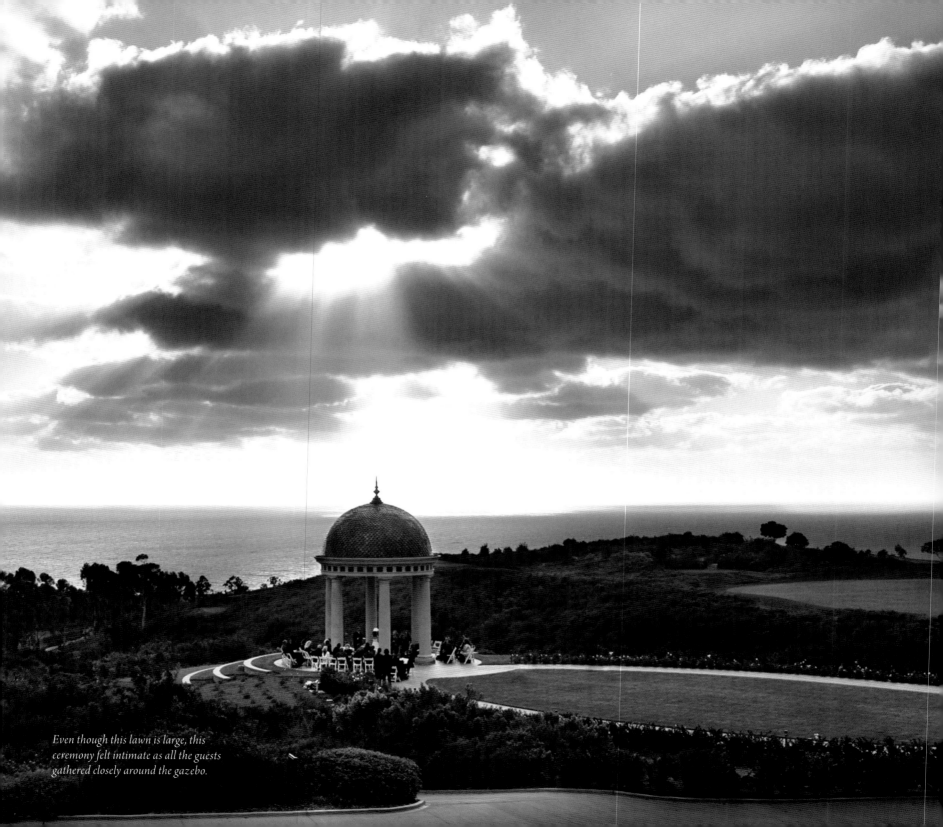

Even though this lawn is large, this ceremony felt intimate as all the guests gathered closely around the gazebo.

Having more than one flower girl lends a very charming touch to the ceremony.

A Wedding Is Like a Play

Think of your wedding day as a one-performance play with no rehearsals. Staggering idea, isn't it? You have only one try to get it just the way you want it, so planning is extremely important. Can you imagine a producer on Broadway even thinking of trying to pull off such a feat? That would never happen! But you, my brave lady, will do it!

Just as a play has a script with lines and cues, every wedding must have an all-encompassing, detailed written timeline distributed in advance so that all the players (wedding party, family, and vendors) are aware of what will happen and when. Here's where a good wedding planner comes in; he or she is like the play's director and will make sure that all the details are in order and then make everything happen on cue. In fact, a very comprehensive timeline for the wedding day is what makes a good planner a great planner. Even if you do not have a wedding planner, you absolutely need a timeline.

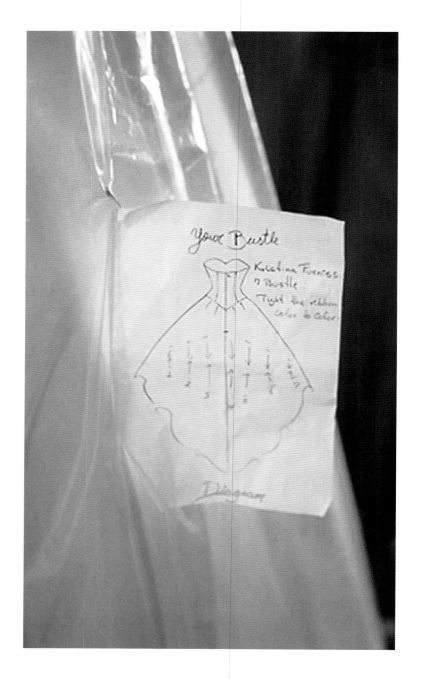

Who Really Is a Wedding Planner?

When I speak to classes of students training to be wedding planners, I tell them that it's more important for them to be organized than creative. Some are surprised, but they understand when I point out that they are being hired to coordinate the day and keep it flowing smoothly; and if they don't have this skill, they are not as valuable as they should be. An organized planner can and will help you find creative vendors, but there is only one place you should expect to get the overall organization, and that's from the planner. If a wedding planner wants only to be on the creative side, I suggest that this individual become a décor designer, florist, favor or invitation supplier, or the like, and leave the real organization to those with a strong ability for it.

Some DJs, bands, and even florists may offer you their services as a wedding coordinator for an additional charge. They will make a timeline of the

The best salons will attach a diagram for a complicated bustle, which helps so much when it's time to bustle the bride's gown. It's a good idea to go over it when the dress is picked up and very helpful if the person who will do the bustling is there.

wedding day, but make sure they are also prepared to handling of the myriad details like bustling your gown, taking care of any emergencies such as the ring bearer's skinned knee, or giving directions to the lost limo driver. Ask a lot of questions and request to see a sample of their timeline and a summary of the services they propose before you commit to them instead of someone who specializes in wedding planning. Get references from former clients as well.

I am not a believer in what is called a "day of" wedding coordinator. In reality, how could anyone come in only on the day of the wedding and make it happen the way you envision? It's impossible. One of my colleagues in the hotel business likened hiring a "day of" coordinator to asking someone to be your maid of honor the day before the wedding.

At the very least, I would suggest someone for a "month of" service, though even this is a bare-bones approach. You'll need to have nearly everything in place and turn over copies of all your vendor contracts and other paperwork so that coordinator can get right down to business and make sure you have all bases covered.

Donning a bridal gown takes a bit of practice. Will you step into it or put it over your head? Your maid of honor or a bridesmaid who was there for the final fitting can help so much on the wedding day. Be sure to have a silk scarf to put over your hair and face if you put the gown on over your head. That will save your hair and keep your makeup on your face and not on the inside of the gown.

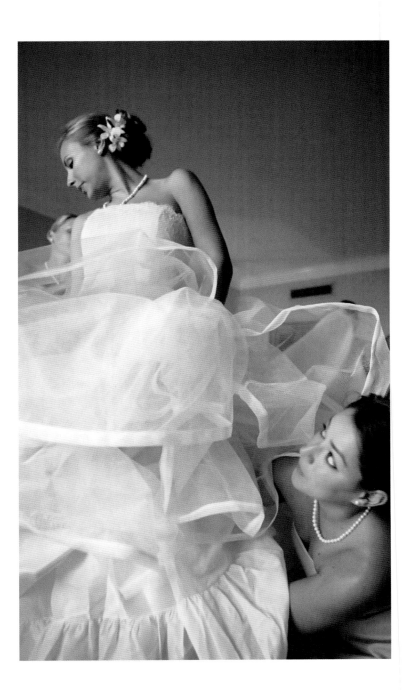

Sample Timeline

GIVE PLENTY OF THOUGHT TO THIS IMPORTANT ELEMENT OF YOUR WEDDING DAY

In your real timeline, add a column designating the person in charge of the activity and another column for notes

TIME	ACTIVITY
7:00 AM	Florist arrives to load into floral prep room
8:00	Ballroom available for setup
9:00	Room setup begins (flowers, dance floor, lighting, rentals, linens) Breakfast delivered to bride's suite—Don't forget to eat! Champagne isn't food!
11:30	Hairdresser arrives
12:00	Coordinator arrives Lunch delivered to bride's suite
12:45	Makeup artist arrives to set up
1:00	Makeup starts with mother of bride
1:30	Bride's makeup begins
2:00	Ceremony area available for setup
2:30	Photographer arrives at bride's hotel/meets in bride's room Videographer arrives/meets in bride's room
3:15	Bride and bridesmaids dress Women's personal flowers distributed at bride's room Reserved signs placed on ceremony chairs Ceremony programs placed on family chairs
3:45	Bride, bridesmaids, and family photographed
4:30	Groom and groomsmen meet in groom's room Men's personal flowers distributed at groom's room Escort cards and place cards displayed
4:45	Groom, groomsmen, and family photographed Ascertain whereabouts of rings and marriage license
5:00	Ceremony musicians arrive Guest book and pen placed at ceremony area Guest book attendant greets guests Water station available for arriving guests Programs distributed to arriving guests Officiant arrives Cake delivered
5:30	Music begins at ceremony area Seating begins at ceremony area/groomsmen greet and usher guests Marriage license signed Bride takes a few minutes alone for quiet time and deep breaths
5:50	Wedding party assembles as directed at rehearsal

TIME	ACTIVITY
6:00	CEREMONY Processional music begins Protocol seating begins Bride walks down the aisle looking fabulous
6:30	DJ arrives and sets up in ballroom
6:45	Ceremony concludes Ceremony items picked up Cocktails and hors d'oeuvres served Gifts moved to bride and groom's suite
6:50	Bridal party photos begin Candles lighted on dining tables
7:30	Photographer takes room shots
7:40	Bride, groom, and parents peek at ballroom before any guests enter
7:45	Guests escorted to ballroom foyer by hotel staff Bride freshens up/removes long veil/bustles gown
7:59	Music begins in Grand Ballroom
8:00	Ballroom doors opened Guests seat themselves assisted by wait staff
8:10	Grand entrance of bride and groom First dance Father/daughter dance Groom/mother dance One or two songs for all guests to dance to get the party going
8:25	Welcome by father of bride
8:35	Dinner service begins Formal toasts—by best man —by maid of honor Bride and groom visit tables
9:00	Break and vendor meal for DJ, photographers, videographers, and coordinators
10:00	Dinner service ends Cake cutting Bride and groom "thank you" speech
10:10	Dancing continues
12:00	Reception ends Bride and groom depart
12:30	Coordinator departs All rentals and props picked up

A Detailed Timeline Is Imperative

Even if you cannot hire a planner, make a detailed timeline and ask your most responsible bridesmaid or, even better, a trustworthy person not in the wedding party to manage it. On the big day, I always have at least one assistant for every one hundred people at the wedding, and more depending on the layout of the venue and complexity of the activities. If your designated "manager" can also have some trustworthy people to assist her, it will save you from being involved with every detail when you are supposed to be having a relaxed and enjoyable time. Believe me, micromanaging your wedding day does not a relaxed and enjoyable day make. I guarantee that you'll be happier turning over the responsibility to someone you trust to execute your written plan once you have it the way you want it and have explained it in detail to her. Reread that last phrase. Be sure to explain it; she cannot read your mind, so you must impart exactly what you wish her to do, preferably with lots of explicit notes. Don't forget to give her a nice gift for her help.

When making your timeline, be careful not to give your guests too many things to do. Example: Many brides want guests to sign a guest book or some advice-to-the-newlyweds notes, or a mat around a photo. But I've had brides who want to display a signing photo and ask their guests to write them notes, too. This is too much to ask of the guests—and most will do only one of the two anyway, which results in only partial participation in both.

The same is true for too much entertainment. By the time you've had the formal toasts and speeches, dining with its accompanying table conversation, and wedding formalities such as the bouquet toss, father-daughter dance, and cake cutting, there is little need for long montages or videos or performers such as comedians. You risk having no time for dancing, which people love to do at weddings and have come to expect as part of the celebration. If you hire a great band or DJ, let them do their job and give them time to fill the dance floor after all the other activities. Remember, too, that a wedding is also a family reunion, and many people are excited to visit with relatives. You must have peaks and valleys in the mood of the evening.

Don't Forget to Eat; Champagne Isn't Food!

One of the first lines I came up with for my wedding day timeline is, "Don't forget to eat," and in the notes column it says, "Champagne isn't food." This is extremely important advice for several reasons. First, we do not want any brides

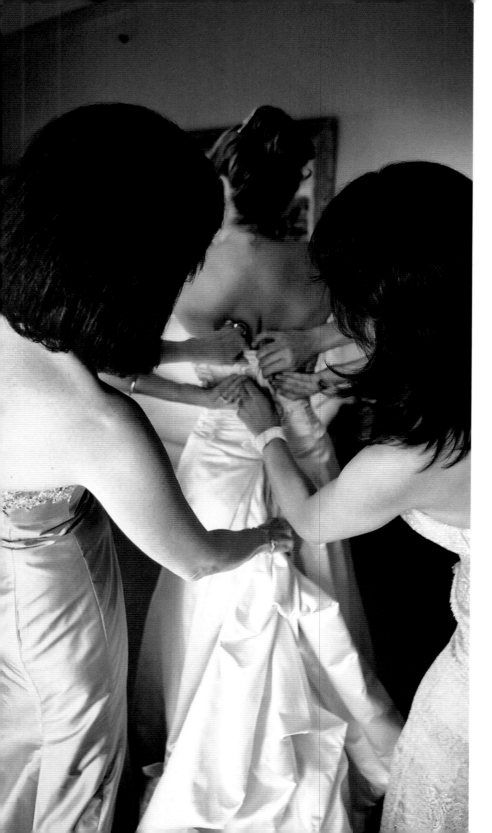

fainting at the altar. If you have not eaten—or have had only alcoholic beverages—while getting ready for the ceremony, there is a real possibility that you will be so caught up in the excitement of the day that you pass out. It's a long time from your first photo session after you don your gown until dinner service, so please, plan on having some light food in the "getting ready" room for the entire wedding party. Not chips and dip, sodas, and other junk food but some light protein such as yogurt, nuts, veggie dips, finger sandwiches, and some fruit.

Another important reason for eating is to avoid having bad breath, which you certainly don't want when you are talking to so many people at such close range. Be sure to brush your teeth after your snacks and have breath mints in your little purse along with your lipstick and powder. Your groom will be happy if you offer him some mints, too.

If you drink alcoholic beverages, yet another very important reason to make sure you eat something is so that you do not get drunk at the cocktail hour or when you start having toasts at the reception. An intoxicated bride is simply not very attractive, and it could come back to haunt you in the video. Remember, the video is permanent!

Anything can happen on a wedding day, so be prepared. The zipper broke on this gown just after the bride put it on, so she was sewn into it with just a short delay in the pre-ceremony photos. It helped that she kept very calm and trusted that this glitch would be resolved quickly. Always have pre-threaded needles in the emergency kit to save precious time.

A Bridal Emergency Kit

VERY IMPORTANT
List of cell numbers of all vendors and key family members.

SUNDRY ITEMS
Band Aids (we use lots of them for shoe blisters), antiseptic or antibiotic ointment, cotton balls, disposable gloves, antacid tablets, mouth wash, breath mints, headache remedies in individual packets, anti-diarrhea medicine, anti-histamine tablets, Ace bandage, throat lozenges, cotton swabs.

WOMEN'S ITEMS
Safety pins (all sizes—this is always a popular item), scissors: to trim off gown-hanging ribbons and threads, needle and thread- pre-threaded with women's gown and men's suit colors, round upholstery needle with white thread to sew bride into gown if necessary, thimble, crochet hook: for the line of buttons on the gown—leave in honeymoon suite so the groom can use it to unbutton them, emery boards, earring backs, needle-nose pliers: to fix jewelry, tweezers, feminine products, hand lotion, straws, Krazy glue, tissues: in small packets, deodorant, hair spray, hair pins, bobby pins, comb, clear nail polish, nail polish remover, spot remover, chalk: to cover small dry spots on gown, anti-static spray, small folding umbrella: to protect bride from sun or rain.

MEN'S ITEMS
Black socks, cuff links and studs (you can usually get an extra set from the tuxedo shop), lint roller, disposable razors, sunscreen.

CEREMONY AND RECEPTION ITEMS
Tape: maybe a couple rolls, pens (one nice enough to use for guest book), rubber bands, blank place cards and pen with appropriate color ink, corsage pins: with white tops, boutonniere pins: with black tops, corsage tape: in case one falls apart or you have to make a quick new one, fake rings for ring bearer pillow, extra garter, music CD or iPod with appropriate music (in case the music doesn't arrive), paper clips, stapler, hole punch, ribbon: white or ivory/several widths, matches or lighter(s), a couple of back-up candles for unity ceremony, duct tape (white is usually best for a wedding), wire or pipe cleaners, Stickum clay.

Most wedding planners have an emergency kit that they bring to the wedding and reception. For some, the contents could fill a steamer trunk. My kit is on wheels, so it's easy to move around, and we try to keep it close to the bride at all times. It actually is in two parts so items for personal use are near the room where the wedding party is getting ready and items needed for the ceremony and reception room setup are located in the reception room.

If your wedding is at a remote venue, your planner (or you, if you have no planner) will need to think of every little thing that could go wrong and have something in the kit to cover that. Even if you are near a large shopping center, there is usually no time to race to the store for a safety pin or a needle and thread, so bring it with you. Above is a list of typical emergency kit items.

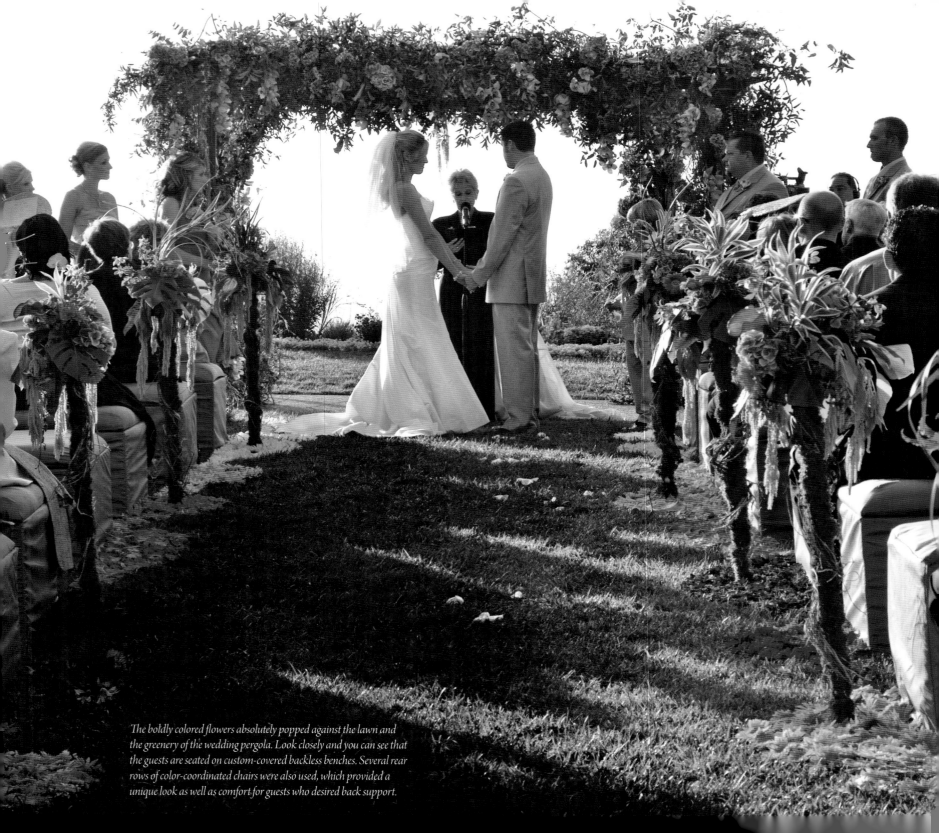

The boldly colored flowers absolutely popped against the lawn and the greenery of the wedding pergola. Look closely and you can see that the guests are seated on custom-covered backless benches. Several rear rows of color-coordinated chairs were also used, which provided a unique look as well as comfort for guests who desired back support.

This darling floral heart was at the beginning of the aisle, which was ribboned off until the wedding party entered.

Table and Seating Assignments

One of the most difficult tasks in the wedding is assigning seating at the reception. It cannot be completed until all the RSVP cards are in, and sometimes it is very difficult to get definite answers from guests until the very last moment. I suggest that for a large wedding (250-plus), you set the respond date three weeks in advance. Smaller weddings are fine with a two-week-out respond date. However, it almost does not matter what date you use, as people respond when they feel like it. It is not considered poor taste to call your guests who have not responded by the designated date. After all, if they have breached etiquette by not responding, why should you worry about offending them?

Sometimes brides panic when the RSVPs come in, as it seems as if everyone is saying "yes" and they are afraid they will run out of room—especially if they over-invited a bit, which is common. Take heart; generally the earliest responses tip toward the "yes" side, as those people know right away that their calendar is open. Those that trickle in are usually on the "no" side, and ultimately it all evens out.

Some good tricks that I share with my brides to help with the last-minute seating process follow. Some

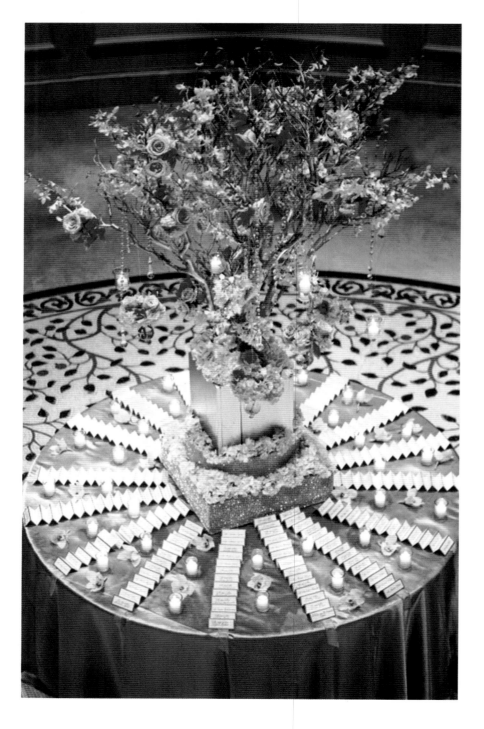

require advance planning, but you will love the time you save in the crunch period during the final week or so before the wedding.

• Avoid having people choose an entrée in the response card. It is a headache for you to track these choices and becomes a challenge during the meal service, as people forget (or change on the spot) what they ordered. (Do you know now what you are going to feel like eating in three weeks?) Because you have to give the venue an exact count of each entrée as many as ten days before the wedding, if there are count irregularities, the last people served might not get what they expected. Instead, choose a duo plate or one entrée for all—except for pre-ordered (and labeled by name) special meals for vegetarians or those with allergies. Because vegan and vegetarian meals have different requirements, I suggest getting good vegan food for all non-meat meals. And I don't mean bland, steamed vegetables or uninspired pasta. It should be as tasty and attractive and nutritious as the regular entrées, so talk to the chef in advance.

• Assign tables only, not seats at a table. The latter is a huge job, done at the last minute, and there

One lovely way to display seating cards (also known as escort cards) is in a wagon wheel formation. It's easy for the guests to circulate around the table to find their names, especially at a large wedding. Look closely and you'll see sheer ribbons over each row of cards which keep the cards more orderly as guests pick them up and also hold the cards in place in case of a breeze at an outdoor event.

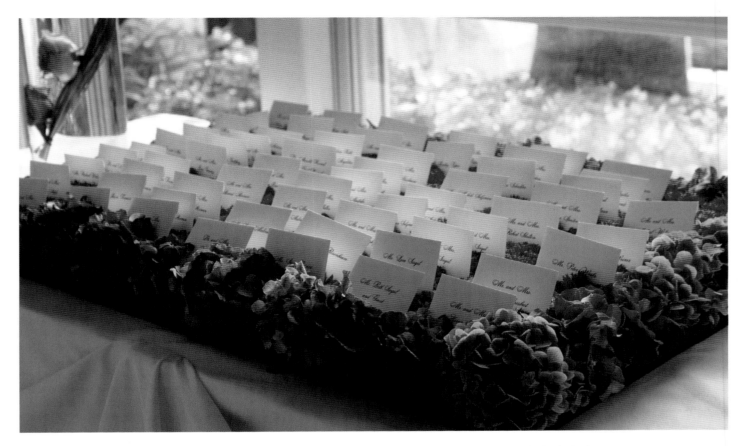

To display these seating cards the florist decorated a box to match the reception flowers—another lovely detail.

is usually no reason to be so specific. More than once I have seen guests move place cards around when they didn't like how the assigned seating at their table was configured. That sure would negate all your work.

- Following a room diagram from the caterer or the venue as a guide, arrange paper plates on your dining table to represent each table. Make a small sticky note with the name of each person who has responded, then use the stickies to assign the guests' seats to their paper-plate "table." If you need to move people around, it's easier to move the sticky than to erase and rewrite a name. Plus, you risk losing someone when you erase a name and get interrupted before you write it onto the new paper plate. Once all the guests have been assigned to their tables, transfer the information to your computer-generated master list, which you will give to the calligrapher for the seating cards and to the wedding planner, who will help guests find their tables.

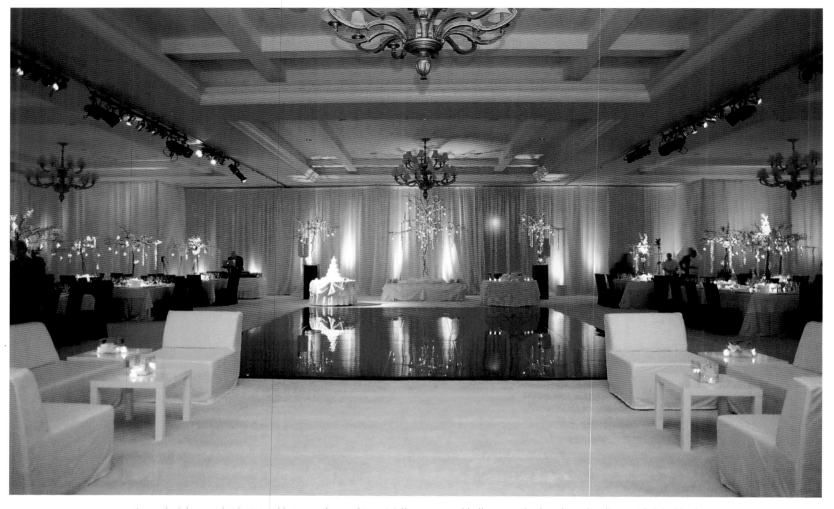

A wonderful example of minimal but very elegant décor. A fully re-carpeted ballroom with white draped walls provided the blank canvas required to achieve this effect. The shiny, patent leather-like dance floor accentuated both the candlelight and décor lighting.

• The computer-generated list should be sorted both by the guests' last names and by the table number as a cross-reference. An Excel spreadsheet works great for this purpose and should be taken from the master version initially used for the invitation list. Having your list serve several purposes makes your job as a bride easier.

• Table seating cards (sometimes referred to as "escort cards") are placed alphabetically (by last name) on a table outside the ballroom, and guests locate their name and table assignment here. Rather than using the more common tent cards with the guest's name on the front and the table assignment on the inside, I suggest using small envelopes with

little cards inside. The guest's name is written on the outside of the envelope and the table number is on the little card, which is slipped inside the envelope (which is not sealed). In the event that you have to move a guest from one table to another at the last minute, you simply remove the card with the old table number and replace it with an insert showing the new number. This will save a trip to the calligrapher for a do-over. Just be sure to have some blank cards and envelopes in case you need to make on-the-fly corrections on the wedding day.

- If you have a head table, I suggest having assigned seats with place cards there even if you don't assign all guest seats. This way, when the wedding party formally enters, they will sit the way you have decided it looks best and also avoid the confusion of jockeying for a seat while all the guests look on. Include a diagram for whoever will be putting out those cards.

The Ceremony Rehearsal

Make sure you have gone over the order of the processional and all the music cues with your wedding planner (if you have one), the church wedding director, and the music provider in advance of the rehearsal. Know which attendants will come in first and which groomsman will be paired with which bridesmaid so that you do not have to waste everyone's time as you discuss this on the spot. Decide in advance who

will be escorting the mothers and grandmothers or anyone else being formally seated at the start of the ceremony. Write all of this down so that you can read it off at the rehearsal. It will make things much easier and the rehearsal will be more organized.

Ask all participants of the ceremony—everyone walking down the aisle as part of the formal seating or the wedding party—to be at the rehearsal location fifteen minutes ahead of the scheduled rehearsal time, so they can greet one another. There are bound to be a few late arrivals, too, due to traffic and other reasons. It does no good to start the rehearsal if people are missing because as the latecomers arrive, everyone wants to greet them and it disrupts the flow of the rehearsal. This is especially true if your attendants have not seen each other in a while and are just arriving from out of town.

Allow about an hour for a rehearsal. Any longer and you have a bunch of bored people who just want to go to the rehearsal dinner and begin the party.

Speaking of the rehearsal dinner, it's generally more casual than the wedding reception and includes your very closest friends, so this is a good place for the montage of kid photos of you and your groom, photos that might not mean as much to all the wedding guests. It's also a good time for the toasts that take on more of a roast tone, which tend not to be as appropriate at the formal reception. Of course, you don't want a free-for-all or embarrassing anecdotes, so plan this in advance, too, and make sure that no one gets too over-the-top.

After a good rehearsal you should be comfortable that your wedding day will go off well.
I hope you'll feel as happy as these three darlings kids look here.

Hand Off the Ceremony and Reception Items to Your Planner

Give all the items that will be used on the wedding day to your planner (or that trusted helper mentioned earlier) at the rehearsal. Have a master list that you have gone over in advance with your planner of everything that will be needed for both the ceremony and the reception, and check each item off as you pass it over to him or her.

Ceremony items will include the marriage license, the guest book and a pen, the unity ceremony items, the ceremony programs with a decorative container to hold them, a container for the gift envelopes (preferably covered and watched at all times once envelopes go into it), copies of any readings, the ring-bearer pillow and flower-girl basket (unless being provided by the florist), any family photos that are being displayed, and any items needed for a particular type of ceremony, such as a Jewish ceremony that includes *kippahs* and bobby pins, a *kiddush* cup, the *ketubah,* and a glass to stomp with a cloth to wrap it in. Keep the rings safe

Dancing Lessons

Something that many of my brides and grooms have been doing is taking dancing lessons to prepare for their first dance. Their guests love the results, and I've seen them stand on chairs, applaud, and cheer as the couple does some lovely dips and twirls.

Many of my couples like to do their first dance just after their grand entrance into the ballroom. I heartily endorse this, as it gets the dance over right away so that they don't have to be nervous about it until later in the evening. It also is a time when all the guests are focusing on them rather than dining or talking to friends and relatives.

Following the first dance, we often invite all the guests onto the dance floor for an energetic song or two so that right away they feel they've come to the party. If you serve alcoholic beverages at the cocktail hour between the ceremony and dinner reception, this is a good way for the guests to use their buzz, and it really revs up the energy in the room. There's nothing worse than sitting at a dining table, listening to speeches, and then eating dinner and not getting to dance until two hours later.

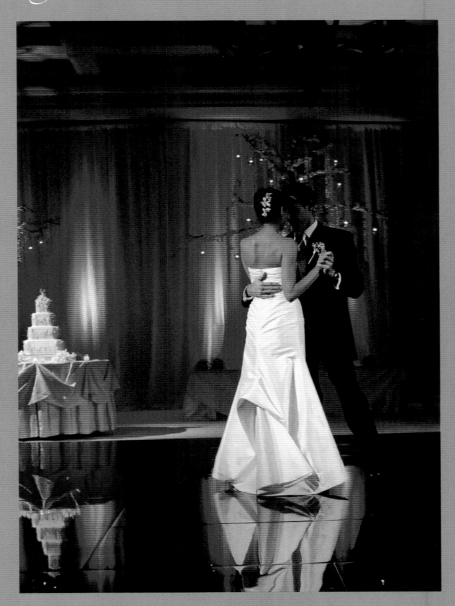

A well-rehearsed first dance like this one is sure to get the attention of the guests. They really went wild when this groom dipped the bride at the end of the dance.

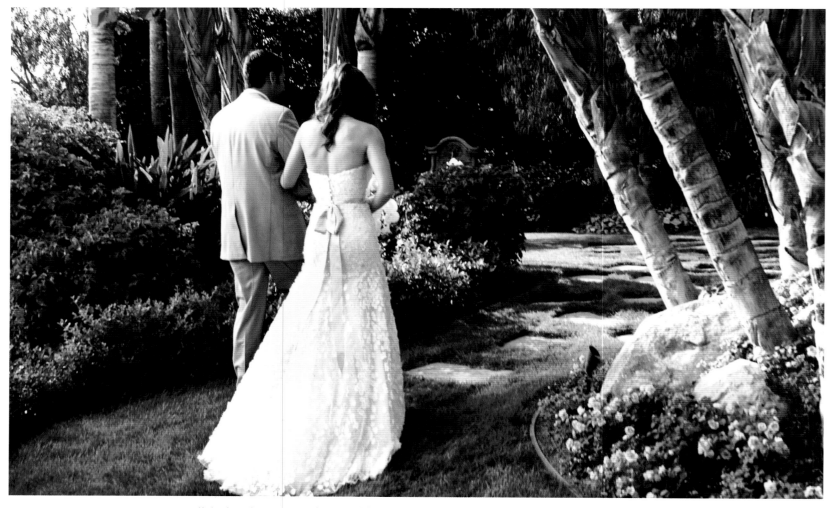

The bride and groom enjoy that special few minutes alone as they continue walking after the recessional.
Build that bit of time into your timeline—it might be the only chance you have alone during the entire reception that follows.

until just before the ceremony, then give them to the best man and maid of honor to carry.

Receptions items will include the pre-alphabetized table-seating cards, the head-table place cards and diagram, a few blank place cards, a copy of the computer-generated master seating list by alphabet and table number, the favors, your toasting glasses, your cake knife and server, the menu cards, table names or numbers if not provided by the venue, an invitation for the photographer's use, and checks for final payments for any vendors not fully paid. Apportion gratuities for vendors in advance and place them in envelopes with the name on the outside; give the envelopes to the planner

for distribution on the wedding day. (Of course, you can hand these out yourself if you prefer.)

Paying in Advance

Recently while out doing some errands I passed a young man talking to a friend. He was saying that on the day of his wedding, he was so busy writing checks to vendors and taking care of that kind of business that he felt he missed part of the reception, and the bride felt she was being ignored and was not happy about it. What a shame to have this wonderful day evaporate because of such an unnecessary distraction! This could easily have been avoided if he had written the checks in advance and authorized his best man or another responsible person to pass them along.

Have a Glorious Day!

Many people rank their wedding day as one of the most significantly wonderful days of their lives. I do hope this is true for you, and I wish you a most glorious wedding day!

Something Lovely for Your Groom

What could be more romantic than a groom receiving a love note or a gift from his bride just before walking out to exchange their vows?

If you are having substantial alterations done to your wedding gown, there might be some scraps large enough to make or trim a pocket square for your groom as a surprise to wear on the wedding day. Ask the gown salon or your seamstress to save these large-enough scraps. Or you could even order a piece of the fabric specifically for this purpose when you order the gown.

Send this artfully folded and wrapped pocket square to your groom as he is getting dressed for the wedding. Include a love note telling him how much you are looking forward to being his wife. If the videographer is there when the gift arrives, you'll be able to see his reaction to this romantic moment in the video.

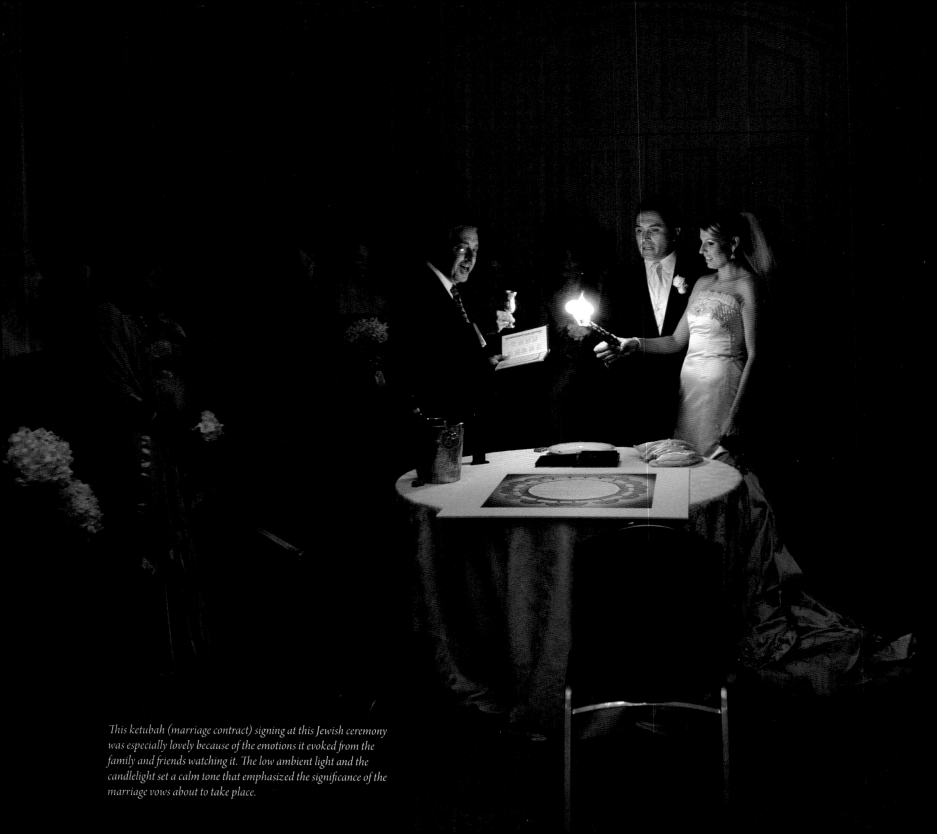

This ketubah (marriage contract) signing at this Jewish ceremony was especially lovely because of the emotions it evoked from the family and friends watching it. The low ambient light and the candlelight set a calm tone that emphasized the significance of the marriage vows about to take place.

CONSIDER YOUR CIRCLE:

Friends and Family

During a time as special as your wedding,

it's important that you surround yourself with people—

especially in your wedding party—who you love and trust

and who love and trust you. Involve only true friends who

will champion and support you during this very special and

emotional day and the months leading up to it. Try, at all

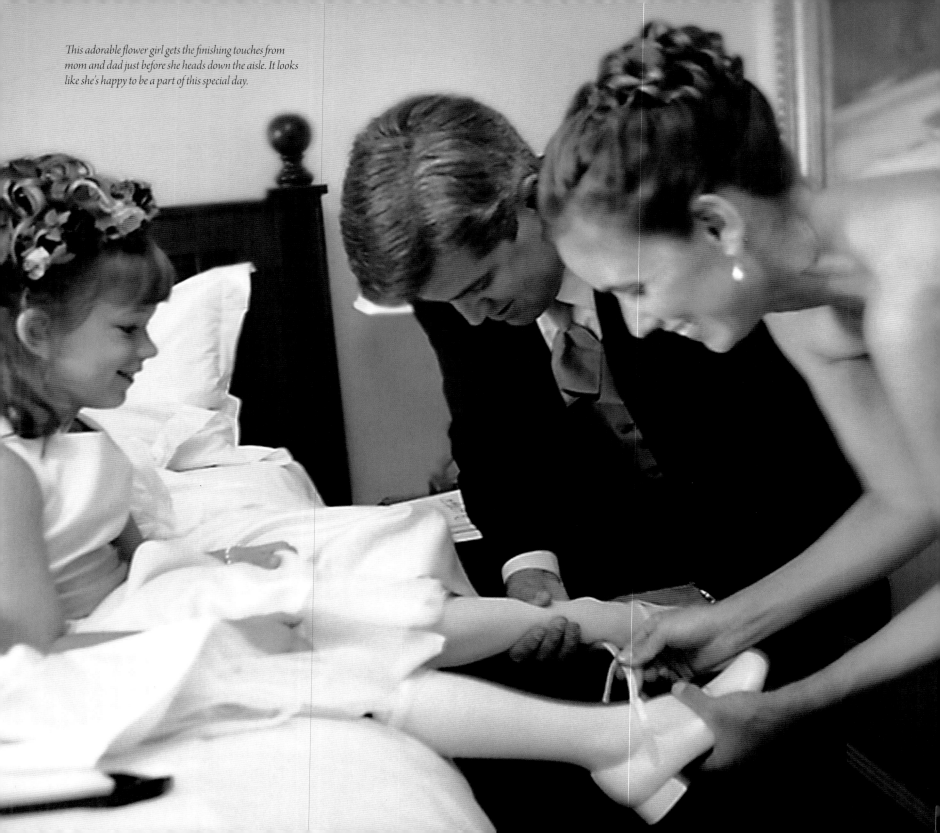

This adorable flower girl gets the finishing touches from mom and dad just before she heads down the aisle. It looks like she's happy to be a part of this special day.

*A magical moment at the end of the recessional. These darling flower girls
wore wings covered with petals. One wonders if they just flew in!*

costs, to avoid including anyone who will sabotage you, try to compete with you, or rile things up as you are getting ready to walk down the aisle.

The last thing you want in your getting-ready room is to have a competitive vibe from someone who wants to "stir the pot." As a bride it's not unusual to be nervous, so strive for calm and enjoyment and you'll be better able to handle little things that inevitably come up during those intense few hours prior to the wedding. For a few weeks before the big day, it might help to visualize a calm atmosphere with your favorite people around you having fun as you transform into a gorgeous bride getting ready to walk into the arms of the man you love.

On a practical note, a very large wedding party can eat up time and energy during both the getting-ready time and at the pre- and post-ceremony photo sessions. Moving a dozen or more people from place to place will always be more challenging than moving half that number. If you have limits on the time at your venues or have a group of habitually late people, take that into consideration when planning the size of the wedding party. If you want a party of sixteen (eight bridesmaids and eight groomsmen) to come into the reception together for a grand entrance, you'll almost certainly have to allow an extra ten minutes to gather the entire group. I can almost guarantee that there will be at least one wayward

Calming Conflict

Here are some points that might help as you approach sticky issues:

- Stay calm and reasonable
- Listen to others' opinions and positions and don't become angry or emotional
- Carefully consider what you've heard and what you believe is right
- Then make the most intelligent decision you know how to make
- Then state what it is
- Then stay with it as much as you possibly can

Be aware that there might be repercussions, such as bribery ("We're cancelling our financial support.") or blackmail ("I'll tell your old secret if you don't do what I want you to do.") or threats ("I won't attend if he (she) is invited."). You will have to make up your mind about how important these repercussions are to you. You might want to seek professional help during this process if you find yourself getting too stressed.

Remember, you are a wonderful woman who is loved by the man who is taking you to be his wife. The reason for this wedding is to celebrate your love and commitment to each other. Keep this in the forefront of your decisions and everything else should fall right into place.

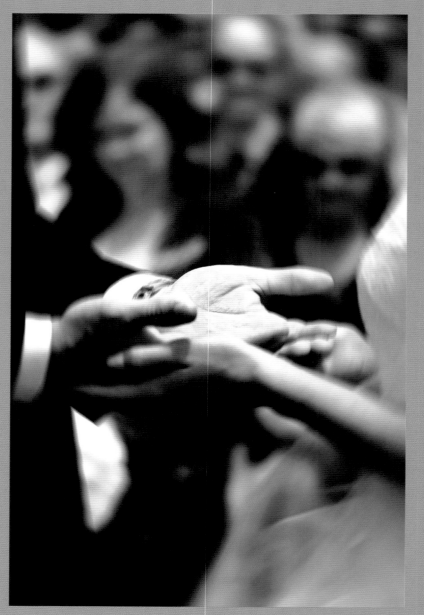

Notice how gently these hands are being held–remember this when faced with conflicts—and breathe.

person who is sure to hold up the whole thing. In fact, lately I have been recommending that the bride and groom make their entrance alone, with the wedding party already inside the reception room and seated at the head table.

Face Certain Issues Squarely

By their very nature, weddings are emotionally charged on many levels, so it's not unlikely that feelings will arise that might surprise you. If there is someone in your wedding party with whom you feel you have unfinished business, someone you believe owes you an apology for past hurts or the like, it might be necessary to have a frank discussion with that person well in advance of your wedding day. Solve any issues before they become overwhelming, intrusive, or unresolvable. As intimidating as this may seem, you must reach down inside and pull up the courage to address the issues. Seek professional help with a psychologist or counselor if necessary, but please do it for your future happiness. This will probably be a time when you'll need the emotional support of your fiancé, so ask him to help you through it. It might even bring you closer together.

Once you have resolved the issues (or even if you have not), work on forgiving the person(s) who caused them. Carrying resentment hurts you more than the person you resent. That person may not even know you harbor such a feeling if you are harboring the anger inside.

As an example, one of my brides had invited a group of eight friends to be bridesmaids. But as the plans took shape, one friend was just not participating as willingly and enthusiastically as might be expected. The bride was feeling uncomfortable with this, as the bridesmaid's behavior was putting a damper on the rest of the group. About a month prior to the wedding, the two of them had a frank talk and the bridesmaid resigned. In fact, she was relieved to be off the team. The bride paid her for the bridesmaid's dress and shoes and graciously let her off the hook. The bride felt it was a small price to pay for the peace of mind it brought her during the last critical month, and she was very glad that she'd faced the issue squarely even that close to the wedding day.

Tackling Family Dynamics

Each family has its own set of dynamics, and unfortunately there is no easy set of rules to follow when it comes to keeping all members happy—or at least quiet. Wouldn't it be nice if there were a neat little manual with all the rules and answers for each family?

Children make a lovely addition to weddings. If they are old enough to understand the role they have been asked to play, they usually take it very seriously.

This image evokes a smile. It seems to be male bonding in its most elementary form.

Even lacking a manual, there is one rule that is of the utmost importance for you. It's to always act with class and dignity. It might not be easy, but it will be best in the long run. It will show your maturity and might even set a new tone for your family dynamics.

Do not allow yourself to be placed in the middle of your estranged or divorced parents' feelings for one another or to be used as a pawn during their or other family members' disagreements. It is not your fault that they don't get along. They are adults, and it is their responsibility to behave civilly during this celebratory time. If they do not wish to sit near each other on the wedding day, or even to speak to one another, that is their choice. Just take that into account when you are

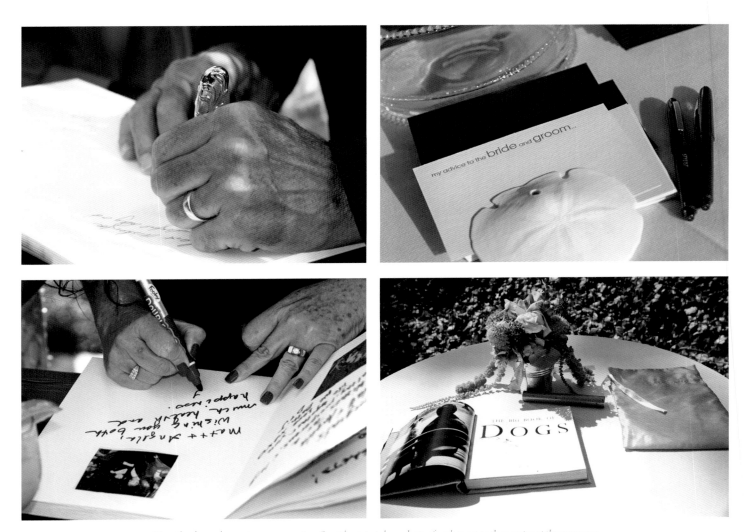

Guest books are becoming more creative. One idea is to take a photo of each guest as they arrive at the ceremony and ask them to sign next to that image in a special album like this Adesso album shown here. Another is to have guests sign a coffee table book with a topic meaningful to the bride and groom, like this book on dogs. Or, to have notes in which the guests write their advice to the newlyweds.

arranging the ceremony and reception seating. Again, take the high road, even if they don't.

You might have an issue with who is going to walk you down the aisle. Will it be your real dad, who was absent when you were growing up? Or will it be your stepdad, who was there for you as a teenager? Or maybe it will be your mom, who played both parental roles for you. You'll have to consider many feelings here, not the least of which are your own. I've seen brides escorted down the aisle with a dad on each side. I've seen brides whose real dad walked them halfway down the aisle and whose stepdad got out of an aisle seat to meet and walk them the rest of the way. I've seen grandpas do the honor of escorting the bride, and I've seen moms walk brides down the aisle. Some brides walked by themselves to avoid any conflict or hurt feelings. There is no right or wrong—only what feels best to you.

There are many ways to handle issues like these. I suggest that you examine the options from all sides and then come up with the solution that pleases you while making sure that you don't alienate others. Start early in the planning process, and have calm and frank discussions with the players. You may find a good solution more easily than you expect. Or you might find that some of the players are willing to step aside for the sake of keeping the peace. To them, offer a heartfelt "thank you" for making your life easier.

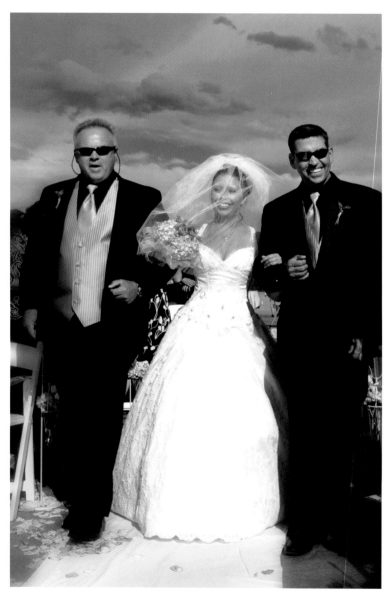

This lucky bride had two dads walk her down the aisle: both her real dad and her stepdad mean so much to her that she didn't want to choose between them.

A Word about Your Officiant

Many of the weddings I plan are not in churches or other places of worship. Only about 10 or 15 percent of my couples have a church wedding or are married by someone with whom they have a prior religious relationship. In Southern California we have many lovely, almost year-round outdoor venues where the ceremony and the reception can be held at the same place—perfect for destination weddings but requiring a local officiant. Also, many couples do not have any religious affiliation or have different ones, which can result in their need to hire a professional wedding officiant with whom they aren't acquainted.

Because the officiant holds a highly visible position, it is important to find just the right person for the task, as the wrong person can ruin your ceremony. Ask your planner or your venue for referrals. Just as you would with any other vendor, carefully interview the officiant to make sure he or she will provide the kind of service that you expect and with the sensitivity you want.

Points to ask yourself (even when using an officiant you already know) are:

- Do you like his voice and style of speaking? You probably don't want a ceremony delivered in a monotone or with attitude.
- How long will the ceremony last? You may not want one that lasts more than about twenty to thirty minutes, including the processional, solos, readings, prayers, vows, rings, and recessional.
- Does she plan to give a sermon or espouse her own views as part of your ceremony?
- Is he open to you writing your own vows or inserting things of your choosing into the ceremony?
- Is she well groomed, and what will she wear on the wedding day?
- How many times will you meet or communicate prior to the wedding day?
- Is he amenable to working with your wedding planner?
- What is her fee? Are there any extra costs?
- Will he be at the rehearsal and if so, is there an extra charge for rehearsal attendance? Please note that it is not common for the officiant to attend a rehearsal, even in a church.
- Will she provide references from former clients and wedding planners?

Unless you have an officiant with whom you have a prior relationship, you are not obligated to invite him or her for dinner or the reception. However, some couples do, as they feel very close to even a hired officiant by the time they have met several times and perhaps had a bit of pre-marital counseling. In this case, it is proper to include the officiant's spouse in the invitation.

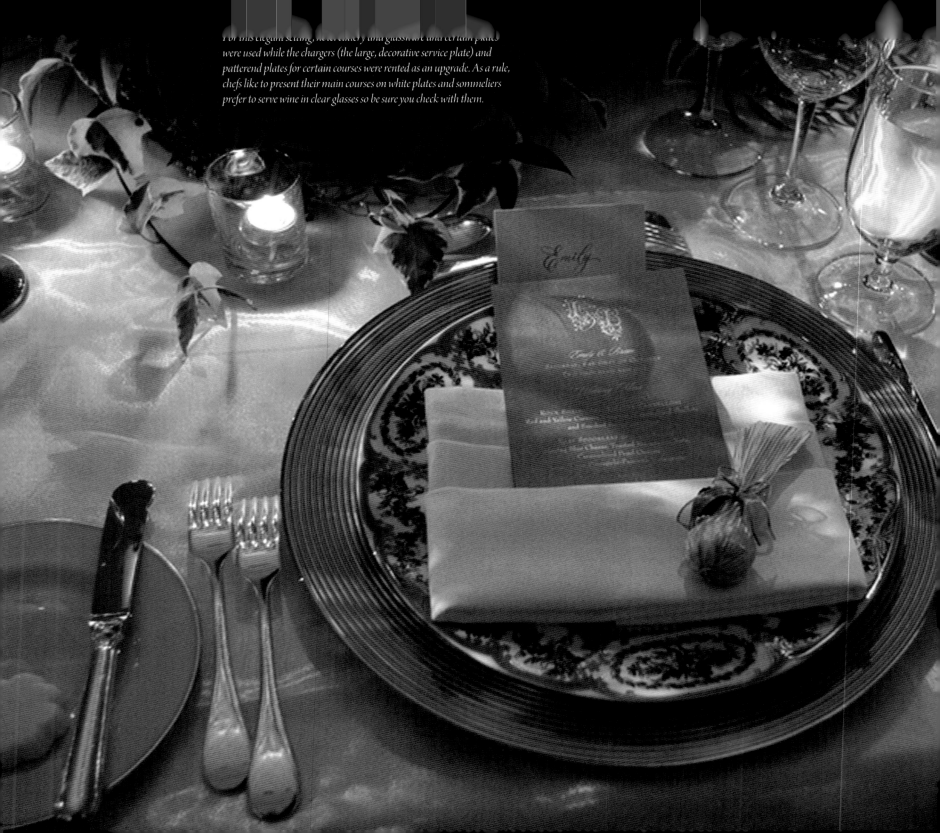

For this elegant setting, flatware and glassware and certain plates were used while the chargers (the large, decorative service plate) and patterned plates for certain courses were rented as an upgrade. As a rule, chefs like to present their main courses on white plates and sommeliers prefer to serve wine in clear glasses so be sure you check with them.

MIND YOUR
Manners

As charming as they were, the manners of Jane Austen's era are anachronistic today. The social rules of that era were structured, formal, and even romantic—so different than our casual lifestyle of the twenty-first century. However, we still use (and, I daresay, need) the basic concepts in order to stay civilized.

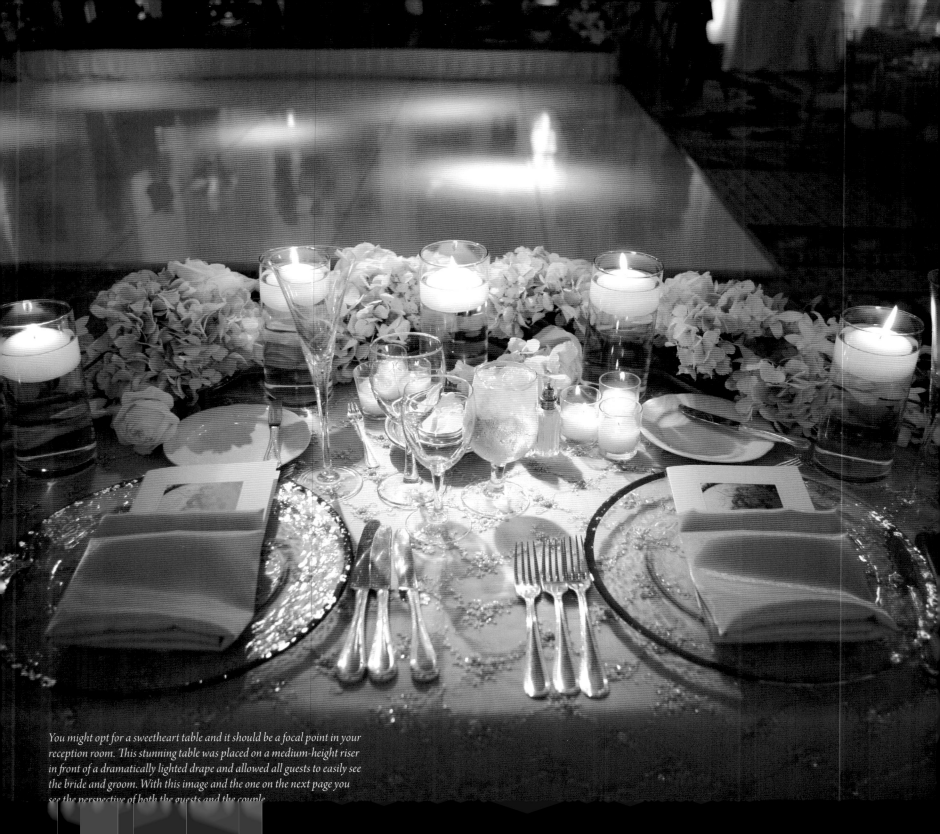

You might opt for a sweetheart table and it should be a focal point in your reception room. This stunning table was placed on a medium-height riser in front of a dramatically lighted drape and allowed all guests to easily see the bride and groom. With this image and the one on the next page you see the perspective of both the guests and the couple.

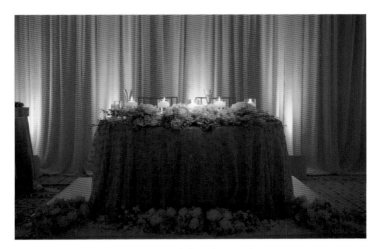

A sweetheart table from the guests' view.

Maybe it's because of what we've seen in movies or read in books, but people who have impeccable manners appear to have more class than those who lack social graces. They may seem more at ease in social situations. My guess is that most people want to give the impression that they are gracious and comfortable and not come across as boorish or ill-mannered.

I love this example of exemplary manners: I recently conducted a wedding rehearsal and my sunglasses got fogged up because of the warm day. I casually mentioned this when I removed them so I could see and, what do you know, one of the groomsmen pulled out a cloth handkerchief and offered it to me so I could wipe my glasses. Wow, was I impressed to have a real gentleman standing right before me! As I thanked him, at that moment I came up with what I call the James Bond scale of manners and told him he had just hit the 10 on that scale. I urge you to strive for that, too.

As illustrated, polished manners are really based on common courtesy and thoughtfulness. You don't have to know or memorize a long, rigid list of "do's" and "don'ts," such as which fork to use or who to introduce to whom. Treating others with respect and kindness and making them feel comfortable is the only

real rule—it might even override a traditional rule of etiquette.

By simply practicing the following suggestions as you get ready for your wedding day and beyond, I can almost guarantee that you will be about 80 percent more informed than most people.

Pre-Wedding Manners

Practice these during the wedding planning process as you meet with vendors and have showers and parties, though it won't hurt to also carry them into your everyday life.

- You might meet with several vendors in each category and, of course, will hire only one. For those you do not choose, a quick phone call, e-mail, or handwritten note (you get extra credit for such a note) that says something like "thank you for taking the time to meet with us, but we have decided to hire someone else" is very thoughtful and courteous. Vendors can handle a "thanks, but no thanks," but to not even acknowledge that you appreciate the time they spent presenting their proposal is thoughtless.

- Put your cell phone and other handheld devices in perspective. You do not have to answer your phone every time it rings, especially when you are in a pre-ar-

ranged vendor meeting. That's what voice mail is for. It is very discourteous to stop the person you're meeting with mid-sentence so you can take a random call or text—especially since you are the one who asked for the meeting. If you are expecting a call or text that is relevant to the meeting, you can always explain in advance that you might get such communication. Then finish it as quickly as you can and share the information.

- Write thank-you notes for gifts and good service. A handwritten note is the most proper (and has tons of cachet), but please, at least write an e-mail when someone gives you a gift, entertains you, or does something nice for you. Make a mantra of "I can never write too many thank-you notes." You would be shocked at the number of brides who don't write one note to their vendors after the wedding—even to the planner, who might have spent months working with them.

- When you are sending the wedding invitations, be sure that you are including significant others who should be invited and that you have the proper names and spellings of all guests. Sometimes it's necessary to limit your guest list, so be sensitive to the feelings of those you must exclude. Discuss your limits with them in advance if you think it will help to avoid hurt feelings.

- When making the table-seating plan, consider who should or should not be near a particular friend or family member. Example: don't seat your best friend's

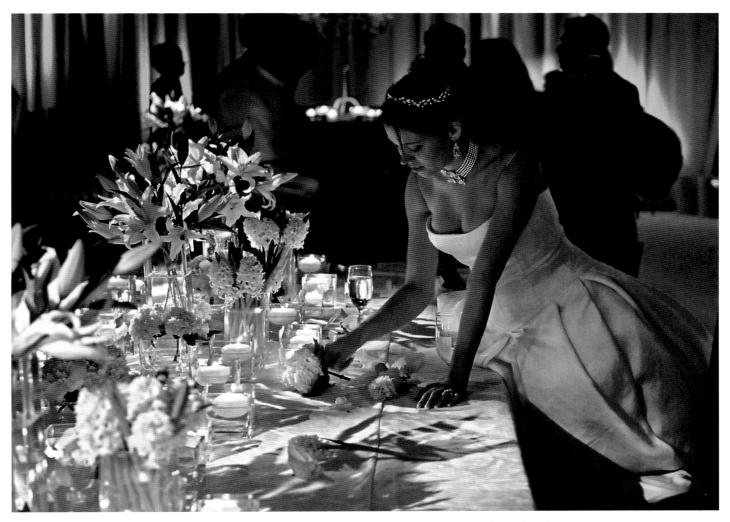

As the reception was winding down, this bride very thoughtfully collected flowers from the floral tablescape for the moms, aunts, and other special friends to take home.

old boyfriend at a table near her if they aren't on good terms, or your grandmother (your mom's mom) near your divorced dad if she still thinks the divorce is his fault and would just as soon he was seated in the next county. Also consider the proximity to the band or speakers, especially for older guests who might be bothered by loud music.

• When planning the ceremony processional, be sensitive to stepparents who might feel slighted if they are not formally escorted in as part of the procession. Example:

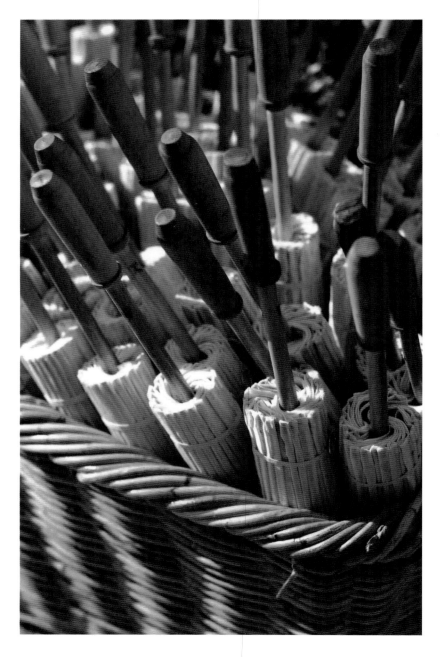

Your dad is remarried after a divorce from your mom. You have had some interaction with his wife but don't consider her to rank anywhere near your mom in your heart. But your dad has chosen to spend his life with her, so both of them might feel insulted or slighted if she is not honored in this small way—especially if your dad is paying for all or part of the wedding. Now, if your divorced dad has a girlfriend but isn't remarried, I don't think she has to be formally seated unless they have had a long-term relationship and you have had interaction with her and hold her in high regard. (On the other hand, if she's the one who broke up your parents' marriage, that is certainly a consideration in how her presence will be handled.) You will have to decide this sort of thing on a case-by-case basis, but the main factor is being kind and considering people's feelings. Remember to take the high road.

• Especially if you have a large number of family members being formally escorted in as part of the ceremony, have a little card that says "Reserved for (name)" attached to each of their chairs. This will avoid confusion if someone forgets what was practiced at the rehearsal or was unable to attend it.

Parasols for your guests are a welcome amenity on a warm or sunny day.

Wedding Day Manners

THINK OF YOUR GUESTS

I assume that the people you invite to your wedding are your closest family and friends, the people with whom you most want to celebrate. They are investing the entire day (possibly the entire weekend) and often a considerable amount of money to be with you, so please consider them when you are making your timeline. They will likely be at the ceremony and reception for about five to six hours, not to mention the time it takes to get ready and travel to and from the venue.

- If it is a hot day and your ceremony is outdoors, be sure to arrange for shade, such as umbrellas for your guests' comfort—especially if there are elderly or infirm persons present.

- Have an attractive water or soft drink station (no cans, please!) for guests to quench their thirst as they await the start of the ceremony.

As your guests arrive at your wedding, they are happy to see a water station, especially on a warm day. You can take the presentation up a notch by displaying interesting waters or other soft drinks coordinated with your wedding colors. Be sure there is a server to collect any glasses or bottles before the ceremony begins so they don't show in the photos.

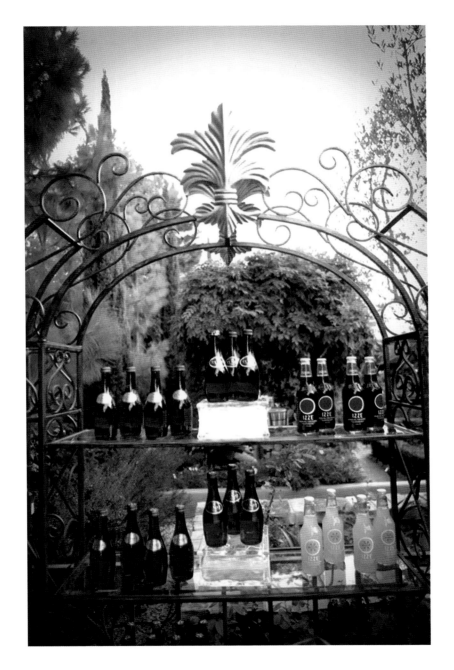

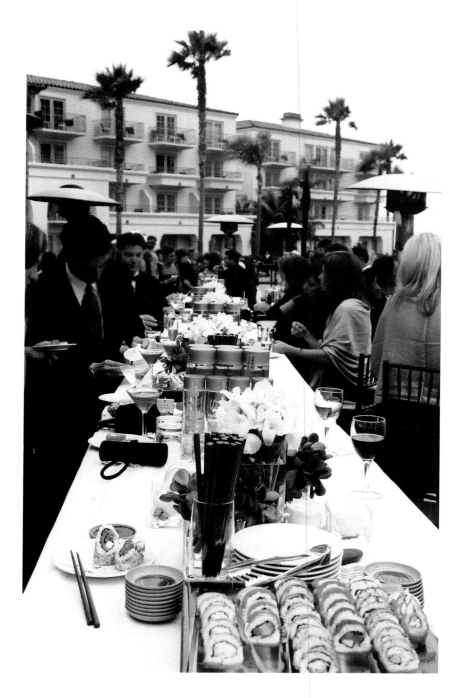

- Start the ceremony on time! This is so important that I want to say it again, only louder. Start your ceremony on time! Here is where your planner (or that super-organized friend) will serve you well. Make your timeline reasonable, building in a few minutes for unexpected delays, and keep to it. Sure, there are always a few delays here or there, but anything beyond starting fifteen minutes past the time on the invitation is punishing the guests who took the trouble to get there on time. Please discuss punctuality with your wedding party, family members being escorted into the ceremony, and your photographer, and let them know this is very important for a successful day.

- Impress upon your photographer that you want all post-ceremony photos to be finished within the time you've allotted for the cocktail period—usually one hour. One of the biggest complaints of guests is that photos went on for a protracted period and they got bored waiting. Plus, a real downside to an extended cocktail hour is that the guests will consume more alcohol, which will drive up your bill if it is based on consumption. Additionally, whether or not you're serving alcohol, you risk running out of hors d'oeuvres if your cocktail period runs longer than the time planned. This will not impress your guests.

A long communal sushi table was featured during the cocktail hour of the East Meets West wedding. (See also page 18.) The table was raised to bar height so guests could sit on bar stools. Note the Norwegian influence with the Voss water and the Korean influence with the food and chopsticks.

• I suggest avoiding a receiving line at all costs. At first blush, it seems a great way to greet every guest in one fell swoop. But, think about it. You will be standing stationary for a substantial period with little or nothing to eat or drink. You will likely spend an average of fifteen to twenty seconds per guest, which in a wedding with two hundred guests equals about an hour. No other wedding activities involving you and your groom can happen during that time, and your entire family will also be tied up greeting guests. So what are the guests who have been through the line going to do but eat and drink and visit with each other? Even though the music is playing, some guests are reluctant to dance until after the formal dances, which, of course, aren't going to happen with you in a receiving line. Here again, you risk guest boredom, excessive drinking, and possibly running out of food. Your group picture opportunities are also infringed upon. You certainly should not begin wedding-party photos after the receiving line. Besides, the wedding party is probably scattered (and perhaps a little inebriated), and it would be a nightmare to get them focused at this time.

• You must greet each of your guests personally and thank them for coming and sharing the celebration with you. I suggest you and your groom stop briefly at each table during the reception. Accomplishing this will take a little diplomacy on your part, as some people will want to talk to you in depth. Rehearse a few gracious phrases, such as "We look forward to catching up with you once we get back from our honeymoon and settled into our new home." It also would help to pre-arrange a signal with your groom when you need to keep moving in order to greet all of your guests. Think like a politician here; shake your guests' hands, schmooze pleasantly for a few seconds, thank them for coming, and move along.

• Strive to start the reception and dinner on time. If you follow the above suggestions, this will naturally happen. But if you fall behind even a few minutes here and there during the ceremony or cocktail portions, you can lose a half hour or more without even realizing it. Delays like this can cause problems for the kitchen, which can result in the quality of the food being affected. Once again, I emphasize the importance of having a good timeline and following it as closely as possible.

• When planning the food, it's important to let the reception venue know about any of your guests' special dietary needs. Is anyone vegan, gluten free, kosher, or allergic to nuts or seafood? A gracious host and hostess will take steps to accommodate these needs, and it's an important precaution in avoiding medical emergencies due to food allergy. Letting the venue know in advance will allow them to be prepared and not have to scramble in the kitchen at the last minute. If you are assigning tables, it's helpful to tell the banquet captain at which table your special-diet-needs person will be seated.

Be Sure to Eat

A lovely salad starts a meal off.

There is a strong likelihood that you and your groom will not get much to eat at your wedding reception. Between visiting tables to greet and thank your guests, you will be continually approached by guests who want to congratulate you. It seems like each time you put a bite of food in your mouth, you'll have to respond to a well-wisher. That is why I strongly urge you to eat breakfast that morning and also to have something to eat while you are getting ready. It's a long time until the end of the reception, especially when you might get only a few hors d'oeuvres or bites of your meal.

Mealtime is very often a social time, whether shared with family, friends, or colleagues. Eating behavior may be the most obvious way that people see our manners—or lack of them. Often we are hurrying and grabbing fast food, so it seems that proper manners aren't very important. Yet they really are. If you slip to the lowest common denominator, that becomes your norm, and it's not too pretty. Just because the people around you are displaying poor manners, you need not stoop to that level.

You don't need to read a long treatise on which utensil to use. All you have to know is to use the utensil from the outside in toward the plate—and here's a secret: probably three-quarters of the people you're dining with would likely have no clue anyway. Even if you are limited to a plastic fork in a cellophane bag, good eating manners should still prevail, and using a few reasonable guidelines will give you a leg up. You have twenty-one times per week to practice the rules, so you'll be very adept in time for the wedding.

• Sit up straight at the table and keep the arm you aren't eating with in your lap (if dining American-style). Elbows and arms should never be on the table except between courses. Please don't drape your non-eating arm on the edge of the table or around the plate. You'll look like a cave dweller protecting her food, and an observer would half-expect you to growl if anyone gets too close.

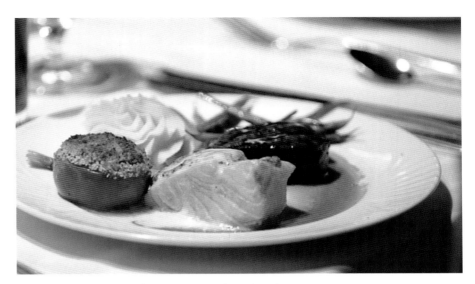

A duo entrée is a nice choice that pleases most guests.

• Take small bites, and use a knife rather than the side of your fork to cut small pieces of food before you take each bite. The continental style of dining is to hold the knife in your dominant hand and the fork in the other throughout the meal. American style uses the knife in the dominant hand to cut, then crosses the fork into the dominant hand to take the bite—a somewhat awkward custom, but proper nonetheless.

• Please don't jam huge bites into your mouth and let the food drip out of your mouth as you try to chew. This is quite unappetizing to your dining partners or other observers and makes you look coarse and gluttonous. I have been shocked to see people in business suits at restaurants displaying this kind of eating behavior. I always wonder whether they will get the promotion they are after if they ever dine with their boss. A few grooms have also been caught on the wedding video this way. Oops! That's what video editors are for.

• Don't talk with your mouth full. Your mom was right! It is disgusting and unappetizing.

• In a group, please wait until everyone at your table has been served before you begin eating. The hostess—in this case you, the bride—should be the first one to pick up her fork, which signals that all can begin. If you have a head table, be sure to go back to it as soon as the next course is served. Some reception venues prefer to have the bride and groom at their places before they serve the head table. This also gives you at least a short break to get a few bites of food before you go back to table-by-table greeting.

• When finished with your meal, place the knife and fork across the center of the plate to signal to the server that you are ready to have the plate removed. Please don't push the plate away or stack up your dishes to "help" the server or bus person. That shows lack of sophistication.

Just for fun, for a few days observe people in restaurants and see what I mean about how yucky poor eating manners look. I'm hoping that this will cause you to think about refining your own manners, especially for your wedding day, if they are not already in the three-star or better range. (Hint: Strive for five-star.) If you're sitting at a head table or a sweetheart table, you'll be the center of attention and will be more comfortable knowing that your eating manners are exemplary.

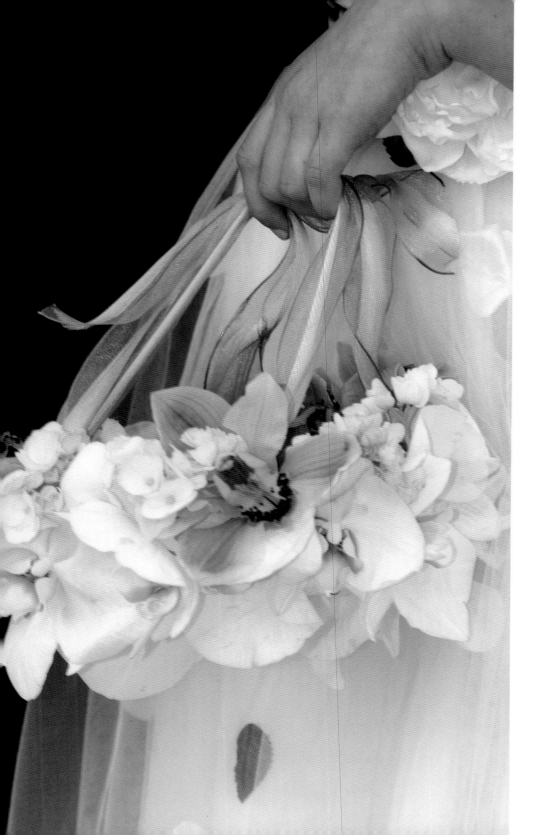

GRATUITIES

Monetary gratuities should be considered for your vendors, especially those who have done an outstanding job for you or your guests. Of course, gratuities are never required but always appreciated. Your planner can help you with whom to tip and how much, and you'll find such information on wedding-related websites and in bridal magazines. Many vendors go above and beyond both before and on the wedding day because of their pride in their job. It gives them a huge boost when the couple expresses their appreciation with a gift of cash. Make a list in advance of the vendors you wish to remember, and get the appropriate bills from the bank. Place them in labeled and sealed envelopes, then discreetly present them sometime during the reception. If you have a planner, he or she can handle distributing the gratuity envelopes, or ask a trusted friend to take charge. The less you and your groom have to worry about during the reception, the better. A warm thank-you note is the very least you should give to anyone who assisted you with your wedding.

A pretty little detail, this flower girl's basket was covered with blossoms.

Married! Taking off in a vintage car is a fun way to leave.
This car belonged to a friend who was delighted to be part of the wedding.

Or maybe you'll make your getaway in a golf cart!

Post-Wedding Manners

Write thank-you notes for wedding gifts as soon as possible. Speed is important here. There is absolutely no truth to the urban (or suburban) myth that you have a year to write a thank-you note for a wedding gift. I have a feeling that it was started by a bride who didn't get her notes done quickly, then tried to justify her behavior in a bridal magazine story. The faster you get your notes written, the sooner they are out of your hair. Furthermore, no one will call your mom or, worse, your new mother-in-law (OMG, no!) and try to

diplomatically ask if a gift got to you. This embarrasses all parties—especially you.

When writing their notes, some couples share the responsibility based on whose list the guest was on. That works out well, as it makes the task go more quickly. It's more than a little old-fashioned to think that the female half of the equation has to write all the notes.

I've just scratched the surface here regarding manners. If you're interested in fine-tuning your manners, good etiquette books are available at any bookstore. But for starters, awareness, common courtesy, and a positive attitude are the basis of what you need. If you take the aforementioned high road, you won't go wrong.

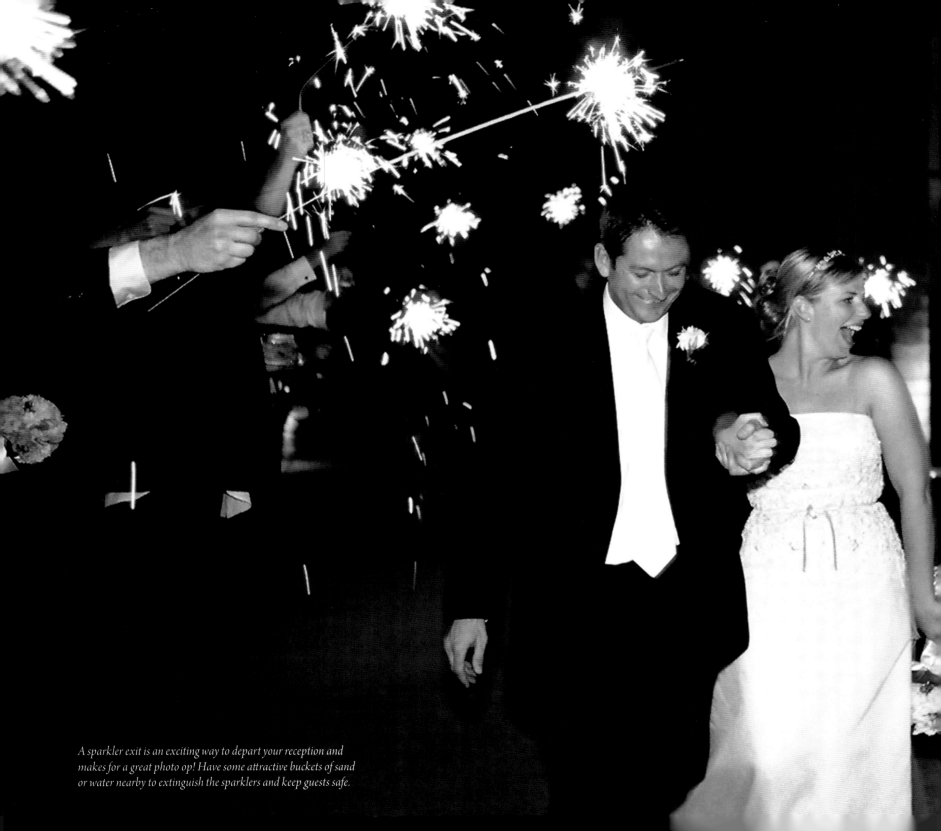

A sparkler exit is an exciting way to depart your reception and makes for a great photo op! Have some attractive buckets of sand or water nearby to extinguish the sparklers and keep guests safe.

Enough Is Enough

There is a point in every task, from washing your car to planning your wedding, at which you have to step aside and say, "This is as good as it's going to get." While striving to do your best, you must also beware of becoming obsessive and working so diligently that the enjoyment disappears. There might be a fine line here, but please, try to find it and stay on the side of loving the process and the outcome and knowing when enough is enough.

One last wish from me is that your wedding day is one of the most joyous and wonderful days of your life—and that you and your groom will have a very long and happy life together!

Cake Gallery

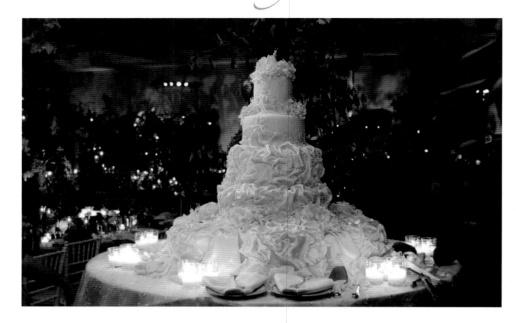

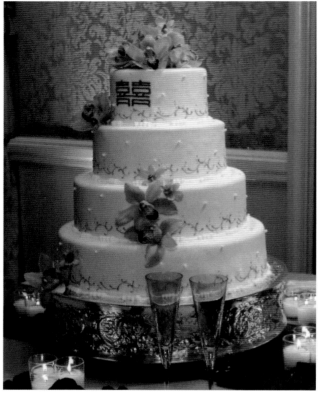

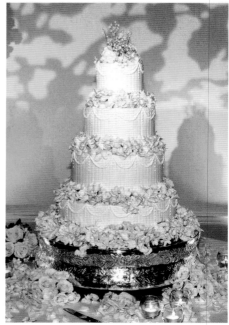

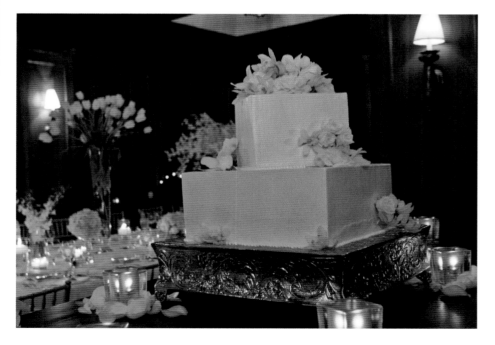

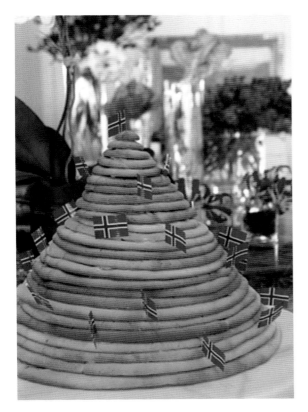

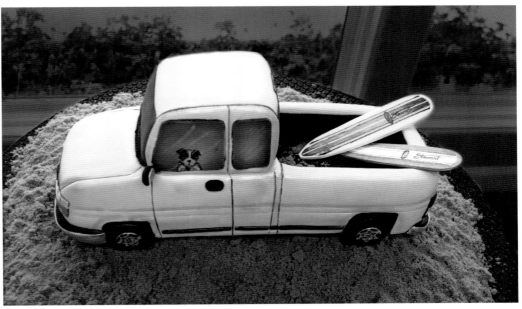

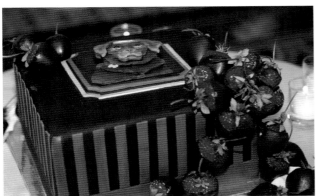

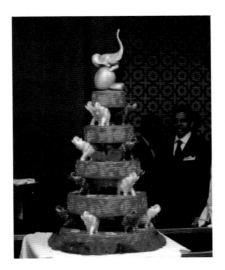

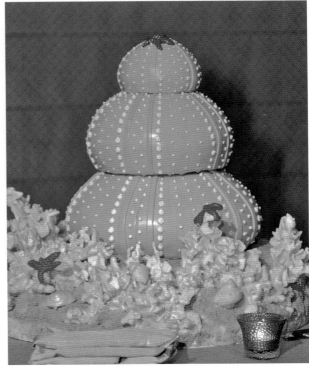

Cakes—especially tiered ones—are synonymous with weddings, and the design is limited only by your imagination (and structural engineering!). Some brides choose to have the fondant frosting emulate their gowns (facing page, upper left: see gown page 172; lower left: see gown page 256). Others want to continue the color scheme or wedding theme (facing page, upper right; this page, lower middle; lower right). Groom's cakes are generally more casual, often humorous, and reflect the groom's hobby (this page, lower left; upper right) or heritage (this page, upper left). It can be displayed adjacent to the bride's cake and cut at the same time. Or some couples serve the groom's cake at the rehearsal dinner.

The STYLIST

This headpiece is so unique that it can
set the style, tone, the "whole idea"
of the wedding theme.

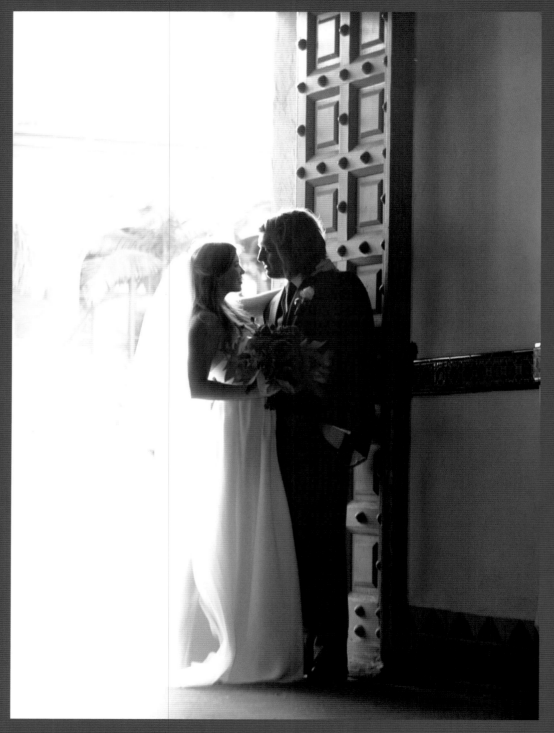

The quiet moments are fleeting on your wedding day,
though they are the moments you will cherish most after it is all over.

ANNIE'S *Philosophy*

"You are who you think you are. Be careful who you think you are." These words, spoken by my father, are a mantra to me. Throughout my life I have been taught to see and appreciate beauty: in art, music, architecture, and all things visual. My parents encouraged me to pay attention to this aspect of the world, which has given me a special insight —or maybe a talent—to perceive subtleties.

With parents in the beauty industry and the arts, I was introduced to diverse expressions of beauty. I pondered each case study, so to say, I encountered. Why does an outwardly stunning woman pale in comparison to a simple, unfettered beauty? Is it the simple beauty's carriage? Is it her clothes? Is it her mind? Her hair? It is all the elements of who she is coming together: clear, bright eyes, soft poetic hair, flawless skin with a wash of watercolor makeup, and a wardrobe style that complements and unites in symmetry. She is comfortable in her own skin, quick-witted, and generous of spirit—a harmony of

The love in the room was palpable. We (the photographer and stylist) feel so fortunate to be in the shadows, to bear witness to such poignant moments.

internal and external expression. You can sense it. You can see it. It is palpable. What is the X factor? If I hadn't been encouraged to look, feel, see, and acknowledge the subtleties, I might never have noticed or asked why.

The pre-packaged, boxed ideal of beauty that is imposed upon us in advertising is a constant source of confusion for me. To define what is beautiful has become more ephemeral, more transitory. It's whatever look is "in," popular, or in vogue at the time. Where does "you are who you think you are" come into play? Store-bought qualities don't resonate with me. A quick fix makes me mad. When a dental hygienist suggested that "getting some veneers would make such a difference," I thought, "Difference how? These teeth are mine. They are me!" It is the smile, as my mother always said, that is the signature of a "Withers girl"—a connection to my family, each of our smiles unique in design, all variations on a theme, but also slightly imperfect in their perfection. It is my identity. What if I had listened to the hygienist? It is dangerous to subject yourself to a barrage of outside expectations or an imposed unrealistic measure that you feel forced to subscribe to, even when you intrinsically know it doesn't fit you, and that it's a daily struggle to live up to. When did one kind of beauty begin to define us? Somewhere along the way we lost sight of

Articulating your personal definition of style is not about vanity. It can be a revelation,
an insight into who you are—or who you want to be—that you carry beyond your wedding day.

our nuances, our subtleties. No one else has that same dimple, that unique arch in the brow, that imperfect smile. Why are we so eager to sacrifice it just to fit in? Let's celebrate our individuality, not defy it. Let us become an eclectic reflection of our own individual types of beauty.

In my own journey of discovery, I have at times been tempted to subscribe to the "group think," commercialized, adopted definitions of beauty. But it never felt right. So in the end I have returned to "the road less traveled." Beauty is subjective and personal. It is work: mental, physical, emotional, technical, even intellectual. You have to seek the tools that will help you with your evolution—for you, not because it is popular or in vogue, but because it will better you, make you feel healthier, prettier, and more confident;

because it will give you something to stand for—maybe even something to say!

Why do we all have days when we feel—and maybe are—more beautiful than others? Why do we get more attention than usual on some days? What is it that we altered? That's not to say that there aren't fabulous products, amazing undergarments, enlightened stylists, and an unending wealth of knowledge and tricks of the trade that heighten our beauty experience. But could it also be our state of mind? Some twenty years in front of and behind the camera have taught me to recognize and identify how to bring these two worlds together. Personal and internal expression meets commercial, technical expression.

Use and draw from fashion and commercial products that you like, that work for you, but reach, too, for your own standards. Imprint and embrace qualities that are unique to you. Unite them, and strike a balance. No more "all or nothing at all." I believe we possess a symphony of qualities. It's so much more interesting. Acknowledge your own personal definition of beauty—draw on it, hone it, cultivate and nurture it, and bring it all to light. Become an architect of your own design. Express yourself, and take credit for it! You are who you think you are—so be mindful of who you think you are.

This photo makes me think of a swan. The way the maid of honor's gloves entwine her neck and the stark contrast of black and white is majestic and beautiful. The maid of honor and the bride could be floating on water.

Cultural traditions often run deep and can be reflected in your wedding, wherever it takes place. This South Asian bride awaits the arrival of her fiancé "from the other village." There is great theater here. The symbolism of each event and religious ceremony is rich in emotion and unbelievably beautiful to watch. Any bride would be so fortunate to be literally dripping in jewels!

This image says so much about style without even showing faces! This could have been taken in the fifties; it's timeless.

Chapter Six

Go With Style
or Stay Home!

This chapter falls under that part of our book " . . . And In Life." Your wedding really just gives you a great opportunity to discover and develop your own sense of self and your own distinctive style.

The process of creating and developing your own distinctive style is paramount to the end result. It takes

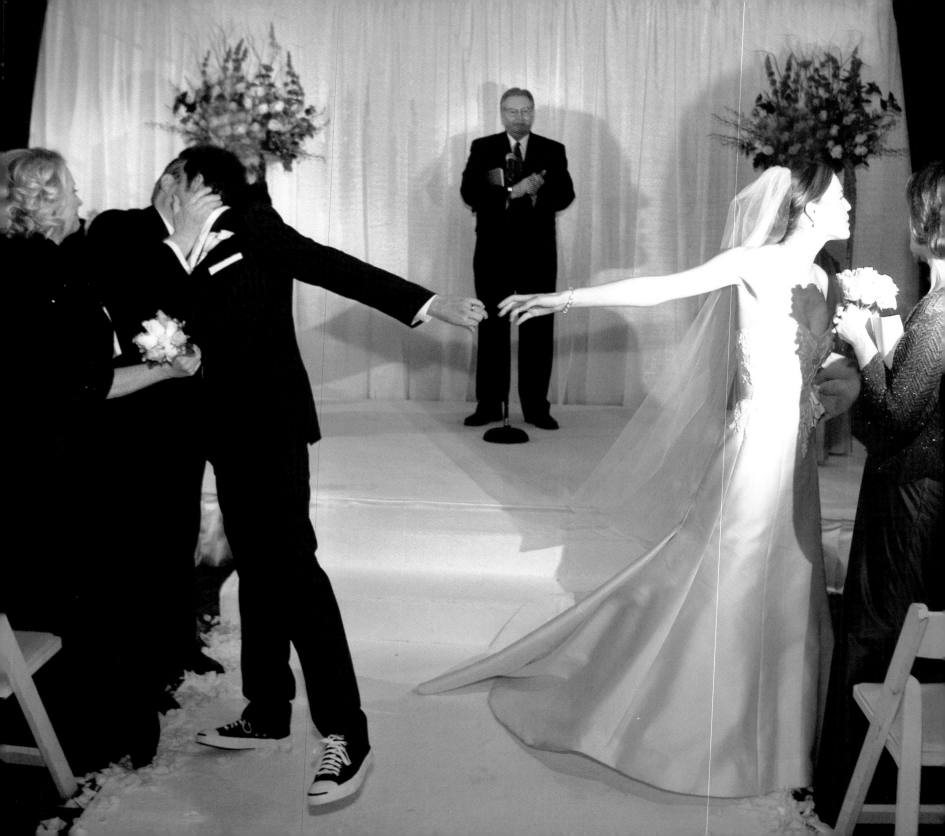

This hand mirror reflects the elegance and beauty of this bride and the emotions that are right at the surface. You can see it in her eyes.

work, both intellectual and creative. You need to really think about who you are and how you want to reflect that in your personal style—for your wedding and your life!

To truly know who you are and what image you want to project, you must first identify what you like and dislike about yourself. That comes through self-examination, even though it might take hard work. If it matters to you, then give it the effort it deserves. Start at the beginning and discover who you really are. Anything is possible.

My parents would often say, "Life is a banquet and most poor souls are starving to death," only to discover through the writing of this book that it was actually a quote by Auntie Mame! The world is a colorful palette for you to choose from, so don't be afraid to seek your heart's desire. There are no hard-and-fast rules that define you; there is no black or white, but shades of gray and a spectrum of colors in-between.

The Process

Where to begin? The process of recognizing and cultivating what's beautiful about you takes self-reflection. Here are a few ways you can try to identify what you love about yourself:

The exaggerated flash effect of this shot came from another pocket camera. Lars's camera lens and eye for theater froze an exquisite moment. It is as if the bridal couple is simultaneously kissing their families goodbye and reaching to begin their life together. Gorgeous!

WHAT MAKES YOU FEEL BEAUTIFUL?

Think of a time when you really felt beautiful. What was making you feel so right? Your state of mind? A fit, healthy body? Happiness? Love? Financial freedom? Your work? Friends?

It is elusive, but if you really try, you can focus on what makes you feel good about yourself, what makes you feel pretty. We all have elements that we like. Our hands, legs, eyes, voice, body, mind, strength, wit—whatever it is, acknowledge it and build on it. For example, if you have beautiful hands, wear interesting, unique jewelry that draws attention to them. If your body is your asset, wear clothing that complements your shape. Legs are easy to draw attention to: heels enhance the contours of your legs and help you move in a more feminine, graceful way. Hair is another asset that helps you set yourself apart. Take the extra time to bring out the shine, color, or cut. If your sense of humor or wit is one of your strongest assets, then let your style express that. Wear fun or unique glasses or hats, choose jewelry in whimsical styles and colors, or incorporate unique accessories such as colorful tights, scarves, or wraps into your wardrobe. Be fearless!

An easy smile makes the whole day better and the bride more beautiful!

These quiet moments, caught without the bride's awareness, show the emotions that run beneath the surface.
Body posture, poetry of the flowers, and hairstyle can add so much to the final look.

CULTIVATE PEACE OF MIND

A person who has peace of mind and contentment exudes a special kind of beauty and has worked, in some way, to achieve it. Do what is needed to give yourself an inner peace. Meditation, exercise, yoga, dance, gardening, open conversation, therapy, reading—whatever gives you comfort. It's hard to feel beautiful outside without internal contentment. "All we are is a product of what we've thought." –Buddha

BODY IMAGE

Find a physical state that allows you to feel good about yourself; just acknowledge a state that feels comfortable and real. Even if you are not at your ideal weight or the "perfect" physical state in your own mind, work with what you have and invest in reality. Do yourself a favor: give yourself permission to be exactly who you are today. As for the future—who knows what possibilities await you?

Discovering Your Personal Style

Who am I, at the core?

We all carry our life experiences and impressions, cultural background, traditions, sense-memories, and environmental influences within our own internal fabric. We "wear it on our sleeves," if you will. Identify these things in yourself. Keep a journal, make a list, do a collage, or create an expression of your wishes and dreams in whatever form you feel helps you to discover more about yourself, so your desires will become clearer in your own mind. What styles do you gravitate toward?

Do you have a specific style already? Vintage, modern, alternative, business, casual? Do you aspire to create a whole new look, one you've yet to have the courage try on? Some people can feel a little trapped in a specific style that they have worn for years and years. Maybe you have always wanted a new look but are waiting for the courage or opportunity to "try on" something new. In my case, after my father passed away, I felt as though I could experiment more, "try on" a new identity, because I truly no longer felt like a child. That gave me an emotional sense of freedom to express this change. For you, the impetus for change could be a death, a move, or a marriage! Any major emotional upheaval can transform you, creating big changes in your life. After all, with a new marriage you are embarking on a new path. Your style is one way to express that. It does take courage to reach beyond your comfort zone to find your own expression of you. Find a style or genre that inspires you and emulate what you like. If you have more than one, pick and choose elements that are in the same world of style. As my father would say, "Don't mix your metaphors." Stay within a concept or general style and build on it. Some things work to complement each other, but it's easy to overdo it when you try to do too much or want to convey too many things at once.

What styles complement my shape?

Long, lean, and tailored, or soft, romantic, and flowing? A combination of the two? Take stock of the items you have in your closet that you think flatter you and make you feel good. Separate them from the rest of your clothes. I know I have combinations of clothing that are surefire confident and "feel pretty" choices. Do an assessment of why you like these particular clothes, then find continuity in a design and fit that pleases you. If you find that you have a plethora of a certain designer label in your closet, start there. There is a reason those designs please you and fit your frame. It might surprise you when you pull the clothes you constantly grab for and realize the similarities and lines that obviously make you feel good.

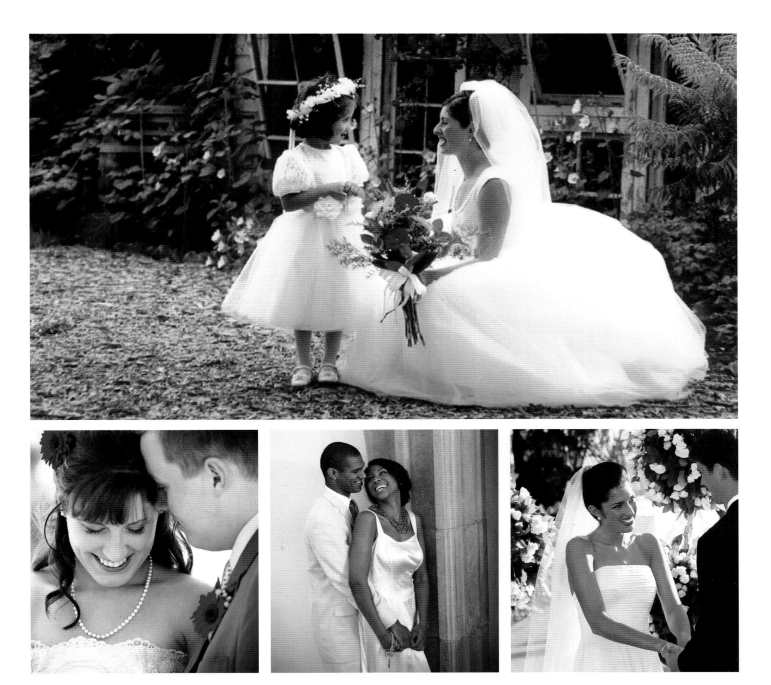

These four images show the clear style distinctions possible within the "whole idea" of a wedding.
Brides can define their own personal look by material choice, design, shape and cut of the gown, with your hairstyle,
whether to go with or without a veil, and much more. Every detail adds to the definition of personal style.

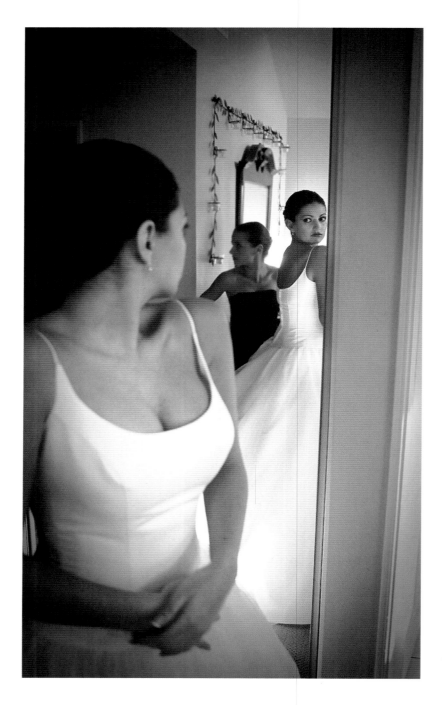

Do I want to project a feminine, masculine, or androgynous vibe?

It's useful when you are in touch with your inner "masculine" or "feminine" energy. It helps you make choices and begin to define your own style. Actress Marlene Dietrich was famous for a very androgynous style. She wore a lot of men's slacks and blazers, ties, hats, and men's shoes, but would combine them with feminine blouses and accents. On the other hand, Grace Kelly gave off a very feminine vibe, with soft skirts, scarves, ruffled blouses, high heels, and lots of leg, and she wore makeup that exuded femininity. Work to discover the looks you like and make choices that are best for you!

Am I more comfortable wearing bright colors or muted tones?

Bright colors connote a fun, free-spirited style—unless it is ethnic, and then you are making a fashion statement about culture or origin. Muted tones tend to indicate a more classic, conservative style.

Try to see yourself "from every angle"—360 degrees of gorgeous!

A classic chignon (left) is a timeless, sophisticated style. Hair worn down and straight (middle) has a very understated elegance. Hair swept up on the sides (left) and with some height makes a more stylized fashion statement.

Does my hairstyle fit my lifestyle?

Hair goes hand-in-hand with your personal style and genre of clothing. If you are busy, you'll need a low-maintenance, no-fuss style. Wavy, straight, up, down, light, dark, long, or short—all are choices to be made. Now, online you can see your face superimposed into any fantasy haircut or color. Play with your possibilities. We see ourselves through our own lens and are often influenced by more than just what's in style. Sometimes you wear the hairstyle you've always worn because

it's easy and you feel comfortable, but is it the most becoming look on you? It's up to you to examine and define the "feeling" that you're trying to project. It should complement the style and genre of wardrobe you have chosen. Do you have a professional look? Or is it sexy, natural, sporty, elegant, or Bohemian? Choose a style that will complete the "whole idea" of the look you are creating. Seek and find options for your hairstyle choice. Like clothing designers, hairstylists are amazing! A good stylist can help to guide you in your pursuit of the best haircut, shape, texture, and style for you.

BEJEWELED . . . OR NOT?

Do you express yourself with jewelry? To make a statement, or to wear as subtle accoutrement? Scarves, belts, purses, and other accents of any kind can create a statement or set the style tone. Be fearless, though not gaudy, and don't limit yourself by fear of judgment. Wear what feels good and makes you feel good about yourself.

If you need help discovering your assets, ask a friend, your mom—or best yet, your fiancé. Choose someone whom you trust and respect and who you know will be honest. The point is, there are many engaging and beautiful things about you: your smile, your eyes, your walk, your courage, your laugh, your joy. Find them. Own them.

You can also ask a professional for help, but don't hand over the power. Keep your personal style clear in your own mind. If you get overwhelmed, trust your own instincts. Who knows you better than you?

Wearing one color from head to toe (monochromatic) creates the illusion of more height and is slimming to the body.

Creating Your Silhouette

Are you tall, short, or a happy medium? It used to be that if you were under 5'11", your hopes for becoming a fashion model were dashed! Not any more. Kate Moss is 5'6½" and one of our generation's fashion icons. Modeling may not be your dream, but looking good in the styles of the day is all about choosing the best clothing designs that complement you. It really is more about understanding how to find clothing with the right "line" for your stature and shape. For example, a button-up blouse worn on a small frame with the buttons open a little lower than you might normally wear it (the right undergarment is key here) can give the illusion of length on a short torso. A very long pair of slacks or jeans with a high boot or shoe that is hidden under the pant creates a very long leg line. Elongating the line is not difficult, but it does take understanding your own body shape and the look you wish to achieve. To add height, you don't want to break the line visually. It is an

Your gown choice can also help you define the most flattering shape for your body. Gowns don't just come in a bell shape any more, hiding your body within. Designers today are creating seamless contours and silhouettes with interior architecture. Amazing!

Choosing this size of a gown for your frame and stature can be difficult. Your hairstyle and shoe choice can help to create height and allow the gown to fall properly. But remember, you want to wear the gown, not have it wear you!

illusion you are creating, and that is the way you want to begin to look at how to wear your clothing.

Hairstyle is another very easy way to give the illusion of height. Understanding how just the right cut or style complements your particular shape and stature can add visual inches. Many very short people will wear very short-cropped haircuts to create one long line. Nothing pulls the

eye downward, only up! Long hair worn down tends to make extremely short people look shorter, unless you have a long neckline. Audrey Hepburn was not "model" height but created the illusion with her style and unique silhouette. She was known for her "dancer" look, very close-cropped hair, tight black tights (leggings), and a black turtleneck. She accentuated her long neck and created a very long, unbroken

line. A monochromatic outfit, one color worn from head to toe, creates length. There's nothing to pull the eye downward, only up, up, up!

Obviously you can become taller by wearing high shoes; that's a perk for shorter people. However, if you're very tall, you must use hairstyle, shoe choices, and wardrobe techniques to create an illusion of looking less tall. Brooke Shields is six feet tall and has always worn her hair long. Long, layered hair worn loose and down can be very pleasing on a very tall frame; it gives balance, visually breaking up the long line a bit. Some tall women tend to wear shirts and tank tops that are a little belly-baring. This breaks the long line between head and hip, which shortens the body visually and balances the extreme length of a torso. If you have extremely long legs (and don't like it), you can wear capri pants to break the leg line at the ankle or higher and shorten the leg visually. Jeans worn very low on the hip helps to shorten the length from your hip to toe and is another great trick for visually shortening very long legs. Flat shoes across the board are good for visually shortening the line. Sandals work very well because they stop the eye from traveling downward when you see skin. If, for instance, a tall person were to wear pointed flat shoes, that would continue to draw your eye down and create more visual length. You want to break the line to give the illusion of less height, and create one continuous long line to create an illusion of more height.

Are you full-breasted or small and dancer-like? Do you want to enhance your bustline or to minimize it? Or are you happy with it as is? This is important to consider when choosing the style you are seeking. Your preference will inform the cut and shape of the clothing you choose. Body image is real! I have come to accept that as a full-breasted woman, I have to do the work to define what I like and do not like on my body. I don't like tight, form-fitting clothing. I prefer to wear an open neckline to create length and not have my breasts become the focal point. Whether you are small- or large-breasted, a bra is a miracle! Undergarments are the real key to creating the line you seek. But it is also an undertaking to find the right bra that creates the shape under clothing that you desire. Shaping undergarments such as Spanx are a revolutionary way to help shape your own body to the desired silhouette. Brilliant! Either way, whether you are large- or small-breasted, it is just part of life to have to work with what you've got. In this day and age, we are fortunate to have so many incredible designers and "body" architects at our disposal who can help us in our pursuit of the "ideal" body shape for us.

Approach a special event or "once in a lifetime" experience such as a wedding in the same way. Begin at the beginning and cultivate the feeling or energy you want to project. Maybe you'll uncover even more than you anticipated as you approach the outcome. I can't tell you how many times as a stylist I started with a concept or image in mind, only to ultimately uncover, add, and cultivate even more to the look.

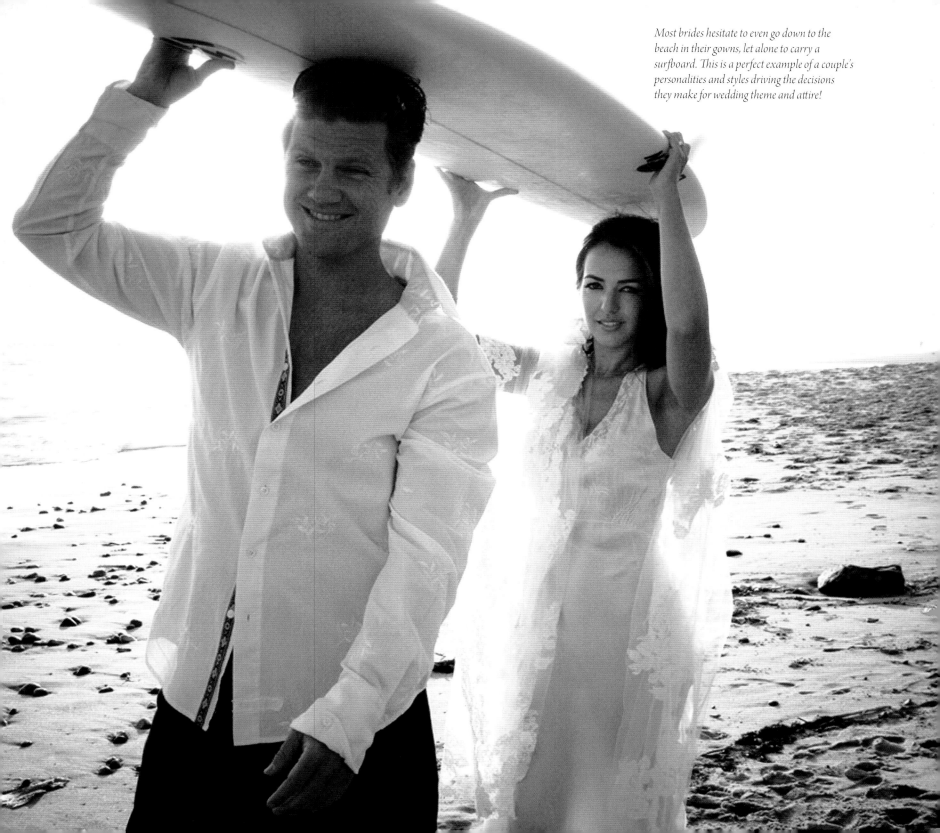

Most brides hesitate to even go down to the beach in their gowns, let alone to carry a surfboard. This is a perfect example of a couple's personalities and styles driving the decisions they make for wedding theme and attire!

Mind Maps

Here is an example of a mind map. Putting it in a prominent place where you will see it every day is a great idea!
It helps to remind you to keep your wishes and desires alive, to help you focus on them and bring them to fruition!

My family and I have become big fans of making what we call "mind maps" or dreamscapes. To create one, take a poster board (or you could even build a collage on your computer and use it as a screen saver) and fill it with images of all of the goals and ideals that inspire you or that you aspire to. For instance, our daughter wanted to go to Africa, so she printed images from the film *Out of Africa*. She was looking for the perfect place to live, so she cut out an image of a stone cottage covered with wisteria. She wanted a new job with a specific magazine, so she cut out the heading and put that on her poster. She added airplanes (for more travel) and symbols that to her meant abundance and love. She found visual representations of everything her heart desired and put them on her poster. So far, our daughter has landed her dream job with said magazine, moved to a new location,

lives in a stone cottage with wisteria growing on it, and just returned from a trip to Africa. Accident? Maybe. Manifestation? I happen to think so.

It is incredibly gratifying when you see this kind of visioning play out right in front of your eyes. When you really think about the things you absolutely knew you would have in your life—and you do have now—it reaffirms that manifestation is a technique you've innately put into play, only perhaps without being conscious of it. There are many books that teach these techniques. Hey, it's just focusing on what you want. It can't hurt.

Seek what interests you. There's a reason we choose what we choose and do what we do. There are no accidents. Trust your own instincts. This is no dress rehearsal. This is your life!

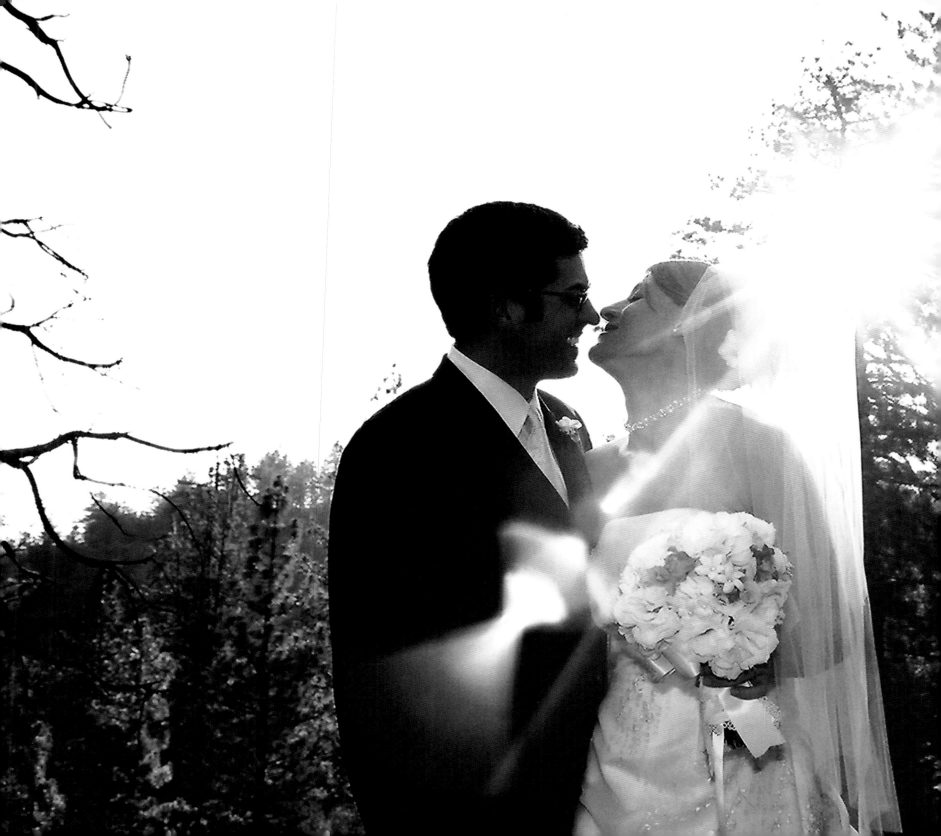

Manifesting Your Wedding

Many of you know about manifesting—envisioning very concretely what you want and focusing on it to make it happen. (See Mind Maps, page 121). Now let's put this technique into play for your wedding day—not just the ceremony, but the whole idea, the complete concept of what you envision your wedding to be. Do you want to build the event around your dress? Or are the flowers your palette? Do you see the event centering around a certain theme that you love? Is the music going to dictate the emotional tug? Could it be that you or your betrothed have a heritage you wish would set the style and theme? Ethnic weddings have many traditions around which people tend to build the day. Subtle statements of color, design, or theme can help create traditions that are culturally accurate but also unique. Try to come up with a list of your five top priorities and work forward from there. Build a mind map. Or create a binder full of your wish lists. Be sure to include your fiancé's dreams and "must haves." I think you might be surprised at what your fiancé holds dear. Most men wait until the last moment to clue you in. By asking, you might avoid surprises later.

Ask in your dream book for anything your heart desires—no restrictions. Start there. You'll be surprised at what you settle on and ultimately end up with. It's a very special, gratifying experience. And be careful what you ask for. You just might get it!

This wedding, held outdoors in the mountains of Idyllwild, California, was truly magical. The bride, groom, and their families handled all of the details. Most of the morning the families and groomsmen were at the site finishing up the final decorations while the bride dressed in the cabin with her attendants. It was a lovely ceremony, intimate and heartfelt. The reception, with candlelight and live music, set the stage for a perfect party! This image captured the magic of the day and the couple.

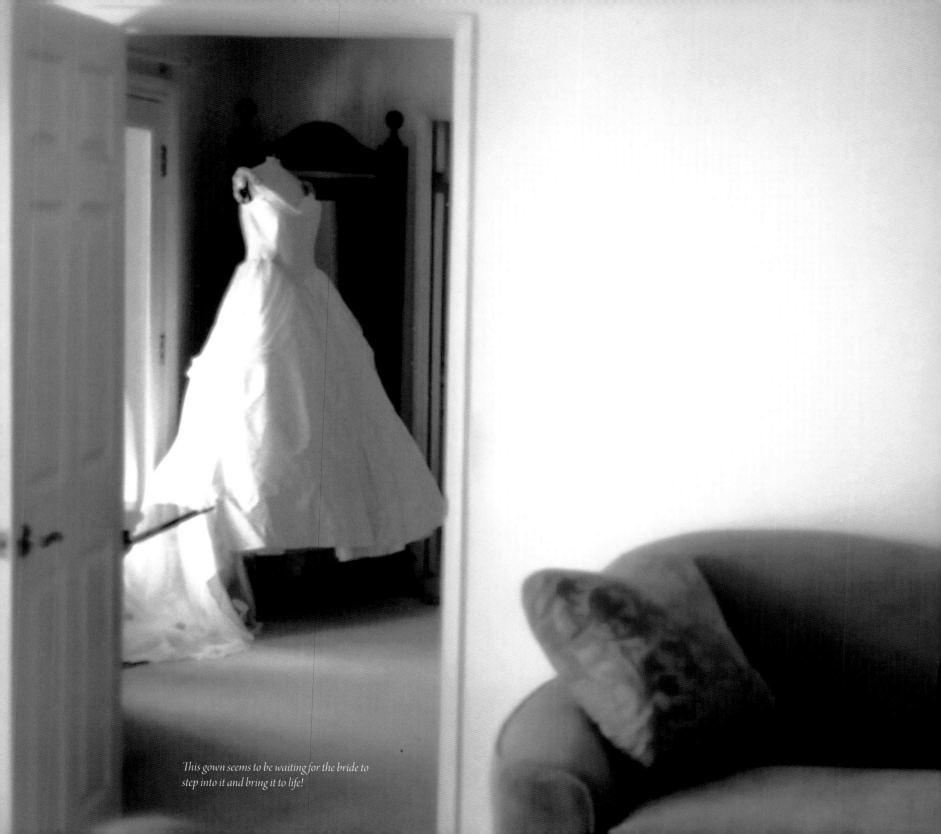

This gown seems to be waiting for the bride to step into it and bring it to life!

THE WEDDING
Gown

More often than not, when the bride

finds her dress the wheels start turning and everything

about the wedding evolves from there. Sometimes that

works out fine, but I recommend that you determine the

"whole idea—location, venue, theme, flowers, music,

lighting, etc.—first. Or at least choose the theme or

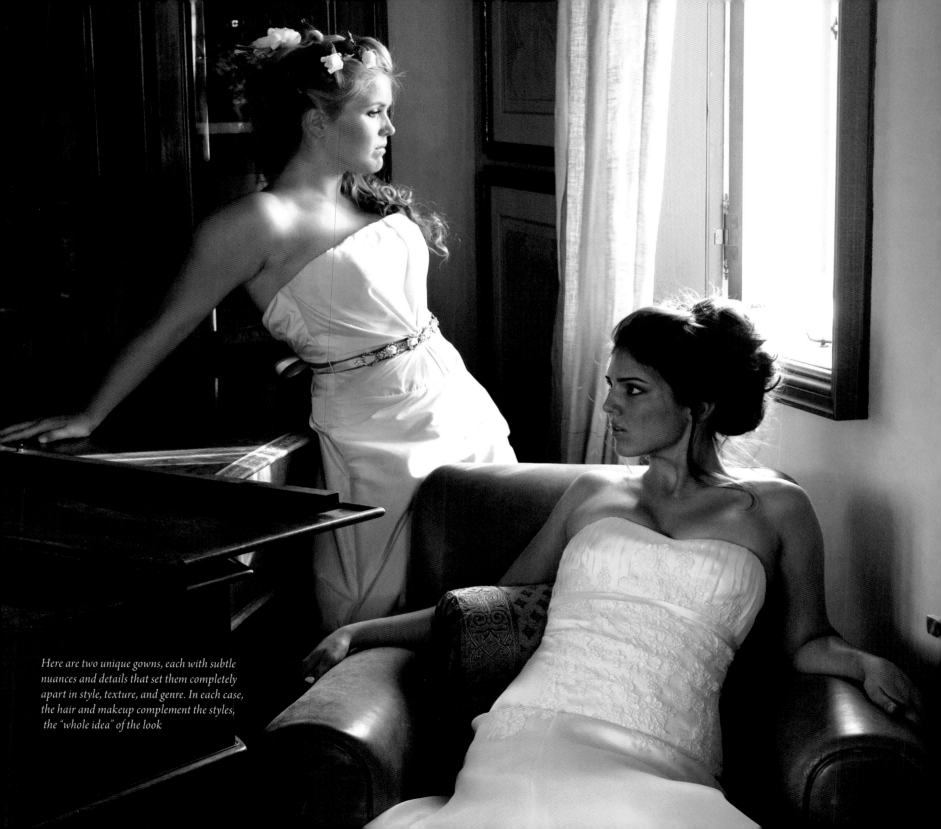

Here are two unique gowns, each with subtle nuances and details that set them completely apart in style, texture, and genre. In each case, the hair and makeup complement the styles, the "whole idea" of the look

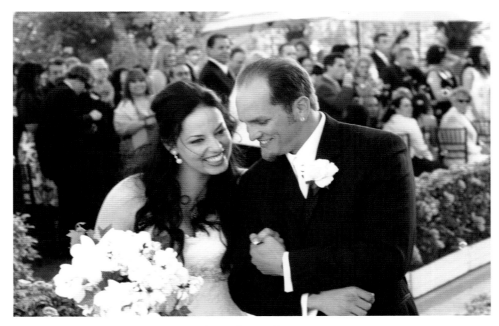

Their joy here is infectious.

genre before selecting your dress. Each genre, color scheme, season, floral choice, even piece of music can influence your concept or "whole idea" of the day. You and your fiancé should decide on your priorities regarding the day and go from there. (See page 29 for an exercise that will help you prioritize together.)

Some women are much more casual about the whole bridal-gown shopping experience. Maybe the dress is really not that important to you. It's your wedding; you choose what to prioritize. This is your (and your betrothed's) day; once in a lifetime, as they say. If the dress isn't in your top five of "must haves" or concerns, then buy off the rack and go to town on hair and makeup, or flowers or the band, or spend the extra money you'll have left on a fabulous honeymoon—whatever is most important to you. If an expensive gown isn't a priority, what is? Inspirations are everywhere. Perhaps you'll choose, as some of our brides have, to take your mother or grandmother's gown and completely rework it, modernize it, and create a beautiful heirloom that you can pass on to your daughter. This endearing choice can mean a lot to your family and bring another level of sentiment to the day. Be unique, be fearless, and be happy about all of the decisions you make.

Choosing Your Gown

You've waited a long time—for some of you, since you were just a girl—to find "the dress," a fairy-tale ideal of the perfect gown for you! Take your time; try to capture in your mind's eye what your ideal is. If you don't have a picture already in your mind, then you must conjure, imagine, design in your own imagination your fantasy gown.

The most important thing when choosing your dress is that you be honest with yourself. It helps to bring a good friend with you, or your mom, or maybe even your brother; he might be brutally honest, and sometimes that's what you need to hear. I think a male perspective is crucial. It's been my experience that many men see beauty and style from a gut level, an emotional level. That's a good and honest opinion, and you want honesty! Ask your betrothed how he likes your hair and makeup, and what clothing he likes and dislikes on you. It helps to hear what he thinks enhances your beauty from every angle—or from his perspective, at the very least. You might be surprised and encouraged by what you hear.

This full-breasted bride wears very delicate straps on her gown. I don't think you have to compromise delicacy and femininity for support; it's the "architecture" of the gown that's the key to structure, fit, and comfort.

WHAT COLOR?

Start by deciding on the color, or lack thereof. White, blush, off-white, ecru, pink, red? Location and the time of year is a very important factor in making this decision. In Southern California, for instance, the light is much brighter. In the fall, it goes more yellow, sometimes even a little bluer the closer it gets to winter. Farther north, the light is much bluer all year round, albeit different shades of blue.

The season, climate, or locale where you have your wedding can have a significant effect on the color of your dress. Sometimes a bride will purchase a gown in the fall, loving the way it looks. But she won't consider that her wedding is in the summer, when her skin tone changes and her hair color is a bit lighter. All of a sudden, the color of the dress looks different in the summer light. Try to shop for your gown—or at least decide on the color—during the season when your wedding will be.

I love this bride's quiet repose. She is just waiting for the next wave of where to go and who to meet. Her dress looks like folds of cake frosting—good enough to eat!

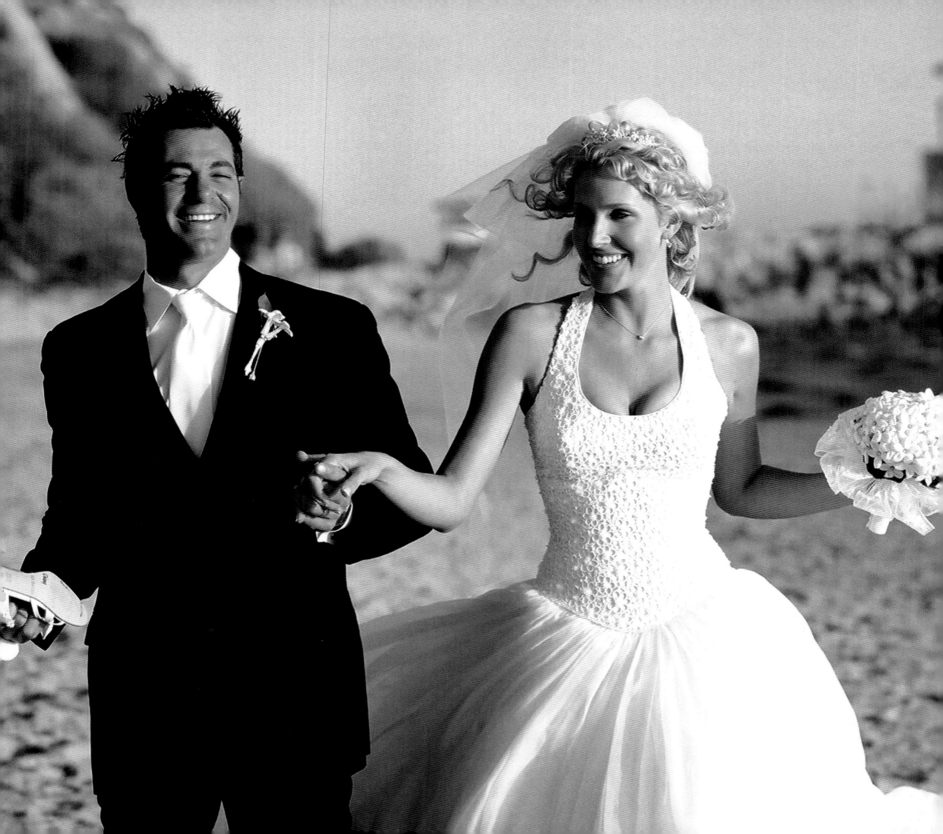

So Many Choices, So Little Time!

I cringe when a woman says of the dress she chose, "It was the first dress I tried on." Why? You really can't imagine what options you have available to you if you try on only one gown. Shop around. Finding the nuances in each cut may surprise you and even inspire you! If you go back and do choose the first dress you tried on, well then, great! But at least you have given yourself the opportunity to see what different designs and shapes can do to help you cultivate the look you're aspiring to achieve. You don't need to have a compromised shopping experience just because you figure, "Why try? I can't afford that." All shops have specials and sales. Try!

Seek Professionals' Help

If you can, work with someone experienced at choosing wedding dresses—a stylist, designer, seamstress, or coordinator. They'll steer you in the right direction, to the people who can help you seek and find the most flattering gown for you. Find ways to describe what you want—perhaps a dress you liked in a movie, a photograph, or a magazine. Don't be afraid to combine designs, such as the top of one dress and the bottom of another.

You may be one of the fortunate ones who finds an experienced bridal salon consultant in a bridal boutique, with a broad and knowledgeable background to help you with fit, style, and selection. This is a fantastic opportunity. You'll be given the chance to try on and consider so much more than if you shopped alone. Go online or make some phone calls before you shop, and see if you can find a bridal salon that offers just such expertise. Ask your wedding coordinator or get referrals from other brides; they are great resources to find the help you seek. Be grateful, and befriend the person or people who are helping you to discover your dream dress. Be courteous and be nice, because no one sets out to become a bridezilla . . . does she?

Designers Are Magicians

They are state-of-the-art body architects. Believe me, they can blow your mind with what they can do! Often you can't even imagine how your body can shape-shift when a simple cut here or a tuck there to a garment creates a unique and beautiful style that is just right for you. The ideas you may walk away with can inspire you and affect the decisions you will make as you move ahead with other details.

Pace Yourself

Maybe shop once a week over several weeks. Take pictures, if the salons let you. Put them side by side. Compare them, and see the dresses within the context of the whole idea of your wedding. Then go online and narrow your choices. You'll be fully prepared when you walk into the store, knowing exactly what you want. Decisions, decisions, decisions.

This couple, though they are dressed to the nines, exude a sense of casual comfort with the way they move and play on the beach. Here the bride is wearing a gown with a halter neckline, held securely in place so as not to restrict movement. Your gown choice should reflect your lifestyle and the essence of who you are.

Are Your Eyes Bigger than Your Budget?

If you have financial constraints, then get creative. Find the shortest distance to your dream dress! Buy a vintage gown for a reasonable price, and rework it with a seamstress who knows her stuff. Have her make something affordable with design elements you love. Sometimes designer dresses are even available in a pattern. Consider this not only for you, but for your bridal attendants as well.

THINK BEFORE YOU BUY!

One more thing: Don't feel pressured to buy or make a quick decision because a salesperson has spent a lot of time helping you. Take the salesperson's card, and remember to make the purchase from her if you should ultimately choose a gown from her store. Be sure to have your support people with you for backup, and don't be rash! Leave the store and come back after due consideration. This, in many instances, will be one of the largest purchases you will make out of your wedding budget. Be thoughtful and consider more than your emotional response. Be reasonable and realistic.

There will be gowns you try on that blow your mind—count on it! But they may also blow your budget, too! Don't make a rash decision on the purchase of an expensive gown before you've considered everything else on the priority list.

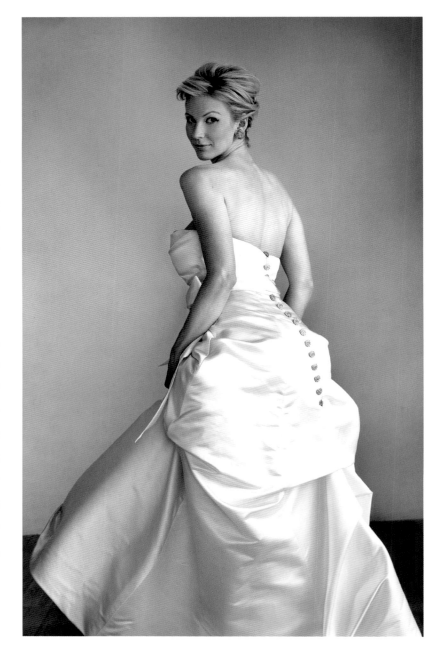

YOU ARE WHO YOU THINK YOU ARE!

Remember who you are. Try not to reach so far from your comfort zone as to feel self-conscious or like an impostor in your gown. Hold true to the "you" your fiancé knows and loves. Keep in mind the things he loves about you and remember what you like about yourself, and use those guidelines for deciding. All of your choices for the way you'll look on your wedding day should be authentic.

With or Without—Straps, That Is

A strapless design is very simple and classic. It can be a good choice when you want to get more elaborate with your hair and makeup, because no matter how elaborate the detail on the gown, the general shape and line is the same. With a strapless gown, your shoulders, arms, neck, and waist are highlighted. If you are very full-breasted, or over fifty years of age, strapless can be a difficult choice. Please, please do consider all of the angles when choosing a strapless or any gown! If you are fit and feel confident about your back, neck (preferably a long neck with a broad back, as you need a strong frame to carry this dress—and no excess skin!), arms (they must be firm!), and waist (a small one makes for a nice line; a corset is a good idea), then go for it.

Viva la Difference

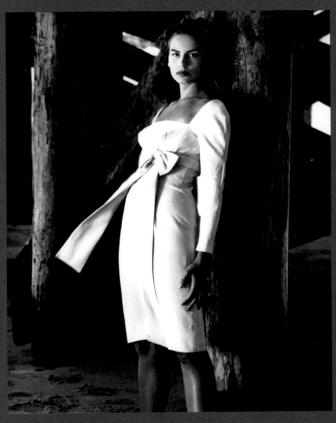

*Choosing a vintage style or using unique accents
from a specific era can say a lot about who you are.
Now is your opportunity for self-expression; be thoughtful in this pursuit.*

Let me say this right up front: Accept before you start looking that the most popular designs might not be the most flattering for your body. There are so many lovely designs for different body shapes and shoulders, neck, torso, back, and waist. Look in European magazines and other resources for inspiration and "new" ideas. Vintage images are so fun to pull from because they are near-forgotten designs.

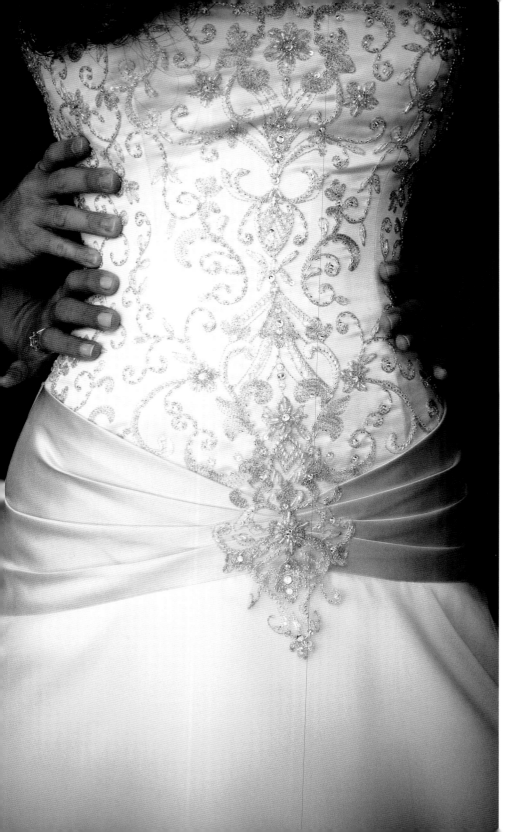

Remember, though, that a strapless dress, no matter what your body shape, can be a constant challenge to keep up. Even the best dress designers can't assure you that the fit will be exact, especially if a bride's weight fluctuates over the course of wedding planning (which it almost always does!). We once did a wedding with a gal whose designer had a great idea. She created attachable, very delicate straps for the gown for the latter part of the evening, during dancing, cake cutting, and the garter and bouquet toss. When the bride really got moving, the dress stayed securely in place! Another bride had a beautiful bustier made from the same material as the gown, more as an accent to the gown than just an undergarment. It was great because even if the dress slipped a little, the bustier seemed like part of the gown. Or better still, have the corset built into the dress (although designers tell me this is very expensive). No pulling on the dress or potential for a "wardrobe malfunction." These are all things to consider about a strapless gown. With whatever design, neckline, or length of gown you ultimately choose, give yourself guidelines and elements to consider for wearability. Every gown will have unique elements that you will want to consider before making your final choice.

Designers are state-of-the-art body architects. My advice is to try on as many gowns as you can, so you too can experience what great design can do for your body.

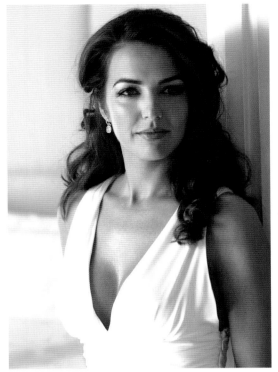

Each woman here is wearing a neckline, shape, and cut of gown that compliments her individual body shape. Notice how the nuances in fabric and details evoke different styles and genres.

Necklines

- **Strapless:** Best on brides with well-toned arms and shoulders. Height helps to carry this style.

- **Cap sleeve:** A little scoop neck and sleeves that just cap each shoulder. Best on very delicate and small-boned, small-breasted women.

- **Sweetheart:** Gets its name for the way it arches over each breast. It's great for a woman with large breasts, since the shape helps to create

support or control exposure. Nice on a figure with a beautiful collarbone and lovely chest. Elegant and feminine.

- **High "V":** Can conceal large breasts in a feminine way. A plunging "V" or wide-set "V" can create the illusion of a fuller breast. Any sleeve length will work with this design.

- **Plunging:** A little daring. You must be very body conscious and confident to wear this. Excellent for small-breasted, toned, dancer-body types. The V-neck creates length in the torso and an

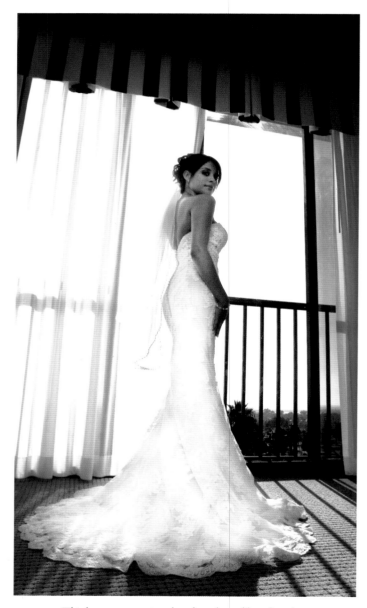

This lace gown carries a lot of weight and length with it, which creates an incredible silhouette to this bride's body.

illusion of height, so if you're little, this is a nice way to lengthen your look.

- **Square:** Has a straight, horizontal bodice. The straps can be sleeveless or flow into any length of sleeve. Very elegant, crisp, clean line.

- **Draped:** Many variations on a theme, any kind of fabric draping and gathering. Very romantic and has a vintage feel. Pretty on petite, small-chested, or tall, lean figures.

- **High collar:** Nice for a long neck and broad shoulders. There are many variations, including one that creates an illusion with sheer or lace overlays over a strapless bodice; it still covers your upper body but allows your sexy side to shine through. Really nice on any figure. Can be a good way to soften very large breasts.

- **Scoop:** Simple, clean, semicircular neckline. Nice on full-figured or large-breasted women.

- **Bateau:** Or a boat neck, it connects at the edges of the shoulders, leaving a long neckline that runs from shoulder to shoulder along the collarbone. Best for small-chested women. Any length of sleeve will work with this neckline.

- **Halter:** Sweeps across the chest and rests below the shoulders. For well-toned upper arms, as it draws attention to your neck and shoulders. Can be a sexier choice, but is also a little youthful.

- **Off the shoulder:** Wraps around your upper arms just below the shoulder. Good for full-chested, full-armed, and pear-shaped women. This look is very elegant.

- **Portrait:** Wide, soft scoop from the tip of one shoulder to the tip of the other. Nice for fuller arms and strong collarbones.

Material Considerations

The material of the gown is another thing to keep in mind in terms of how much shape and contour of your figure you want to show.

- **Clinging materials:** Silk, nylon, satin, crepe

- **Materials with body and texture:** Lace, brocade, taffeta, double-faced silk, silk duchess, silk dupioni, pin-tuck, French satin, charmeuse, silk shantung

- **Ethereal materials:** Chiffon, silk, velvet, sparkle organza

These gowns, each made with different material, move differently, drape differently, and will shape your body in a very specific way.

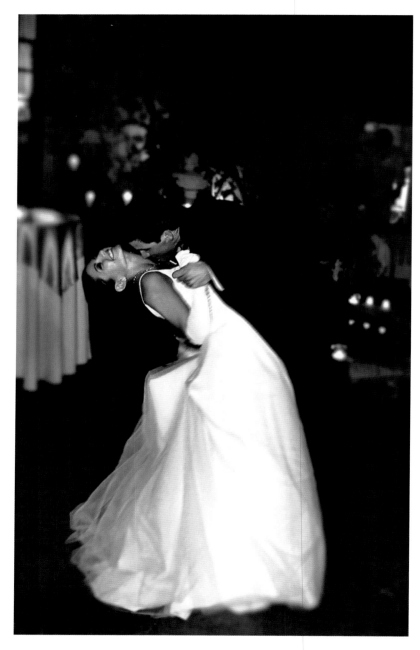

Pay attention to the nuances in a gown—length, width, and drape, for instance—and choose one that "fit" your personality. Add distinctive accessories (like gloves) that keep a thread of continuity throughout your entire wedding look.

Bridal Gown Lengths

- **Knee-length:** A traditional length for bridal attendants. The skirt drops just below the knee.

- **Intermission:** This length falls anywhere between the knee and the ankle. A lot of sixties-inspired suits have this hemline. It is a very nice, classic choice for a civil service.

- **High-low:** This gown has an intermission hem on the front and a floor-length (or longer) hem in the back, for a tiered effect. Very nice design to show off a little leg and lovely shoes.

- **Tea-length:** The gown falls just to at the shin line. Conservative and elegant.

- **Ballerina:** Has a full skirt (full tutu design) that drops to just above the ankles. Very delicate and feminine. Sets the stage for showcasing beautiful shoes with ankle detail.

- **Ankle-length:** The ankle-length gown is hemmed right at the ankles and can be either full or form-fitting. Nice length for showing off a pretty shoe.

- **Floor-length:** The hem on this gown just barely touches the floor on all sides. Adds a gliding, graceful element.

- **Miniskirt:** Nice for someone who has lovely legs and is confident and comfortable with being a little sexy. Good choice for a tropical, island, or destination wedding ceremony.

Seven Things to Consider When Buying a Gown

1. Fit—all around: When you have the dress on, lift your arms and reach. Watch how it lays when your arms fall back to your sides. Often a very structured dress can pull away from your body, giving a little peek without meaning to! Bend over and even crouch as you would in a photo with a small child. You will be hugging all day and into the evening, so choose a gown that is to some degree touchable and not so delicate as to prevent the love! You want it to fit like a glove but still be comfortable. Can you breathe, for real? When the nerves kick in, it's easy to feel faint. A too-tight dress will only make that sensation worse.

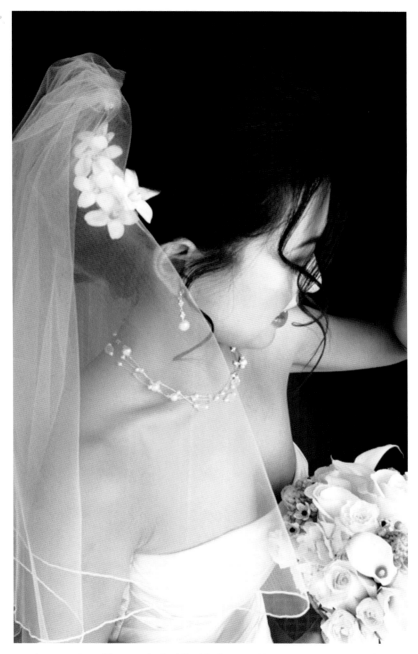

Jewelry is another addition to the final "look" of your wedding attire. Again, stay in the same style, genre, or design that will complement your gown. Don't "mix your metaphors." In this case, the delicate necklace is in keeping with the simple veil and romantic hairstyle.

2. Length: Can you handle all the material of a heavy, full-length gown? Will you get tired of carrying it around? When you're carrying a bouquet, wearing a new pair of heels, trying to look through a veil, and stressing over your wedding vows, the whole experience can be exhausting, hot, and even a bit claustrophobic.

3. Design: Choose a dress that complements your whole idea of the wedding. Don't get swept up in the shopping frenzy; take a moment before purchasing your gown and make sure that it will fit into the overall theme of the day. Once you think you have found "the dress," step away. Get a cup of coffee and go over your details with your mom or trusted friends so that you are certain you are making the right decision. Consider genre, color scheme, hairstyle, makeup choices, shoes, flowers, season, climate, location, and formality. Keep the connection between all these decisions crystal clear in your mind. Some gowns are nonrefundable, and buyer's remorse is something you want to avoid.

4. Genre/Style: It's important to have a cohesive look to your whole wedding. That said, as I mentioned before, if you pick your gown before choosing your whole concept of colors and genre, you just might put yourself in a difficult situation. The dress sets a strong visual theme, and you want that to be a common thread throughout the entire event.

5. Wearability: This is key to a good day! Please don't forget to wear and move around in your gown before the big day. It's really important to be able to sit, walk, dance, and breeeeeathe. As with your shoes, it's important to wear your gown around the house to make sure you feel good and comfortable. You don't want to be self-conscious about what your dress may or may not be doing or have discomfort affect your memories of your wedding day. Comfort and beauty can go hand-in-hand, so strive to that end. Or be uncomfortable for the actual ceremony and pictures but plan to change into a more comfortable party dress for the reception. (Hey, if you've got the funds, it's a great opportunity to shine in two amazing gowns!)

6. Pace yourself: Whether you're shopping for your gown or having menu and cake tastings, design meetings, or makeup consultations, don't try to do too much in a short span of time. Try not to make hasty decisions just so you can check things off your list. Give yourself plenty of time before the big day so you can make good, sound decisions.

7. Enjoy the whole process: Keep it fun. Don't allow the scope and pressure of the event to overshadow what this is really all about—celebration of your love for each other. Let your fiancé partner with you in these decisions so you share the responsibilities. Check in with each other; consider his needs, too, and be sure that you are both on the same page. Purchasing a dress typically uses a large portion of the budget. You and your fiancé need to be clear on the numbers and the whole idea so that you both are able to have your dreams and desires included in the day. You want to still like each other when you finally get to say "I do."

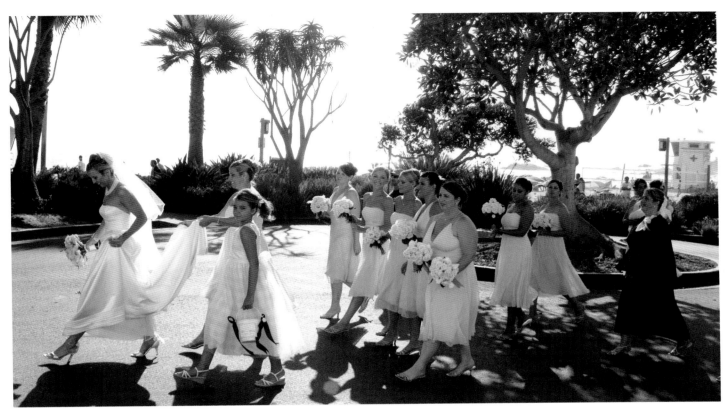

This is a wonderful example of a large wedding party with attendants who range in age and shape.
They've been allowed to choose the neckline that compliments their silhouettes.

Bridesmaids' Dresses

When choosing bridesmaid dresses to complement your gown style and color choices, please do be kind. Designers really have come a long way in bridesmaid fashions. You will have no problem finding options and designs the fit all body shapes and sizes (even for pregnancy). I think it's wonderful and interesting when the bride chooses a specific design and color palette and then allows each bridesmaid to choose the neckline and length of dress that fits her body best. That goes for the shoes, too. It really can help to make your attendants feel as though they are individuals in your wedding, friends you value for who they are. They are so much more excited to be in photographs and probably will be more helpful to you and share in the joy of the day more when they get to look and feel pretty, too!

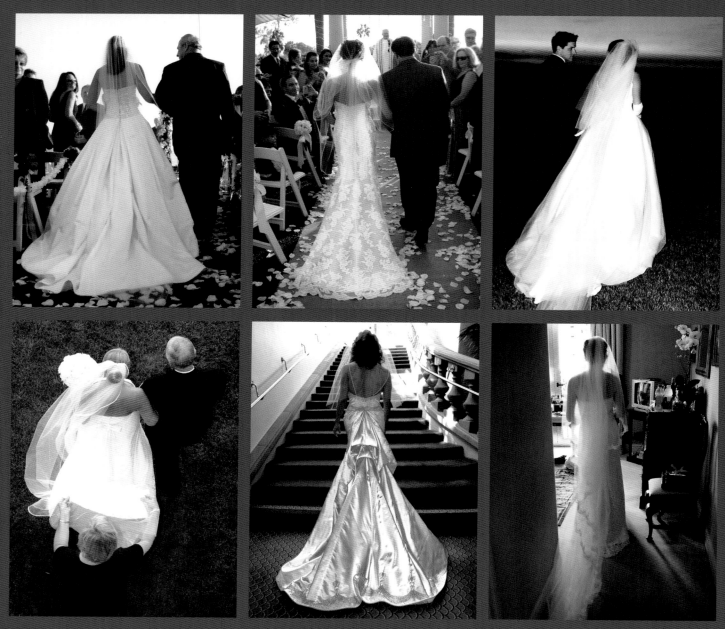

Here are examples of six different train and veil options on brides. They all evoke different genres and styles. You will be seen "from every angle" throughout your wedding day; why not include some wonderful detail or unique character to your train or veil that will set your gown apart?

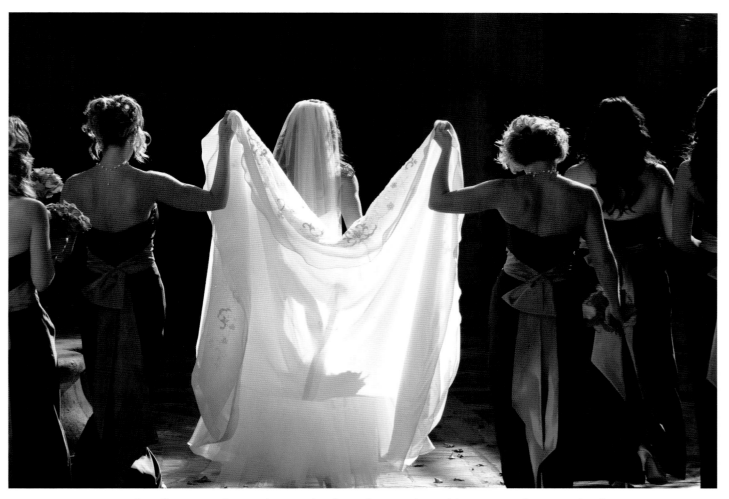

It can take a village to get you from one place to another when you have a very long or elaborate train. Do let your attendants know that you will need them to help you wrangle your train throughout the day. But once your gown is bustled, you are on your own!

Trains

If you have a train, will you have a wrangler there to assist you, or will you try to manage on your own? Will you have a removable train, or bustle up for the dancing and festivities?

- **Sweep:** One of the shortest train, barely touches the floor.

- **Court:** A train that reaches one foot beyond floor length.

- **Chapel:** This train flows from three to four feet behind the gown.

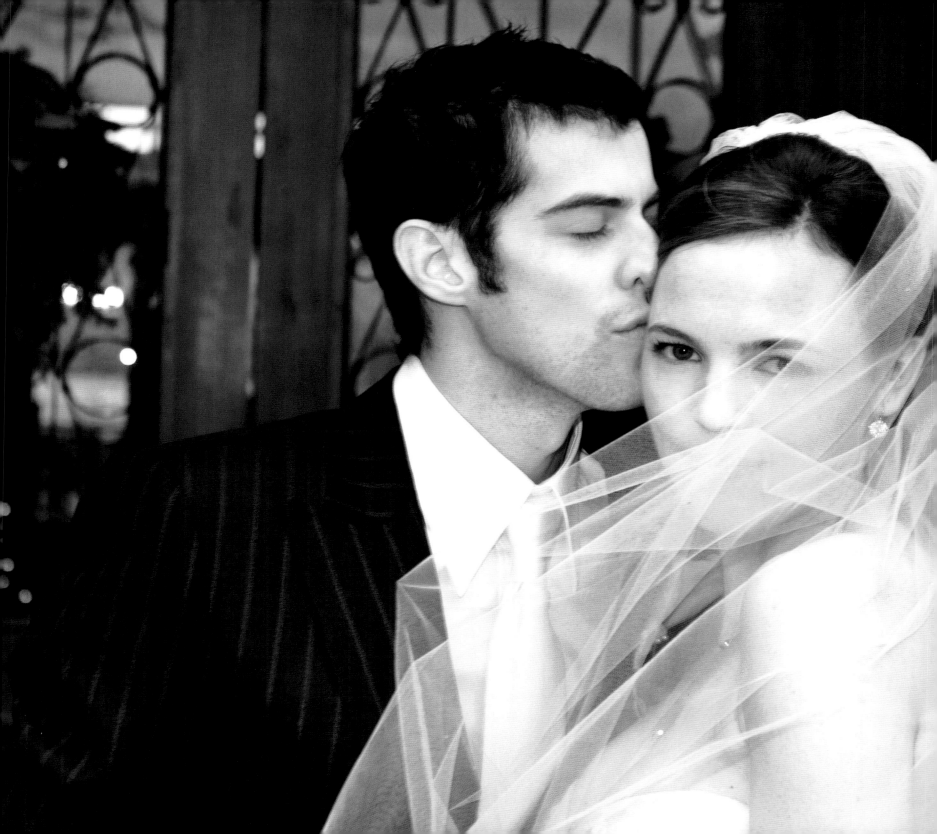

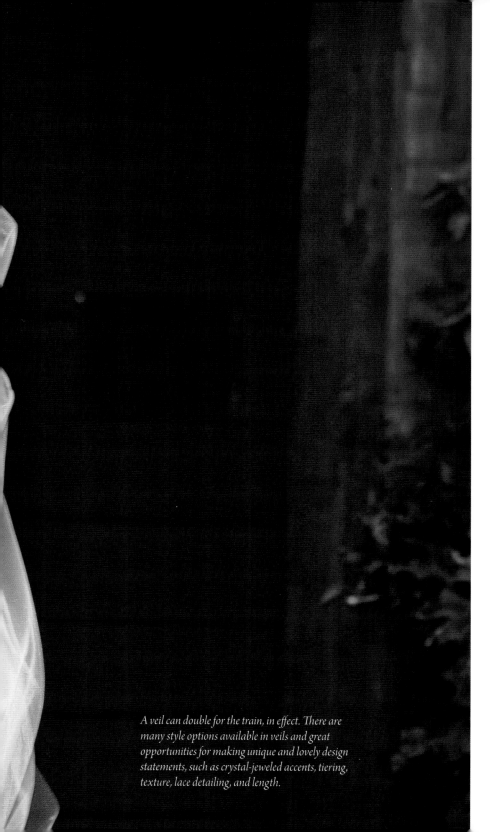

- **Extended or royal:** A train that is longer than four feet long.

- **Watteau:** A train falling from the shoulders to the hem of the gown.

- **Cathedral:** A long train extending six to eight feet behind the gown.

The train can also be a consideration when deciding on your wedding shoes. Are you a heel girl, or would you rather wear flats? Will you tower over your groom if you have a very full, long gown that's in need of stilettos? How might he feel about that? Can you dance in stilettos? Do you want to have a unique cut to your gown that may show more leg (Spanish style?), which might also influence your choice of shoes?

The obvious choices—wedding gown, shoes, rings—are things you probably already have anticipated. But it's the subtle nuances, the artful details, that help to make your wedding unique and personal to you and your fiancé. Imprint your own style and taste. With these insights to help guide you, you can feel confident in your approach to beauty and to planning one of the most important and memorable days of your life.

A veil can double for the train, in effect. There are many style options available in veils and great opportunities for making unique and lovely design statements, such as crystal-jeweled accents, tiering, texture, lace detailing, and length.

*We chose Kelly for our cover because
she exudes her individual sense of style.
She radiates the kind of beauty we all
hope for on our wedding day.*

WEDDING
Makeup

It has taken me some years working as a wardrobe stylist and makeup artist for many different kinds of photography and for different mediums—portrait photography, fashion, commercial, editorial, sports, special event, weddings, video, and film—to understand that no matter what the medium or the event, all of the choices you

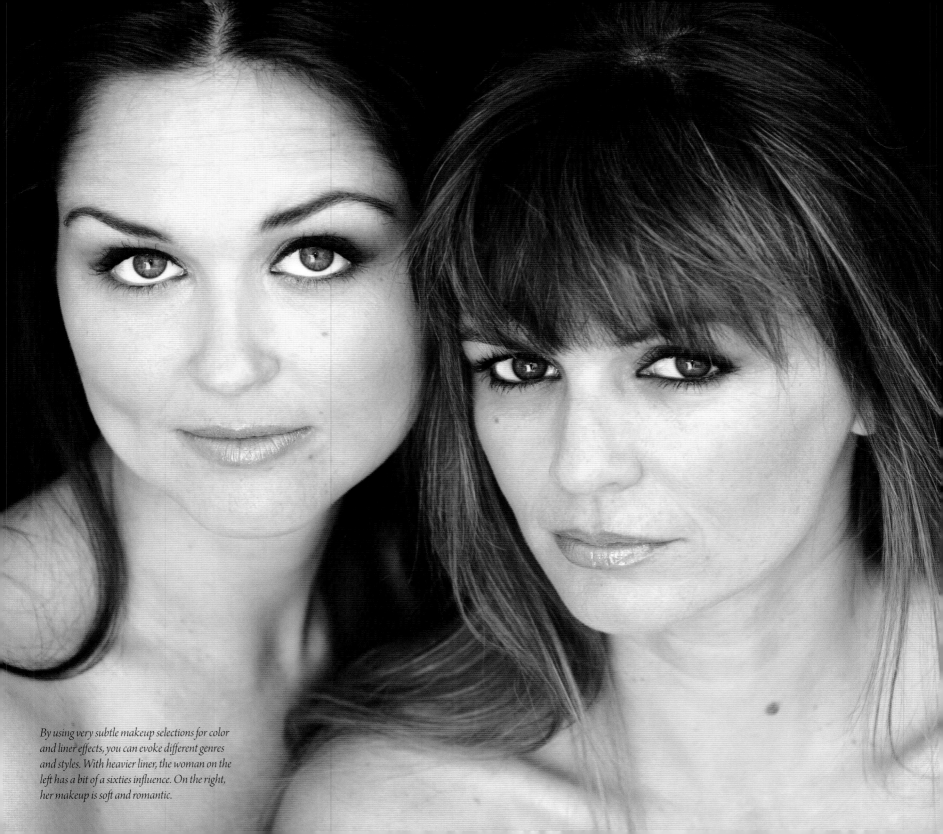

By using very subtle makeup selections for color and liner effects, you can evoke different genres and styles. With heavier liner, the woman on the left has a bit of a sixties influence. On the right, her makeup is soft and romantic.

*I'm a big fan of vintage makeup—clean, feminine, and delicate.
It has a dreamy, finished quality.*

make in the pre-planning stages inform the final outcome of the look. So many things can help to guide you in your ultimate choices. My goal is to encourage you to work from the concept of the "whole idea," especially in visualizing your wedding day. Try to see the whole scope or feeling that you're trying to set forth first, then move forward and begin choosing, purchasing, or working with what you already have in your own wardrobe, makeup, and hair products to bring it to light. These choices will help you to define your look.

Here are some style distinctions or "whole ideas" that fall into different categories: polished and professional, warm and approachable, holiday and special-event glamorous, everyday casual. In this chapter, I want to help you understand how makeup can have a big hand in helping you create these different styles.

Using makeup to create style is not rocket science, but it can be overwhelming at times. It becomes so much easier when you understand how making the right choices in the beginning, by choosing a look, can help bring together a cohesive feel and style. It's important to know who you are and what "whole idea" you're trying to project. Makeup is an amazing art, but you don't have to be an artist to understand the general concepts behind choosing products that are best for you and how to apply makeup well.

*Even when you want a natural, clean look, well-groomed eyebrows
bring symmetry to your face.*

*Eyebrows can bring it all together in the end.
Like lipstick, it's one of the final touches that helps to create a finished look.*

Choosing which shade of light or dark is where it can get a little tricky. But the principle remains the same with concealers, powders, and blush.

EYEBROWS

Eyebrows bring balance to your face. In my opinion, you should never alter or dramatically reduce away the length at the beginning or end of your brow. This is one of the most common mistakes people make. Shaping your brows can result in a dramatic change in the way your face looks—it's a

The Inside Skinny

Here are some a few basic principles and artistic insights that everyone should know:

- Darken places you want to sink, disappear, or drop back.

- Lighten what you want to bring forward, enhance, or highlight.

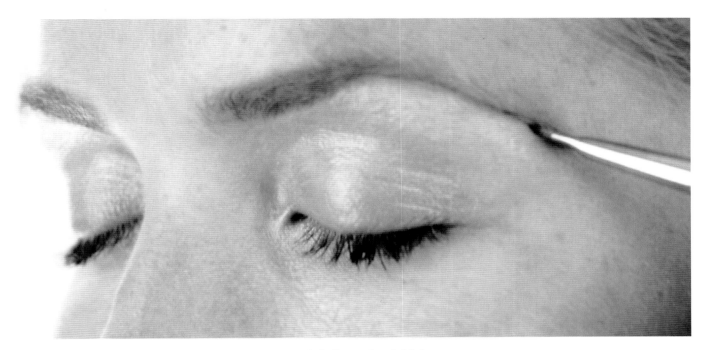

A common issue is lack of hair at the end of the brow.
With a little powder, pencil, brow definer, or gel and the proper technique you can build a brow where there never was one!

delicate balance. Some women don't have a full brow or have very little or no hair at the end of their brows to begin with, and need guidance in how to add length and color to their existing brow shape. Adding cream powder or pencil takes a delicate hand and a clear concept of shaping. It's not difficult; it just takes technique to help you learn how to define your brows. More and more makeup companies are incorporating brow specialists into their lines, which will make it easier for you to find the right makeup line and techniques that work best for you. Anastasia's line of brow waxing, threading, and stencils (so cool and easy!) are an excellent option (available at Nordstrom and other retail stores). Most of us can identify with a particular actor, model, or singer we feel we "look like" or aspire to emulate; that's a good place to start. It's another way to help you narrow down and define the style choices for the look you want.

Just make sure the brow specialist clearly understands what you're striving for. Bring a tear sheet from a magazine of the brows you like, to give the specialist something to go by, and make it clear what you don't like. Find a face in a magazine with a similar shape to yours and see how the eyebrows have been shaped. This is subjective and can be dictated by what's in style this year. Styles that have been popular include the young Brooke Shields' brows (full and natural) and Sharon Stone's brows (a classic brow shape— long, clean, arched, and defined). Ask the brow specialist to show you how to maintain the general shape for the period between visits.

It is so important to make sure that your skin is moisturized. Many young women feel that if they put something too rich on their faces it will make them break out or look shiny. You must find a balance between a matte, powdered face and a fresh, moisture-rich face. Most makeup lines make oil-free foundations, oil-free tinted moisturizers, lightweight translucent powder products, and camouflage concealers that won't cause acne. Some lines (such as Bobbi Brown's blemish stick) even make products to specifically treat skin issues—these are brilliant! Primers will sometimes give your skin a moisturized glow as well. They, too, have oil-free options but still enhance the texture of your skin. We all want that youthful glow, and now it's possible to achieve at any age!

Older women should categorically stay away from thick cream and powdery products. They do not enhance the skin, but simply stay in the creases of your face and create a tired, more weathered texture.

Find a product and technique that makes your face glow. Even if blemishes, rosacea, or scarring is an issue, there is a way! Laura Mercier makes a camouflage brush that applies her Secret Camouflage face concealer, which diminishes the bumps and discolored areas of the skin. You use it with her primer, which contains botanicals that help to cut ruddiness and has a luminous quality that is lovely in photographs. But not shine—that's a photographer's

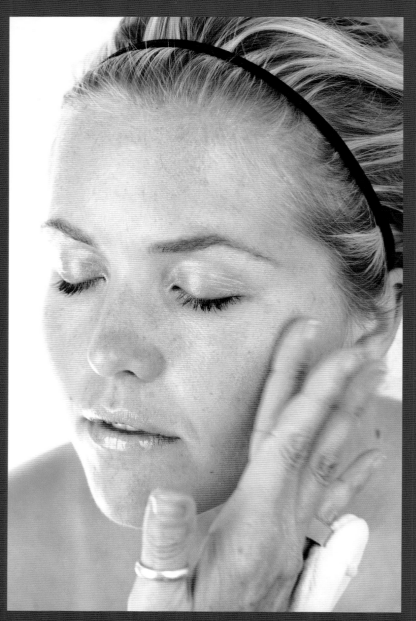

The right products with proper layering can create a flawless, dewy, moisture-rich quality to the skin.

Laura Mercier also carries a few pink-based foundations that do amazing things to the skin. They actually cover red blotching and even out any irregular color by adding a soft pink hue. The results are amazing! With tinted moisturizers or lightweight foundations, you, too, can have a flawless face.

Moisturizer is a very important part of sustaining a hydrated quality to your skin. Again, this is unique to you and your needs. Try to find a line that meets your skin type and is best for you. Oil-free options abound, but do they hydrate enough? Only you can discern the answer to that. Trial and error is one approach. My advice is to first zero in on the type of skin you have: oily, dry, normal, or combination. This is key to helping you find the best product for meeting your skin care needs.

A good way to start looking for a quality moisturizer is by starting with dermatologist-recommended products. Especially when you have very specific concerns; rosacea, acne, or extremely sensitive skin: Dr. Perricone MD, StriVectin, Kinerase, Dr. Brandt MD, Skinceuticals, and Obagi are all great examples. These are just a few of the "big guns" in skin care, and can be found in beauty supply and department stores. When your skin needs are less of a concern, good moisturizers such as Neutrogena, Cetaphil, Oil of Olay, and Aveeno are a good choice and easy to find at any drug store. Of course, the most popular makeup lines now carry excellent options for moisturizers, too: Lancôme, Philosophy, Laura Mercier, Kiehl's, Estée Lauder, Clarins, and La Mer. Depending on your needs and price point, you'll have a lot to choose from! Visit a dermatologist or an esthetician to find more answers about the best skin care products for you.

When choosing moisturizers, here are a few things you might want to keep in mind:

Sunscreen is very important, but you can use a separate sunscreen from your moisturizer. I find that when a moisturizer has sunblock in it, it can change the texture of the product, and it does not absorb as well into my skin. Besides, who needs sunblock at night?

Avoid wearing moisturizer with fragrance in it for daytime. Even if your moisturizer has sunblock in it, it may still have fragrance. Fragrance, especially in products that contain fruit acids, can cause freckling and spotting on some skin types when exposed to the sun. This goes for perfumes, too; apply your scent to areas that are hidden by your hair or clothing. Your chest is extremely vulnerable to spotting! Most products with exfoliating properties have some kind of fruit or other acids in them. These are excellent products, but my advice is to use them only at night, or when you will not be getting sun exposure. Be sure to cleanse your face thoroughly in the morning and apply a fragrance-free, acid-free moisturizer and a good sunblock for the day.

 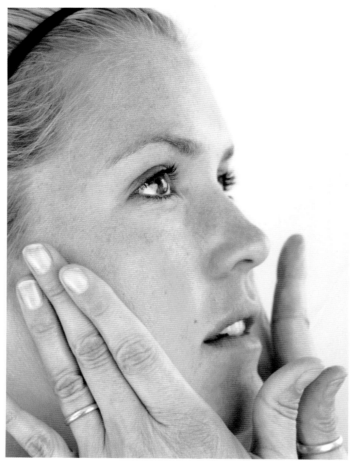

Applied over your moisturizer, primer locks in moisture, leaving a luminous quality to the skin.
Primer protects your skin, becoming a barrier, blocking your skin from absorbing too much product.

Here are my tips on how to choose the best products for you, and additional advice on the best makeup options to use on your wedding day and in life. Wedding pictures will last a lifetime, so let's make them flawless and beautiful!

Primer

I suggest finding a good foundation primer to bring a little more moisture into the skin and to help create an even, smooth coverage under your foundation, concealer, and camouflage product. I am a huge proponent of primer with liquid or powder foundations. It aids in evening out foundation and adds emollient that helps to create a smooth finish, locks in moisturizer, helps to protect your skin from absorbing the product and powders, and locks the products in place for a much longer-lasting, finished look.

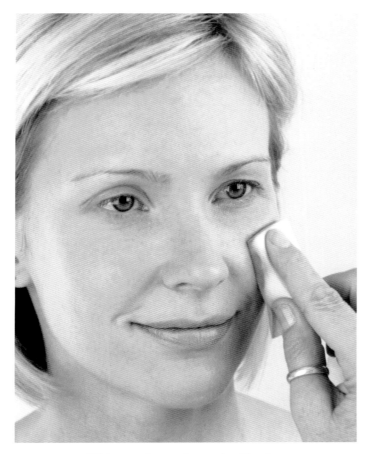

Fill the pores of your makeup wedge with water,
squeeze out the excess, and use to apply foundation to skin

Less is more when applying foundation . Spot ruddy or blotchy areas
and use concealer or camouflage makeup for the heavier, direct coverage.

FOUNDATION

If you apply foundation properly, you can give a beautiful texture to your skin and save money, too! When you apply liquid foundation with your fingers, you end up using much more of the product and, unless it's a tinted moisturizer, you run the risk of a very uneven application. Instead, always use a moist makeup wedge to apply liquid foundations. When you wet the sponge, its pores fill with water to prevent it from absorbing too much product. Squeeze out the excess water and dab the sponge in foundation; then, when you apply it to the skin, that bit of moisture on top of the primer helps the foundation spread and settle lightly and evenly. Less is more to start, and you can always "spot-add" the product to a specific area. Don't coat the whole face all at once; just soften and blend the blotchy, red, or discolored areas, then touch up the already even tones as you move along. Always include your neck in the blending process—nothing will give your makeup naïveté away

faster than forgetting the neck! If you will be wearing something strapless, with your neck, chest, and shoulders bare, spot-use the foundation from your face or a bit warmer foundation or warming powders to bring the color all the way down to your shoulders and chest (watch out for your gown!). Most people have more color on their shoulders and chest than they do on their faces, so balance the color accordingly. If your choice is to use only powder foundations or mineral powders (mineral is all the rage right now!), application is very important, too. Each product comes with its own application sponge, puff, or brush. Try to seek direction for proper application technique from an artist at the counter or a knowledgeable salesperson. There are so many different weights and textures to choose from, and the techniques for application are unique to each product. This same process holds true when applying bronzing gels and bronzing foundations. (Not the tanning body products that turn the skin brown, but the already tinted and bottled bronzing colors.) Use a light hand to build up the product slowly and evenly, and blend, blend, blend!

Concealers and Camouflage Makeup

Once you have moisturized, primed, and spot-added your foundation, you will use a concealer that is moist and gives an even coverage to conceal any blue or gray circles under or around your eyes. For heavier coverage on the areas of your skin that have scarring, discolor-ation, or blotching, Laura Mercier makes an amazing product I use on all my brides called Secret Camouflage. A bit drier in texture than concealer, it is meant for areas of the skin where you'd like to hold product in place and offers stronger coverage than a light, moist concealer that may travel more easily. It is available in a two-shade compact in six different combinations. You can choose from two shades in your color palette—one light, one darker—to create the exact tone of color you desire. Using the pointed concealer brush, you jiggle the tip of your brush with product into the texture of your skin (the pointed brush is key here) over the discolored area with Secret Camouflage and pat it into the skin with your fingertip, depositing the product flawlessly into the foundation and primer for perfect, even coverage, color, and texture. It can be used around the nose, along the chin line, and in any area that may need additional coverage, including the chest. Finish with a translucent light powder to set the product.

Mascara

For photography, I've learned that many brands of mascara dry as soft black or gray, and it's important to find a mascara that dries black and stays rich. The rich black saturation helps in photographs to make your eyes more defined, and in contrast to the subtle tones of blush and shadows, it is very beautiful and more dra-

Laura Mercier's "Secret Camouflage" makeup is revolutionary, creating a flawless look no matter what issues you may have—scarring, rosacea, blemishes, or hyper-pigmentation. Comes in oil free, too, Amazing!

If you are already blessed with beautiful, long, thick lashes then you've got a head start! For those who don't, there is now a serum that may help your lashes grow. I have found that organic New Chapter vitamins do amazing things for your hair and lashes. Try it!

matic than soft gray/black mascara. Maybelline Great Lash mascara (pink wand with a green lid) has been a stylist staple for years for this very reason. However, there are many options available now. One of my favorites is L'Oreal Double Extended Waterproof Mascara (pale blue and white packaging). This brand is nice because it gives you a clean yet full, rich black look. With one end you apply a white lengthening product and with the other, the mascara. It creates excellent lengthening, especially when you blink against both products to completely coat and build the lash. Dozens of brides have purchased this brand after our makeup run-through prior to the big day so they could use it for the rehearsal dinner and all of the pre-wedding events. Waterproof is key, too, for the bridal party, moms, and others. Lots of tears can be shed during a wedding!

EYELASH CURLER

It's back (it never really left) and it's brilliant! An eyelash curler will dramatically enhance your eyes. In the eighties, we pinched them once in the middle for a doll-eyed look. No more. Try pinching at the very base, the middle, and then the tip to give a gradual swoop, not a startled look. Don't be afraid to curl after you've applied mascara—often lashes curl better, especially with waterproof mascara. (Something in it makes them hold.)

Lengthening products, such as L'Oreal's Double Extended Mascara, are wonderful to build your lashes to their fullest. You want a mascara that dries rich black, not grey, especially for photography. An eyelash curler is a fabulous tool. It creates drama and opens the eyes up. Waterproof mascara helps your lashes stay curled!

If you've had individual false lashes put on, feel free to curl once more after mascara—it's tougher, though, when you have a full set of lashes applied. Make sure the curler is clean and free of mascara, which will help your lashes to release more smoothly from the curler. Always keep a lash comb handy to separate and soften if needed.

Different lines carry different shapes of curlers. For instance, Shiseido makes an eyelash curler suitable for an almond-shaped eye. They even make eyelash curlers now that are heated! There is a half curler, too, which you use for the outer edges of your eye for the "cat eye"/exotic look. Everyone has a unique eye shape, so test a few products to find your comfort zone.

EYELINER

I recommend Laura Mercier's "tight line" technique cake liner. Use it wet with a flat liner brush. It dries in seconds and stays on all day! Place it with a flat-tipped

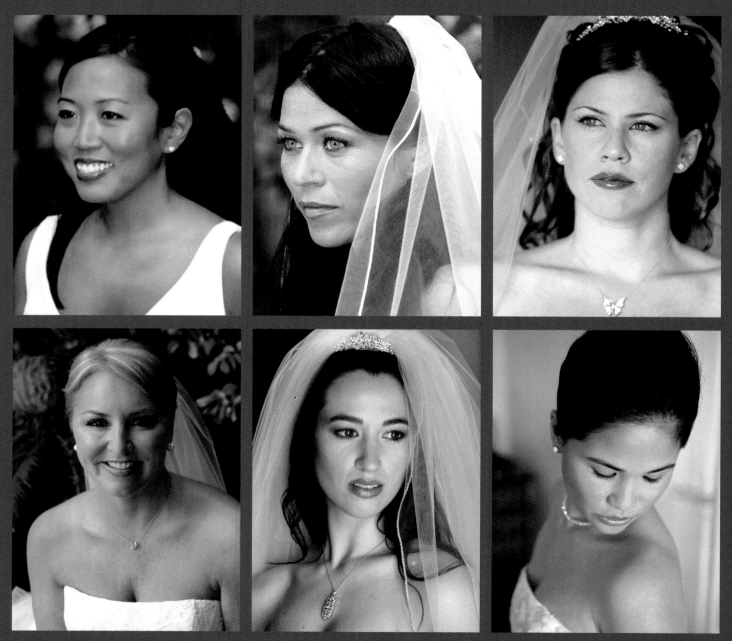

Here are six examples of different styles of make-up, each complementing the "whole idea" of the wedding look.

Top row, left to right: Fresh, clean and finished. Elegant and dramatic. Glamour, starlit.

Bottom row, left to right: Elegant and sophisticated. Romantic and youthful. Soft and delicate.

brush underneath the upper lash line, in between the lashes; fill in and jiggle as you move it across your upper lash line. This technique gives the illusion of fuller, thicker lashes. You can also use it on the lower lash line for a very dramatic look. Line the inside of your lower lash line with the wet liner, then press plum, gray, or brown shadow into the wet liner before it dries for a softer, smoky look. You can use this wet liner product as you might use a pencil. Inside the lower lash line, along the upper lash line, smudged at the corners—anywhere you might like to add a little drama! It also comes in mahogany brown, navy (dries blue-black), and other colors. Black liner with brown, blue, plum, or gray—all of these shades have different undertones (contrast and compare and you'll clearly see the difference) and can give plenty of options to the drama you are trying to create. Smudged is amazing, too!

POWDER BLUSH VERSUS CREAM BLUSH

This is a tough one. I have to say that the season dictates the choice I make. Cream blush gives a very fresh, clean look that I think is very becoming in the spring and summer months. It's especially beautiful on fair skin—like watercolor. In the winter months I tend to reach for stronger, warmer hues that can give more saturated color and increase the ability to shadow, to make up for the lack of natural color you get in the warmer

months. Even if you wear sunblock, your hair and skin tones change over the seasons, and this creates a different canvas for the colors you will choose.

LIP COLOR

Lipstick or lip pencil? Both! I am a fan of using the combination of pencil and cream lipstick. I'll often use more pencil, because it stays in place longer and won't lift as easily when eating and drinking.

The best insider tip, when it comes to applying lip pencils, is: Prep lips first with a lip primer or foundation, concealer, or powder to even out tone and help to hold and prevent bleeding. Then apply the pencil line in broken strokes, versus one solid line. It gives the illusion of fuller lips without the bleeding and separation that often occurs when a line is bold and solid. It's less obvious if you choose to extend the line over your natural shape for a fuller lip. Apply cream lip color or a lip gloss to finish the look. Another great trick for making your lips look fuller is to always dab a lighter shade of lip color or gloss in the center of your lips and blend. That spot of light gives the illusion of plumper lips.

The new "stay-put," twelve-hour lip color is actually pretty cool and effective. When choosing, be careful to find a supple texture, as some brands can be very drying and ball up over time. Test some on

Whether your lips are full or a small bow, the right technique with lip pencil, lipstick, or glosses will help you enhance your shape.

your hand—walk around for a bit until it completely dries, and see how it looks. Some brands will dry dull or with a matte finish. If you prefer a moist look, keep testing different product lines. You'll find it! Some "stay-put" brands come with their own gloss and they don't bleed—amazing! Since I prefer a supple, moist-looking mouth, especially in photographs, I have combined "stay-put" with regular "moist-lip" color. It works

quite nicely and is more pleasing in photographs than "stay-put" products alone. But remember, when adding lip gloss or a rich moisture product to "stay-put," it changes the texture and can alter length of duration for the long-lasting effect. There are so many different options for long-lasting color out there that I'm still on the lookout for the perfect combination of texture, shine, and staying power!

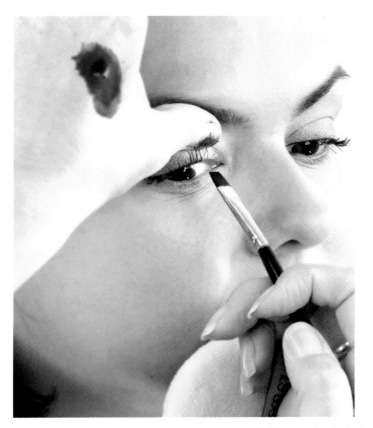
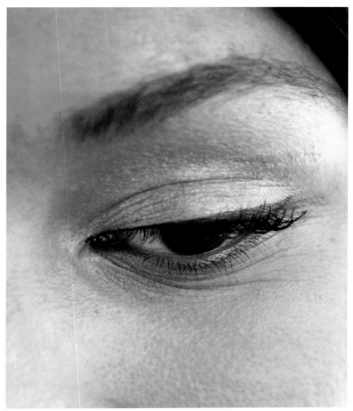

Laura Mercier's wet liner (left) applied with the "tight line" technique underneath the upper lash line does amazing things to the eyes, and gives the illusion of fuller, thicker lashes. Laura Mercier's wet liner can also be used on top of the lid (right) for a dramatic accent. Once dry, it stays in put!

Show Me the Color!

There are so many shades to choose from—where do you begin? My mother always told me, "All you need to do is look to nature to find the answers for the shades that will work best on you." Look in the garden for color combinations that complement each other. Combinations of colors you might not ever consider putting together in your makeup or wardrobe really do work in nature! Chocolate browns and pale blues. Oranges and plums. Pinks and browns. Look to your own hair, eyebrows, skin tone, and eyes to find your base color palette and then try contrasting those tones with subtle, muted color. You may find green in your eyes that you'd like to bring forward. Plum gracing hazel eyes (brown/green) creates more green than brown. Play with color wheels, paint, fabrics, and watercolors, and observe how subtle contrasts of color can dramatically change the quality of the hues when

combined and contrasted. Consider the seasons: spring, summer, fall, winter. The changing light, too, can help influence your color palette. It tells you what works! You merely have to interpret the variations and roll with the changes. It's really fun.

The combinations are endless for shadows, highlighters, and subtle touches of color (cream shadows, cheek and lip pigment stains, powders, cake liners or pencils). Your eyes and your skin carry a great deal of subtle undertones of colors as well: yellow, green, beige, pink, brown, blue. Try to focus on discovering and understanding your own "body of color" palette first. Avoid a direct contrast unless you are making a statement or have a great deal of confidence in your application. Start by choosing shadows and color hues that have undertones of the colors in your "body palette" or are subtle enough to complement with a splash of color. I'm just going to keep driving this home.

Find the combination of hues here that match your palette, and explore!

Brunettes: Brunettes have a little more room for experimentation than women with lighter hair. Darker hair allows for more color options, since you already have a rich tone as your canvas. Of course, the rich canvas will also handle darker, richer tones. Lucky you!

*Each of us carries a "body of color" in our hair, skin, and eyes that in contrast with certain shadow shades
can enhance the color of your eyes, warm your skin tones, and bring out the contrasts in your hair.*

What are the undertones of your hair? Red, tan, green (ash)—even blue? Very dark, ink-black hair can have blue undertones. Explore brown shadows: here, you have all different shades and undertones of orange, gold, red (auburn), gray, and green (ash). Gray shadows have undertones of green, blue, brown, plum, black-brown, and charcoal.

Blondes: Light hair needs a little richer makeup and more warming tones. You'll want to bring up more color in your skin (unless you are naturally bronzed) when going light and natural with shades. It's all about balancing the hues as a whole (unless you are making a statement with the makeup—vintage or just subtly reaching for a specific look or era). It depends on your style choices.

Gold tones, peaches, nectar (peachy pink), beige, pinks, rose, warm soft browns. Look at the undertones in your hair and eyebrows—sandy tones, brown, or burnt orange, for instance. If you are all burnt tones, bring in the roses and pinks; it will really warm and soften your look. Of course, you can experiment with more dramatic colors, but try to stay in the family of your base and undertones of color first. Dark plums, grays, blacks—these bold statements of color are more accents to the base shadow color.

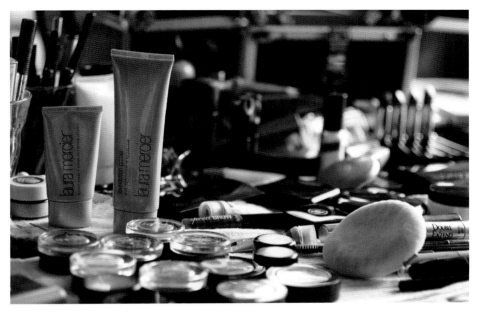

I use many different makeup lines but I am especially fond of Laura Mercier. Because she is a working makeup artist herself, I find her products to work exceptionally well for photography. Most of her products are geared for use in front of the lights and camera. The subtle luminous qualities, light-refracting ingredients, and amazing coverage make skin tones look fresh and natural, reaffirming her techniques and quest for a "flawless face."

Platinum blondes (including gray hair): Platinum pulls the color from your face. That's why many older women tend to color their hair to a lighter shade of their natural hair color instead of allowing the gray to grow in. When you begin to age and gray, the saturation of color in your skin, hair, and eyes softens. The same holds true for platinum blondes. Pale skin and platinum hair can be very pretty, but it can also be a challenge to keep the warmth and youthful blush to your cheek. You'll see a lot of women with platinum locks wearing very strong mascara and rich, dark eye shadow, or using spray tan to create drama. Or in lieu of strong eyes, many women with light hair go with very strong or bright lip color, simply because it creates

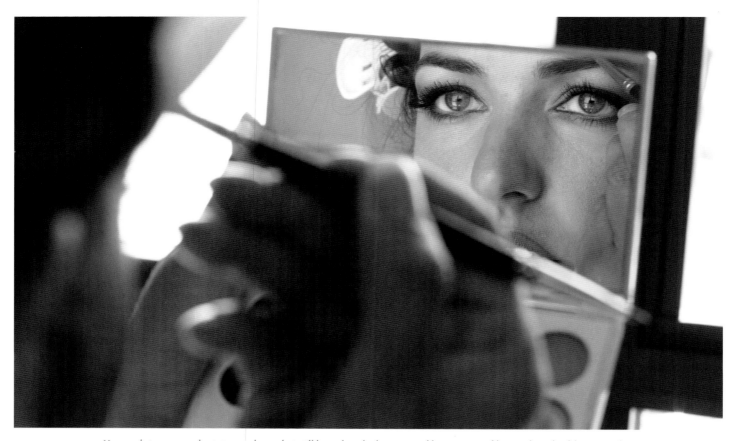

You can bring more color into your brows but still keep them looking natural by using tinted brow gels and soft brow powders. Bobbi Brown makes a fabulous tinted brow gel and Laura Mercier makes a great "eye duo" brow powder. However, blending tones to create the hue that's right for you takes practice. Even just a little bit of clear gel darkens and keeps brows controlled and defined. Try it!

more richness of color; the skin undertones rise to the contrast and give the illusion that your whole look has more saturation, more color. Test it . . . wait until the last moment to put on lip color and watch how it all comes together; it's the "cherry on top," no matter what your hair color.

To make up for that light palette, you must bring the color to your skin, lips, and eyes with a delicate hand. Lift, lift, lift, and bring these subtle tones and colors up in your skin by adding foundation or warming powders, pinks,

plums, corals (Sugar plum or Coralista from Benefit are good), bronzer, or a tinted primer. Liquid cheek and lip stain or delicate tinted powders with pink, rose, or lavender hues are wonderful on light skin. Most women (even when all platinum or gray) have some brow color, skin tone, and of course, eye color, which helps you to pick the shades best for you. Soft black or plum liner, soft heathery plum shadows, and warm brown shadows work beautifully. I use dark shadows for drama—dark browns, grays, deep purples, dark

*Whatever your skin tone, warm beige or rose ivory, choosing just the right enhancing shades
of tinted moisturizer, foundation, face powder, and highlighter can help your skin to come alive, even glow!*

plums. Exaggerated contrasts—bright colors blended very, very well—are quite beautiful with very light hair. The right shades used on a pale palette can be like a watercolor painting. Actress Cate Blanchett is one example of someone who (or has a makeup artist who) creates lovely, delicate makeup against a very light palette; it's just beautiful.

Redheads: This, all by itself, is a statement. True red hair is fun to play with. Even if it falls more into the light strawberry-blond category (strawberry blond with soft red burnt undertones), a softer blush of auburn, these shadow colors will still work beautifully. Brown, green, and rose shadows work well with red hair, depending on the base tones (peach, orange, red, brown, gold, sometimes even yellow). Plum shadows are beautiful against auburn hair, as a highlight or in combination with browns. There are many shades of plum shadows with undertones of pink, blue, and gray. Orange-based burnt tones can be awful with red, so

really look for the colors you already have in your "body of color" palette. Stay with light, subtle hues if you're unsure. Browns and beige tones can go muddy and dull against red, so be careful when choosing to find a color that will complement your hair and skin tone. You have plenty of color already on your canvas, so you'll need to make informed choices as to your style. A lot of redheads have very pale (blue) skin and freckles. Use a tinted moisturizer one step warmer than your natural skin color, and a little light Laura Mercier Secret Camouflage skin concealer, to even out (not cover freckles, just soften) your skin using very little makeup. Add a spot of color on the lips, a subtle wash of cheek color, and a little black mascara. Put a little glow serum, or Laura Mercier's Secret Finish or Chanel Healthy Glow Fluid, to create a fresh, just-washed clean look to your skin and you can't go wrong! I love a kiss of color in lip gloss for reds, too. Rosy or peachy lips really pop!

Depending on your hair and eye color, sometimes blending a little auburn or reddish highlight into your brow color can make your green or blue eye color pop even more!

The "Eyes" Have It!

Because all eyes are not just one solid color but instead an array of colors or subtle hues, it's fun to take a magnifying mirror and look deep into your eyes and see what colors you can find. Often you'll be shocked when you spot gold flecks or light green or pale, pale blue in the depth of ocean blue-green. It's just amazing when you try an array of shadow colors up against your eyes and see which of the eye colors comes up strongest. It changes with each different shadow hue. Try it!

Green eyes: Plums and deep, rich browns will make green eyes pop! White shadow with a subtle pink base is pretty, too. Kind of a sixties feeling, but it really contrasts well with green eyes. Add black liner on the top lid, close to your lash line, either very defined or softly smudged depending on your mood. Again, Laura Mercier's "tight line" technique, wet eyeliner used under the upper lashes to build up the illusion of fuller, thicker lashes, is a must! Plum, navy blue, and brown mascara are all gorgeous, and subtle enough that one might not notice that your mascara is purple! Mix the purple or other color mascara with black if you feel that it's too daring and want to make it a bit softer. Mascara comes in an array of different colors now, even pink.

Soft gray and heather plums blended together are very soft and romantic with green eyes. Even very pale green shadow, a "moss" color with smudged brown or black pencil or liner, is beautiful and so feminine. Anytime you combine golds, light browns, and black with green eyes, you've got yourself a "cat eye"—it's very feline and gorgeous!

Brown eyes: Some think brown shadow is boring. Not so! The right shade of brown can give a dramatic contrast to the subtle shades of color in brown eyes. Again, your base colors and undertones affect this. Look for the green (hazel hues) in brown eyes. Most of the time you can bring out the hazel green by using plum or gray shadows with the base of green, plum, gold, or brown. Charcoal, gray, golds, violet, plums, and smoky colors are fabulous with brown eyes, with a pinch or a

By using gold and brown shadows against a green and gold eye color palette, you can create a subtle "cat eye" look. The soft brown/black mascara and gold and brown shadows draw forward and accentuate the greens and golds in her eyes.

smudge of brown in there, too! Very dark, chocolate-brown eyes can handle black, dark gray, and more intense deep shades and colors very well. When you line the inside of dark brown eyes with a soft white/pink eye pencil, with the smoky colors on the lid and around the eyes, it makes for a soft, dreamy-eyed look.

Blue eyes: Deep, warm brown shadow and espresso-colored eye pencil with rich black mascara do magical things to blue eye color. I find that smoky blue-gray colors also enrich the pop of blue. If you're going to use blue eye shadow, it is best used in combination with another shade, unless it is very soft or a wash of color. Using only a bright blue shadow will pull the color from your blue eyes. Instead, combine your blue shades with smoky black, charcoal gray, or a pinch of smoky dark brown; smoky plum gray is gorgeous, too. Use navy or deepest black liner or mascara for a dramatic look. Slate gray, golden shimmer browns, charcoal, silver, and even charcoal browns with a burnt-orange base can do really interesting "cat eye" coloring against your blue eyes.

With a Cherry on Top

Final touches are great fun and easy to do. It's remembering to do them that's the trick! Brides are often where you'll see these shimmery accents and touches of sparkle to the skin and hair, and sometimes even rhinestones are used in bridal makeup! Why not? Glow serums, shimmery touches, highlighters—these are all so delicate and feminine. There are many products that make you sparkle-licious—shimmer hair sprays, shimmer body lotions, and sparkling loose powders. Eye shadow shimmer for the corners of the eye. Even champagne gloss by Laura Mercier will make your lip color shimmer under the lights.

Special Note: Women with sun-damaged skin or women who are over fifty, in my opinion, should stay away from shimmer shadows. I think that the refracted light play adds depth to the creases and can make you look more weathered or tired. Very subtle shimmer accents, highlights in the corners of the eye or shimmer lip colors, and subtle shimmer powders or blush are all okay, but a full lid of shimmery shadows can be aging.

With moist, metallic, shimmery shadows such as Benefit's Moon Beam and Laura Mercier's shimmer bloc, you can highlight and add shimmer to any area of your face, to highlight and create delicate, feminine effects.

A Dress Rehearsal

Whether you choose to have your hair and makeup done by a professional for your wedding or you do it yourself, try to work out the kinks beforehand. My advice is to always, always have a hair and makeup run-through. This experience gives you an insight into what really is possible to create for hair and makeup on your wedding day. Time is an issue and depending on how creative you plan to get, this is a factor to consider on your wedding day—you don't want to have to get up at the crack of dawn!

Bring tear sheets from magazines, or any other visual that will help the artist or stylist understand what you're looking for. Bring your veil and even your dress if it has unique lines or elements that you may need to consider. Some brides just have the team arrive on the big day, and whatever strikes the artists is what they get. If you do this, you're taking a risk. Seek out an artist with sensibilities similar to yours, or get an artist referral from a makeup line that you buy who will understand the style you're seeking. Referrals from other brides is always a good place to start. If you are having your makeup done but are going to have

I highly recommend a makeup run-through. You don't want to have to think about making any changes or questioning choices on your wedding day! Have your artist take notes or create a finished face on paper to be sure that everything you experimented with and finalized is detailed and noted. Taking a photograph for you to have as a reference is a good idea too.

the bridesmaids do their own, consider whether each of their individual styles will complement your "whole idea." There is always the bridesmaid with the strong lip color or very heavy makeup. My suggestion would be to choose, at the very least, the lip color, pencil, and gloss you like and feel will complement you, and perhaps give that as a gift to each of the bridesmaids. That way there is some continuity among you.

If you have the means, hire a team of artists to do everyone so that you will have continuity throughout your wedding photos and will love the final outcome. This includes your mother, the mother of the groom, and any female in the wedding party. Make it clear to your artists

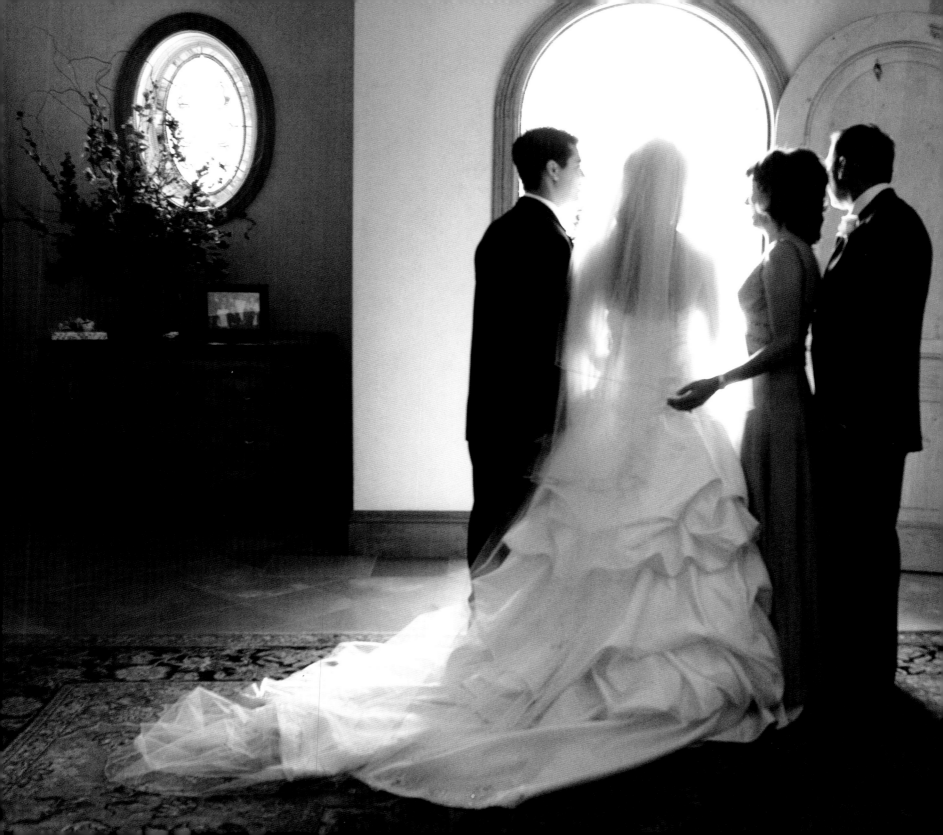

what you want them to keep in mind when doing each woman's makeup. Describe it as precisely as possible—"soft and feminine," for instance—or show them a picture of the "whole idea" and ask them to keep everyone in the same color palette and style. Any professional team that does weddings for a living will understand these guidelines.

Please, please, don't tell your bridesmaids to just go to the mall and get their makeup done. It can be a debacle! If things don't go well, they'll be upset, and you'll be upset. No makeup line can do that many women at once, which leaves you with different styles of makeup on each of them. Not to mention the amount of time each gal will need on the wedding day. Things are timed down to the minute, and when you fall off the timeline, that puts you in a very vulnerable position. You have no control over that at a counter. My advice: have them do their own makeup with the lip color, pencil, and blush that will complement you, or bring in a team of professional artists to get the job done right. You want everyone to feel pretty and be stress free. Try to anticipate everything! Find out if your makeup artist will stay until after the ceremony to reapply your lipstick (after all that kissing) and refresh your makeup for photos and the grand entrance. If not, have a handbag with the lip color that the artist used and any other gloss, powder, or what-have-you for you to use. Continuity is key!

All of this preparation has led you to this moment. Now the photography begins and all that you have envisioned for your wedding look is coming to light.

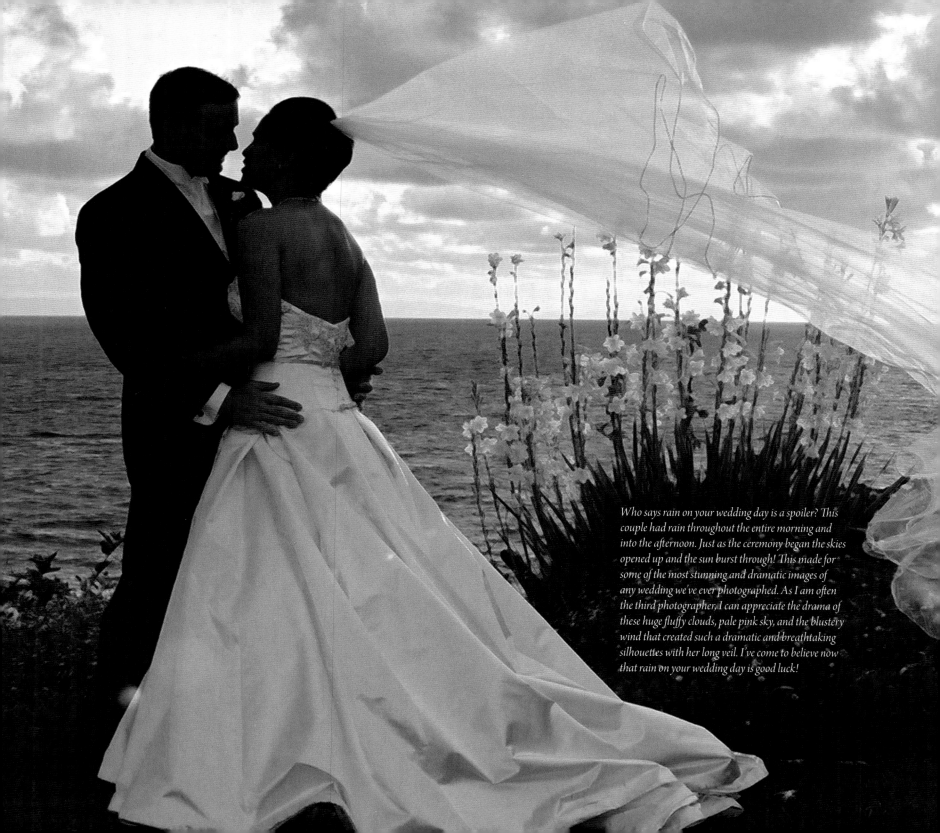

Who says rain on your wedding day is a spoiler? This couple had rain throughout the entire morning and into the afternoon. Just as the ceremony began the skies opened up and the sun burst through! This made for some of the most stunning and dramatic images of any wedding we've ever photographed. As I am often the third photographer, I can appreciate the drama of these huge fluffy clouds, pale pink sky, and the blustery wind that created such a dramatic and breathtaking silhouettes with her long veil. I've come to believe now that rain on your wedding day is good luck!

WEDDING
Hair and Veils

What 'Do will I do? Some women have an elaborate wedding hairstyle in mind from the start, even before they choose their gown. That's fine. Yet more often than not, "less is more." When the look gets too big—big hair, big veil, big gown—it can be a little much for the eye to take in. I'd suggest considering the "whole idea," the

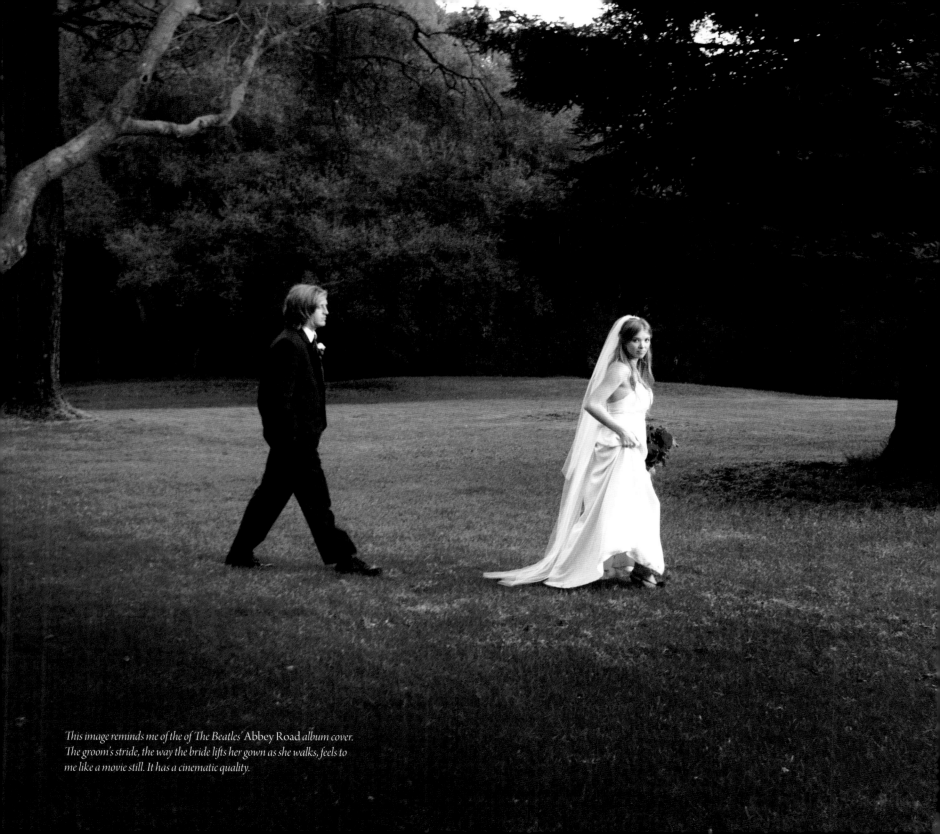

This image reminds me of the of The Beatles' Abbey Road album cover.
The groom's stride, the way the bride lifts her gown as she walks, feels to
me like a movie still. It has a cinematic quality.

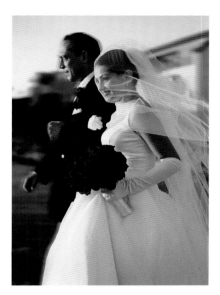

An outdoor wedding imbues photographs with so many elements that you don't have indoors. The breeze against this bride's veil and the motion in their step makes for a much more dramatic and poetic look. The winter light creates more saturation of colors for makeup and flowers. It's simply gorgeous!

overall look and style choices you have already made, in choosing your hair and veil. Balance and symmetry—that's the key!

The hairstyle you wish to wear on your wedding day should be one of the first things to consider when deciding on the style of your veil. They go hand-in-glove!

Find a style that is comfortable and is "you," not some fancy incarnation of someone else's idea of you. Be true to your own sensibilities. You don't want to look at the photos later on and wonder, "What was I thinking?"

When choosing a style, consider wearability. A wedding day can run as long as twelve hours—that's a long day. You don't want to be constantly worrying that your hair's not sitting right, and you don't want to be pushing and pulling at it or be self-conscious about it. There will be a lot of hugging, with people grabbing you around your neck. Keep that in mind, too. Weather should play into your decision as well. Have a backup option if curls are the plan and there is a possibility of rain. A lovely silhouette and romantic lines and nuances are all one needs. Find a happy medium.

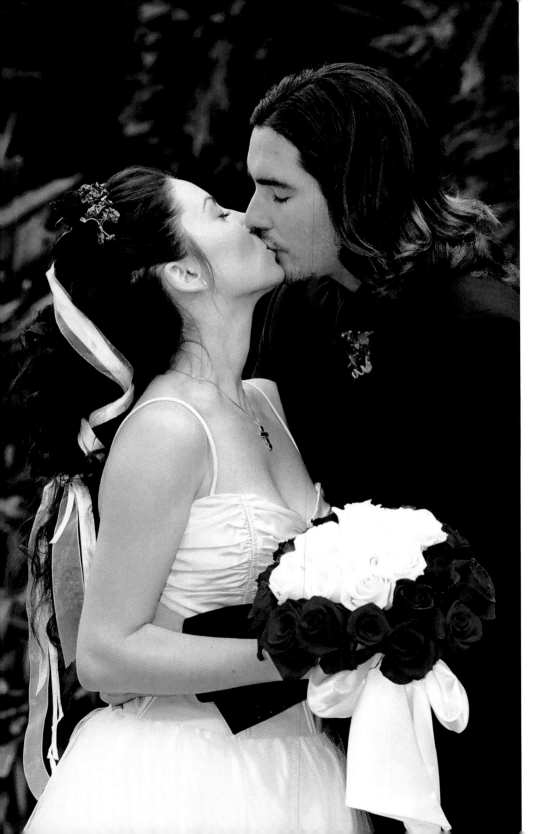

When it comes to choosing a hairstyle for your wedding day, rely on your own instincts first. You know what shape and cut works on you, and you should know by now what hairstyle you like best. It's a good bet that your groom knows what he likes, too. It's up to you whether you'll honor that, but let me say this: Be sensitive to the fact that if there is one thing he should be able to count on, it's that you will look like the woman he asked to marry him and that what he loves most about you will still be evident. Don't be radical. Please do consider his feelings when it comes to making bold changes without discussing it first.

Other Hair Considerations

WEARABILITY

Over the years, I have found that more and more brides are choosing to wear their hair down. This can present many challenges, but none more so than the weather! Wind, rain, or even a hot, sticky day can affect

There are so many lovely and interesting ways to wear your hair for your wedding. Do a little research and see what ideas you can come up with. Be creative and unique. Red roses and sheer organza ribbon woven into a soft french braid with a gold leaf headpiece is just so feminine and complements this bride's whole idea beautifully.

Even if you choose a wedding day hairstyle that does not have any loose hair or tendrils, you can have your stylist create the illusion of movement within the design. Here I wove and tucked this bride's hair to create the illusion of movement and lyrical lines, without compromising a strong, secure hairstyle.

Large rollers make for soft and feminine waves and curls in long hair. The curls will soften subtly throughout the day, not noticeably as they would with tight curls. Sometimes, less is more!

a long curled mane of hair. I would suggest, if you insist on wearing it down, that at the very least you take a small amount of hair from the front and pin it loosely back, securing it so that the temptation to put your hands in it throughout the day is squelched! Oils from your hand and fingertips can cause the curl to drop and hair to become limp.

When your hair is completely down you'll also find that it is extremely difficult to manage your dress, bouquet, and veil while trying to clear your eyesight for walking in high heels and posing for photographs. You can still have the silhouette of loose hair in the photos by pulling just a few strands back and save the style by not constantly fussing with it.

*This chignon updo is so elegant and timeless.
I don't think this hairstyle
will ever look dated.*

*Hair worn down on your wedding day can be a nuisance,
and the soft look can be affected by weather, veil, hugging, and
unencumbered movement. My advice is to at least pull a few strands
of hair back out of your face (as this bride has) so you can clear
your sight for walking and managing your veil and train but
still have the style and look of wearing your hair down.*

*I love the poetry in this one lone strand
of hair and how it makes this bride
look so soft and feminine.*

A chignon is a classic bridal choice and a lovely way to showcase a beautiful pair of earrings, choker, or necklace. Do a little research, and try to find a design or shape for your hair that will complement the "whole idea" of your specific style, genre, or era of gown. Whatever hair design you choose, remember that as with flowers, lyrical lines look feminine and poetic in photos and in life. Soft tendrils, subtly upswept hair on the sides, or a romantic twist secured with an encrusted hairpiece is so lovely, touchable, and you!

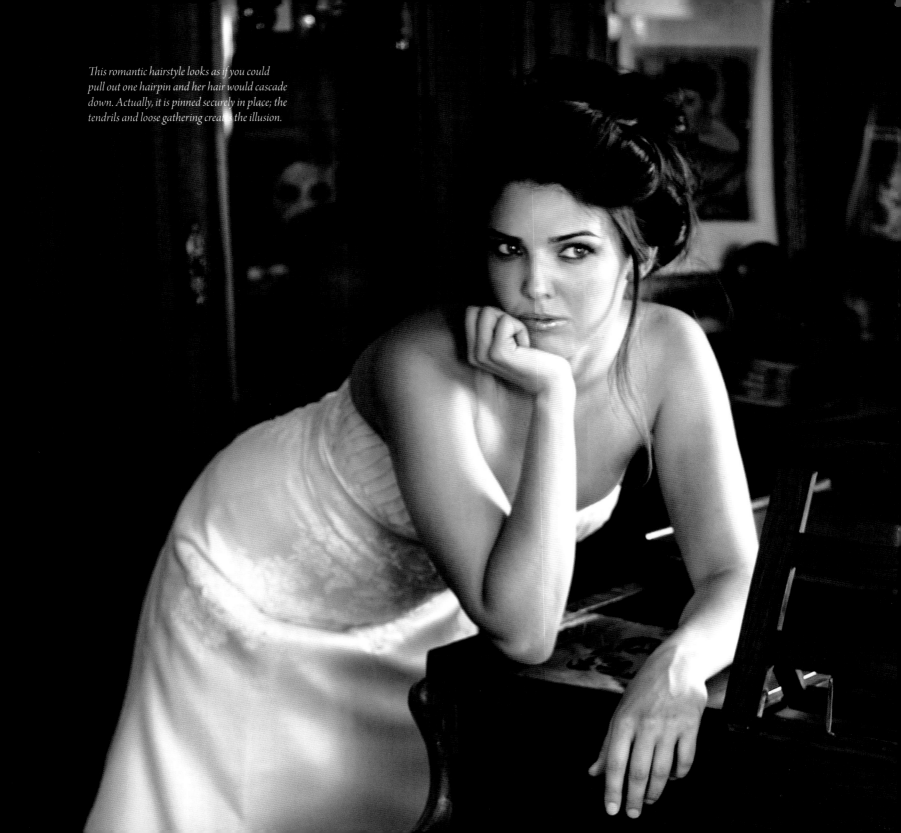

This romantic hairstyle looks as if you could pull out one hairpin and her hair would cascade down. Actually, it is pinned securely in place; the tendrils and loose gathering create the illusion.

 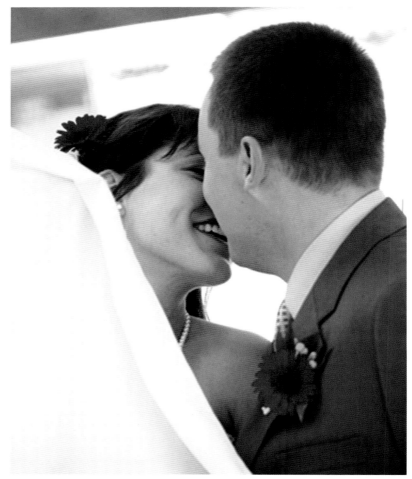

However you choose to wear your hair, I think flowers only add to the beauty of a bride and bring poetry, lyrical lines, and a feminine quality to complement your whole wedding look. Make sure the flower you choose for your hair coordinates with your bouquet—same genre, color scheme, or style.

SCENT

One thing brides forget when they go off to the salon is that every product the salon is using on them has a scent. A strong scent from hair sprays, gels, and lotions can be off-putting. Consider bringing along your own lotions, styling gels, or other products so that you smell like you.

TOUCH

Crispy hair is not sensual or esthetically pleasing. Tons of pins and crunchy product residue are not exactly romantic. Sticky hair does not blow in the breeze (for photos) or cascade down your back as you pull the pins out when touchability is important.

FLOWERS

Flowers in your hair for your wedding, I think, is one of the loveliest touches you can add to your look. Not only is it romantic, but the spot of color or silhouette tucked into the hair, hidden under the veil, or at the nape of the neck, is gloriously beautiful. You can choose scented flowers and smell divine, too!

The gardenia in this bride's hair adds so much to the "feeling" of her whole wedding look. Flowers add a delicacy to an updo and femininity to whatever a bride may be doing—walking down the isle, interacting with family and friends, or dancing. The options for color and design are endless and, let's not forget, they smell divine, too!

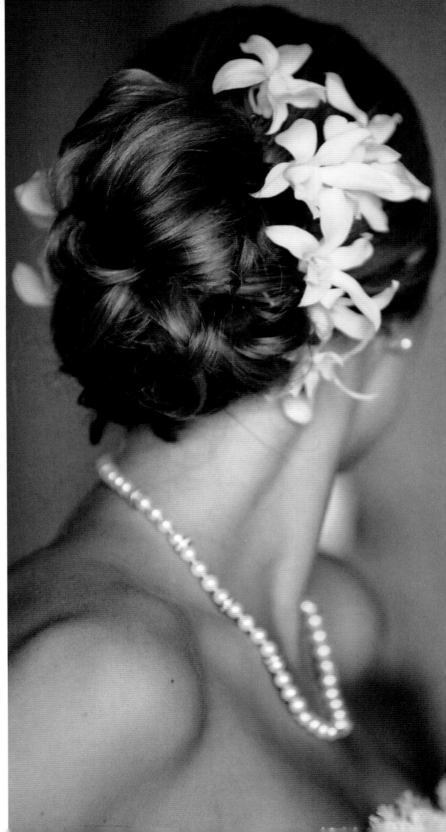

It's so important to have a run-through to discern which direction you will choose for your wedding makeup and hairstyle. I always suggest the run-through take place about a month or so before the big day. By that time, you've made most, if not all, of the final decisions. I can't tell you how many times we ultimately change the design for hairstyle after we do makeup and talk about veil and the "whole idea" for the wedding look. Continuity, a thread of style elements that keep your look all in the same "whole idea," is really important. You need to know—beforehand—how you will look for your wedding day. No surprises!

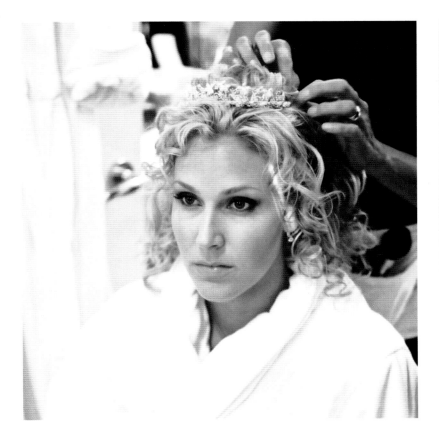
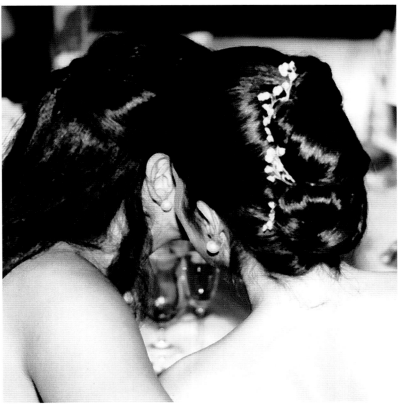

Choose a hair and makeup stylist who have your same sensibilities. They must understand what you want and promise to honor that. Style is subjective; you and your stylists need to "speak the same language." You don't want to be disappointed by miscommunication. To get the results you desire, you must paint a picture with words and examples or bring along tear sheets from magazines or use your laptop computer. A picture speaks a thousand words!

Work with a Professional

Choose a hair person you've worked with for years, or get a referral from someone you trust. Do a run-through, and bring tear sheets or photographs. A picture paints a thousand words. It's a good idea to bring your veil to the hair run-through, too. Often the veil changes the final hair design. With the veil in place you often need more height on top. When it's removed, things change; the shape of your hair might not need as much height, or your hairstyle will be more evident when the veil is no longer covering it. Have someone at the ready to help you with minor adjustments. Or, better yet, find out if your stylist will stay until after you remove your veil, if you will be wearing it only for the ceremony. This can be super important in preparing you for the grand entrance, especially if you go right into your first dance.

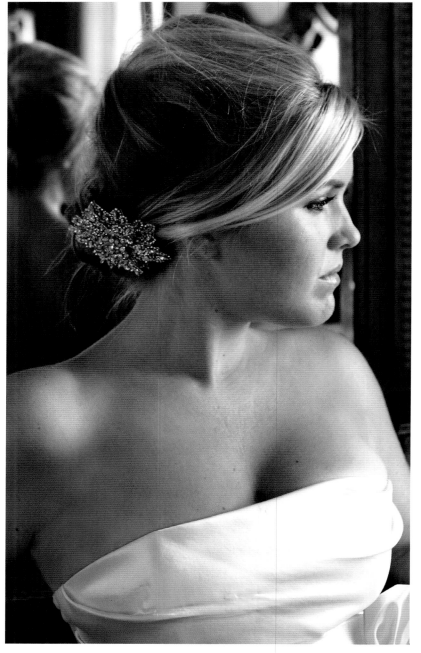

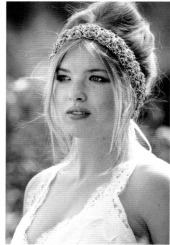

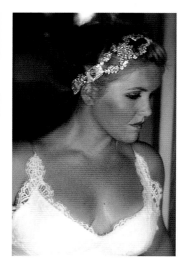

There are so many beautiful hair accessories and accents available now, it will be hard to choose. I have even used my grandmother's brooch and vintage shoe clips in bridal hair before. Don't be afraid to experiment; if it sparkles and shines, try it!

Hair accents with the shimmer factor abound: pins, brooches, ribbons, clips, barrettes, and even shimmer-encrusted floral pieces are available. They can be worn in your hair for special events, worn under your veil, or even used to secure the veil in place for your wedding. Vintage, fantasy, and unique elements are in fashion. Just keep your eyes open. When you set out to find a particular accent, you'll find that you will see new and fabulous things that were already there, right under your nose. Have fun and be creative!

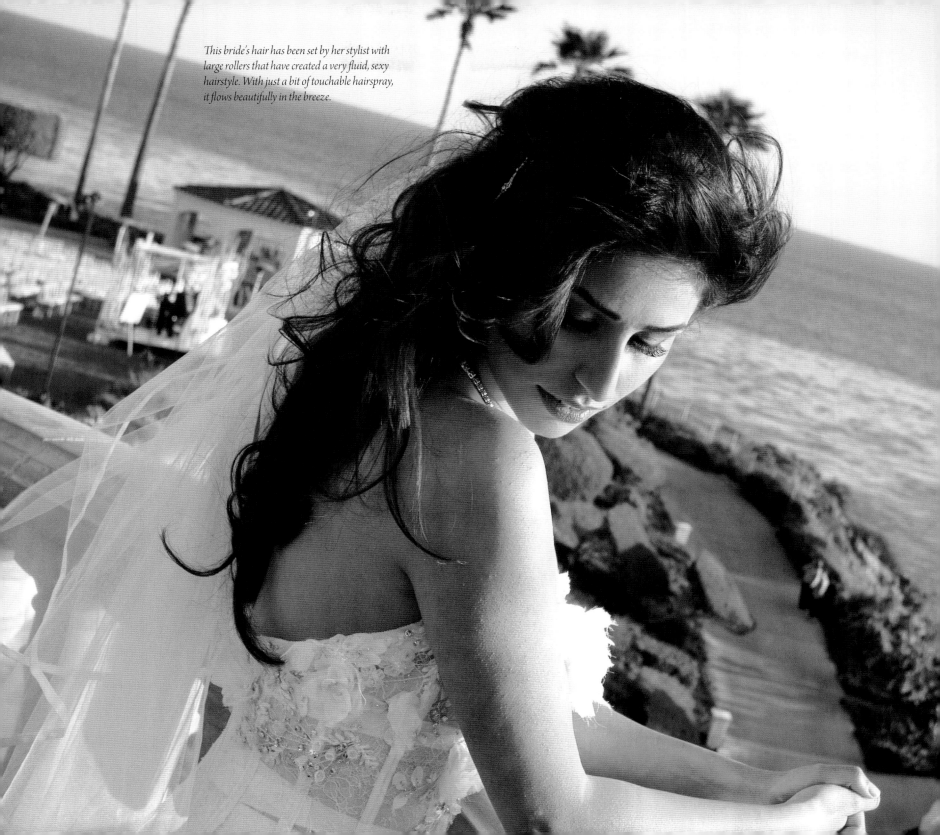

This bride's hair has been set by her stylist with large rollers that have created a very fluid, sexy hairstyle. With just a bit of touchable hairspray, it flows beautifully in the breeze.

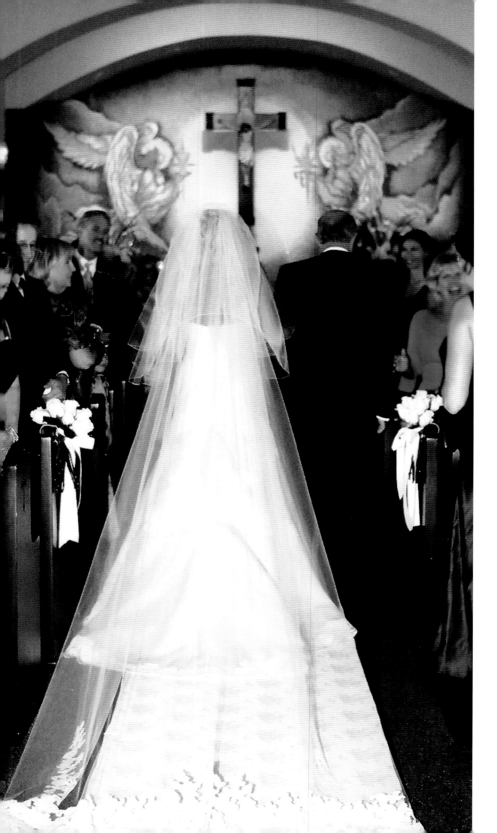

Veil Style

Your decision on the design, style, and era of your gown will affect your ultimate choice of veil. A veil can make a statement and bring a great deal to the photographic imagery as well. Some of our most amazing photographs were made so much more ethereal and poetic because the veil added another dimension to the captured moment. The wind, sunlight, and silhouette are so much more magical enhanced by the right veil.

Styles of veils to choose from:

- **Blusher:** A short veil worn over a bride's face. Generally, hair is worn up.

- **Flyaway:** This layered veil just brushes the shoulders. Hair is generally worn up or gathered at the nape of the neck just above the veil line.

- **Birdcage:** Veil drops to just over the chin. Often worn at civil services, this is a nice veil worn with a tailored suit or a fitted dress. The hair is worn up, short, or controlled.

A veil can double as a train in design and look. This is a very dramatic veil that has gorgeous lace detailing that works beautifully in place of a train.

- **Elbow-length:** Veil length drops down to the elbow. Can have multiple layers. Hairstyle options open up as veil gets longer.

- **Fingertip:** The most commonly worn veil, the length drops just to the bride's fingertips. Hairstyle options abound.

- **Ballet-length:** Veil length drops down to the ankles but never touches the ground. Hairstyle options abound.

- **Chapel-length:** Best worn with veils that have a cathedral-length train, this veil drops about 6 to 12 inches beyond the end of the train of the gown. Hair options are open.

- **Cathedral:** Best worn with a cathedral train. Also drops beyond the end of the train of the gown. Hair options are wide open.

- **Mantilla/Traditional Spanish:** One tier, fingertip length. Many options for of lace and scalloped edging. Variations on length and options to select the number of tiers available. Hair options abound.

A veil creates movement and emotion that you might not otherwise see in a photo. It's has a lovely and dreamlike effect.

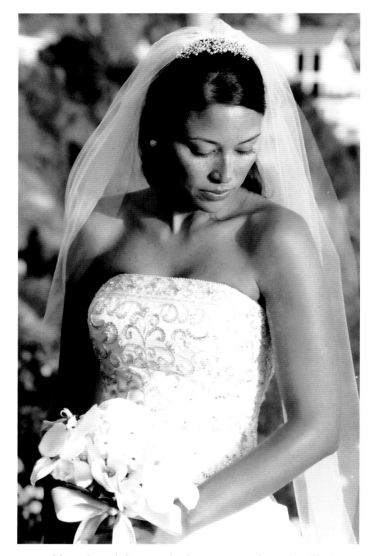

Wearing a headpiece on your wedding day is a lovely and dramatic choice. It will influence your hairstyle and the "whole idea" for genre and look of your wedding. Don't mix your metaphors; keep continuity in design and style.

A delicate, bejeweled tiara is a lovely accent to your hairstyle and look. It helps to set the tone for style choices. Keep that in mind as you pull together all of your accents and accessories.

Other options are vintage veils:

- **French birdcage:** Gathers to the crown of your head, drops over your eyes and ends just beneath your nose. Reminiscent of the forties. Hair should be up, pulled tightly back, or controlled.

- **Bubble:** Fifties flyaway length. Fully gathered at the crown. Hair should be worn close to the head; so much veil calls for modest, controlled hair.

- **Pillbox hat with blusher and rose:** Sixties, made popular by Jackie Kennedy. Worn with white

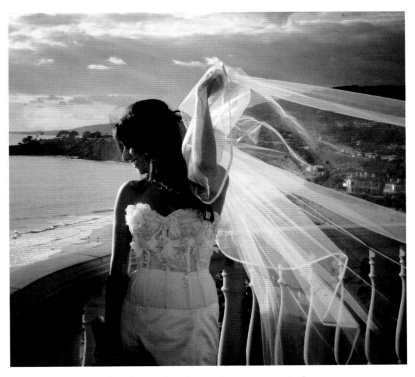

A long, large veil needs wrangling, just as a train does,
so ask your maid of honor or attendants to be at the ready to
help you maneuver throughout the day.
You'll be glad you did!

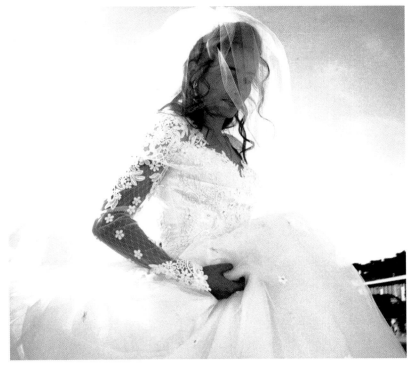

A veil adds drama, creates lovely, languid silhouettes, and can soften your whole wedding
look. In most cases it will be the one clothing item that your fiance may have never have
seen you wear. That first glance, to see the realization wash over his face that
you are his bride. It's a defining moment and beautiful thing to witness!

French net blusher, nose or chin length. Hair should be short, worn up, or controlled close to the head.

All these vintage designs are available with scatters, crystals or glass pearls.

Many accents can be added to any veil, such as embroidered lace (floral scallop, leaf design, etc.), or cord (satin edge, ribbon edge, etc.). Combs, tiaras, and hairpins are more touches that can be sewn into the veil or added as accents.

Jewelry

I find jewelry to be a very personal thing. The jewelry you choose can say a lot about who you are. Delicate diamond earrings, pearl studs, or long diamond teardrops. A cross on a gold chain, an encrusted choker, or a simple strand of pearls. Whatever you choose should, again, fall into the "whole idea" of your look.

Every choice you make, each sentimental detail and accessory, will influence the final direction of your wedding look. Just as a veil imbues you with a poetic silhouette, gloves, jewelry, headpieces, and flowers denote different styles and genres. As Lars and Barbara have both said, a wedding is like a "one act play" and the costuming is paramount. This is no dress rehearsal, this is your life!

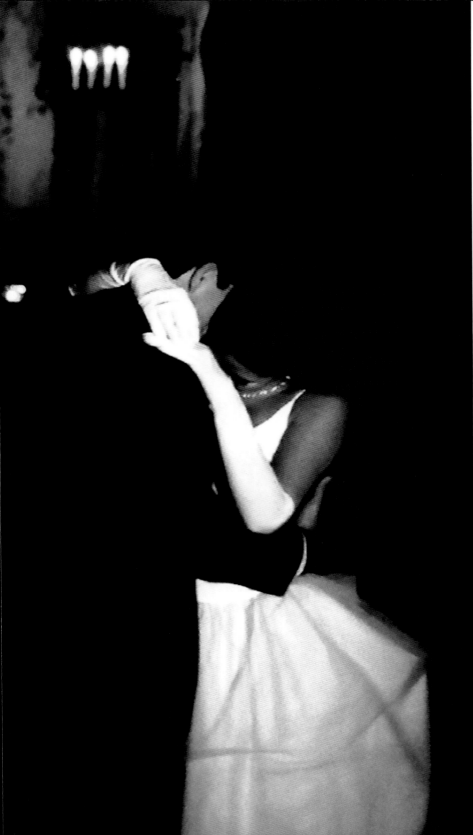

Make sure you don't mix your metaphors—choose pieces of jewelry that are the right vintage, design, or style for the genre for your gown and theme of your entire look. It's another way to bring it all together. Ask advice from a jeweler or do a little research to find lovely pieces of jewelry to complement you and your look!

Sentimental Touches

You could wear a locket with photos of a deceased family member or members. You can display images of grandparents' wedding photos, or other wedding images that you wish to celebrate can be displayed. Any memento that means something to you can find a place.

Parents' wedding rings can be worn on a gold chain, or any heirloom can be held with a chain around your handkerchief, in your hand, or in the bouquet, or worn around the neck. More obscure pieces can even be sewn into the dress or veil or worn in the hair.

A vintage hair comb from a friend, a mother's brooch, a grandmother's bracelet, or an heirloom of any kind is unique and can bring considerable style and sentiment to your day.

Bouquet Gallery

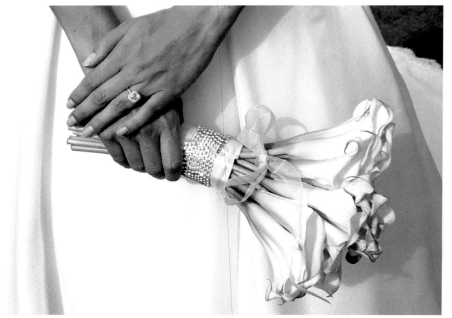

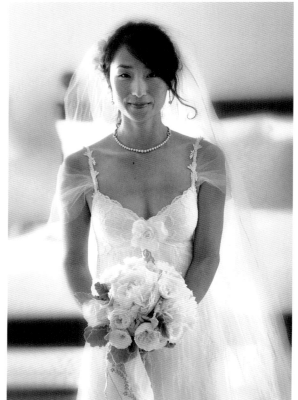

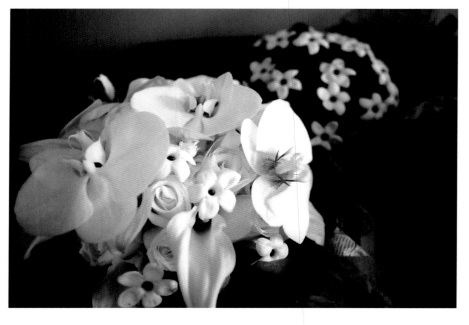

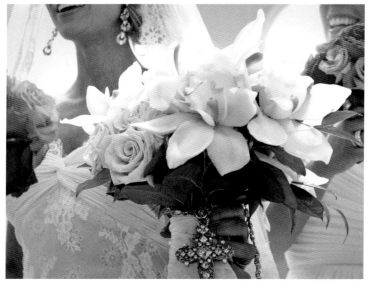

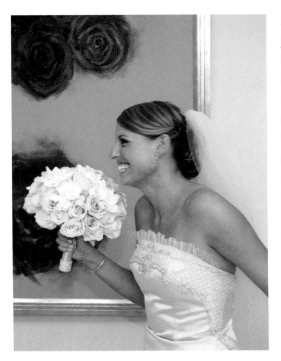

Lovely detail accents the simplicity of this elegant lily bouquet (facing page, top left). Orchids, the flower of choice for many bouquets and hair accents, are so delicate. The subtle wash of colors and shapes in this bouquet (facing page, bottom left) make it lovely and feminine. I love the way this bride's bouquet has a touch of the same color as her bridesmaids' nosegays (facing page, bottom right). The texture and choice of flower for this bouquet echoes the textures and silhouette of her gown. Even the filler leaves are soft and dreamy (facing page, top right). Moving with your bouquet creates lovely silhouettes in wedding imagery (left). Red roses make a vibrant statement, and that splash of rich color is very nice with all of the white (bottom right). Lily of the Valley are very expensive, but a few sprigs can bring refinement and style to your look (bottom left). Choosing the right scale for your bouquet is so important. It should reflect your "whole idea," not over shadow it (top left).

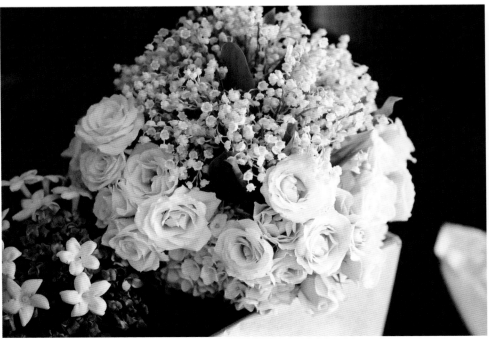

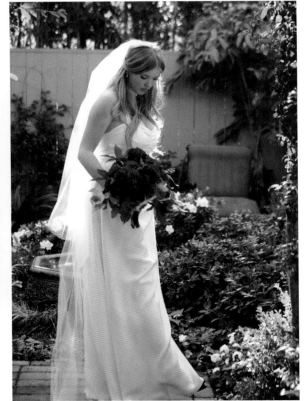

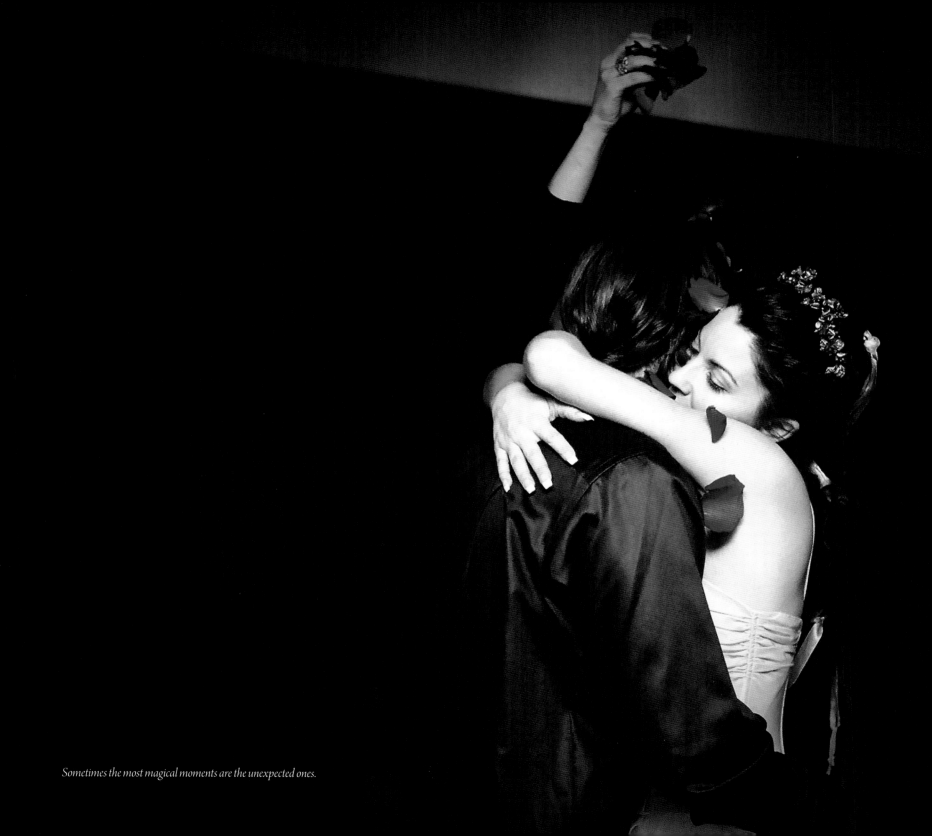

Sometimes the most magical moments are the unexpected ones.

The PHOTOGRAPHER

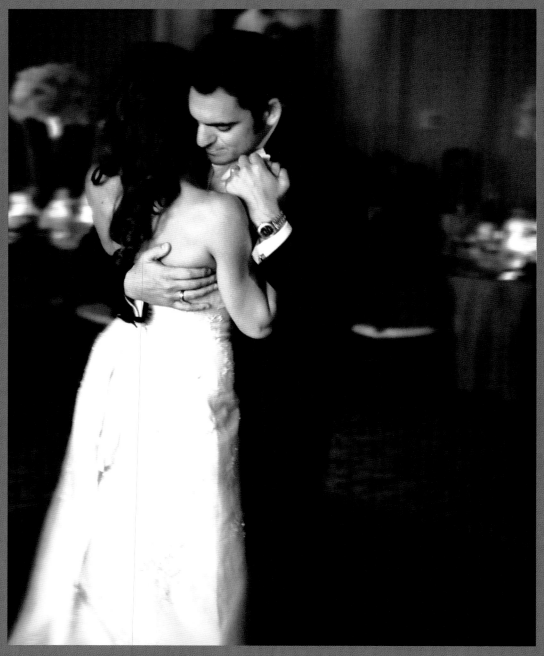

When you're confident in your dance steps, your first dance will say so much more in the photographs, and to your guests.
Let your guard down and allow your emotion to be present through your body language.

LARS'S *Philosophy*

I love photography; it stills a moment. It forces me to slow down and really look. I am free to let the image wash over me, to go corner to corner like a scanning machine absorbing the composition, angles, light, and subject matter. It allows me to make my own interpretations. The image is a poem compared to a novel, a beautifully prepared hors d'oeuvre compared to a smorgasbord. We all seem to have the same response when we look

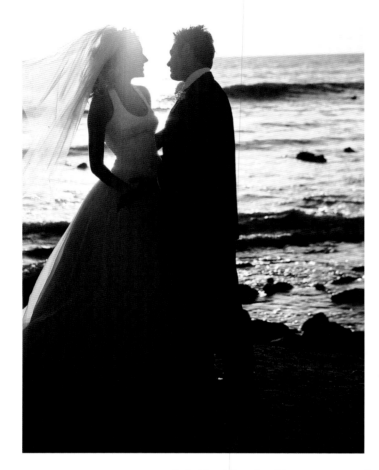

Left: A break from the celebration gives you a chance to connect with each other in a quiet moment.
Right: A simple gesture of touch is something a photographer is always looking for.

at a photograph: we pause, take an instant away from the outside world, and reconnect our visual senses to our emotions.

Photography can be an art form, a simple visual record, a social document, a method to advertise and sell products, or a way to candidly catalog our lives and our family history.

Wedding photography can embody many of the above, plus the abundance of emotion at every wedding is tailor-made for a talented photographer to capture. For a visual storyteller, a wedding is a feast! So much is happening, with potential in every minute for an iconic wedding shot. For me, the creative juices never stop flowing.

The processional is when the curtain is drawn and the play begins.
There should be no hint of the long hours of preparation to get to this point.
Walk tall and walk slow and allow your family and friends to admire you as a beautiful bride.

However, the deluge of imagery and emotion can be overwhelming. I've had to learn to work within a tight timeline, always ready for challenges; using my adrenaline to advantage, yet always remaining calm. Everyone, especially the vendors you hire, should bring their talents and passion to the table to make this a memorable day for you and your groom.

A mix of journalism, some portraiture, and a dash of fashion define my photographic style. Most photographers have a similar blend—some heavier on candids, some on posed portraits. Many photographers find their unique style in post-production techniques, while others are purists, using only black-and-white film. Although photographers need a strong technical aptitude, most consider themselves artists and each is unique in style and personality. I like to fade into the background and not be noticed, coming forward only when a group shot needs direction. Others are front and center with a contingent of assistants. I rely heavily on Annie as the stylist to help shape the look of the day, and on Annie's female energy to tune into the bride.

In your search you'll find many talented photographers, each with his or her unique perspective and definite personality. Most are in the business because they have a passion for taking beautiful pictures. I'm a big believer in the bride and groom finding like-minded people; think about whether or not you would want to spend eight to twelve hours with this person on your wedding day. In teaming up to make the most of this special day, that may be the most important question of all.

Wedding photography is a collaborative art form. Without a makeup artist, hairstylist, gown designer, event planner, and a florist, there is nothing to photograph. A strong team of vendors working hand-in-glove as professionals will make your day run smoothly, all serving to keep the bride relaxed and happy, which is the key to great photos.

Preparation is essential, for both the photographer and the bride. An organized photographer has a good timeline and family shot list so that the group shots can be completed quickly. This keeps everything on track and the wedding party happy. But preparing for your photos, both candid and posed, takes work. With twenty years' experience in front of the camera as a model and fifteen years behind the camera, I know what it's like to be standing in space to have your photo taken. Preparing both bride and groom for those moments helps to relieve pressure and allow for intuition and spontaneity to take over. This is often where the best photographs happen. Whether journalistic (without any direction) or stylized (with direction and purpose), you know a camera is around and the more you know how to act, or react, the better your pictures will be. And you'll actually enjoy yourself along the way. After all, a wedding celebration should be fun!

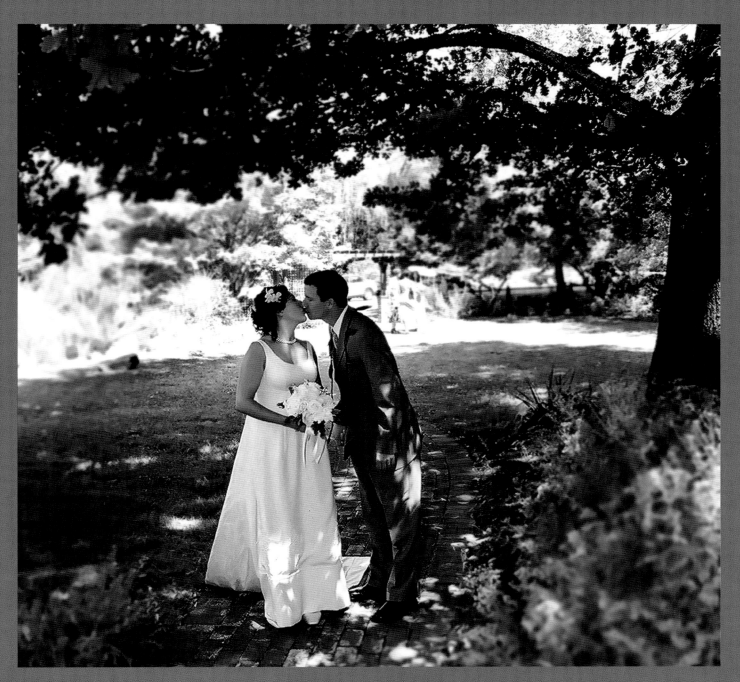

A brief stop under the shade of a tree was the perfect place for the groom to steal a kiss as they walked from the ceremony to a designated area for family portraits.

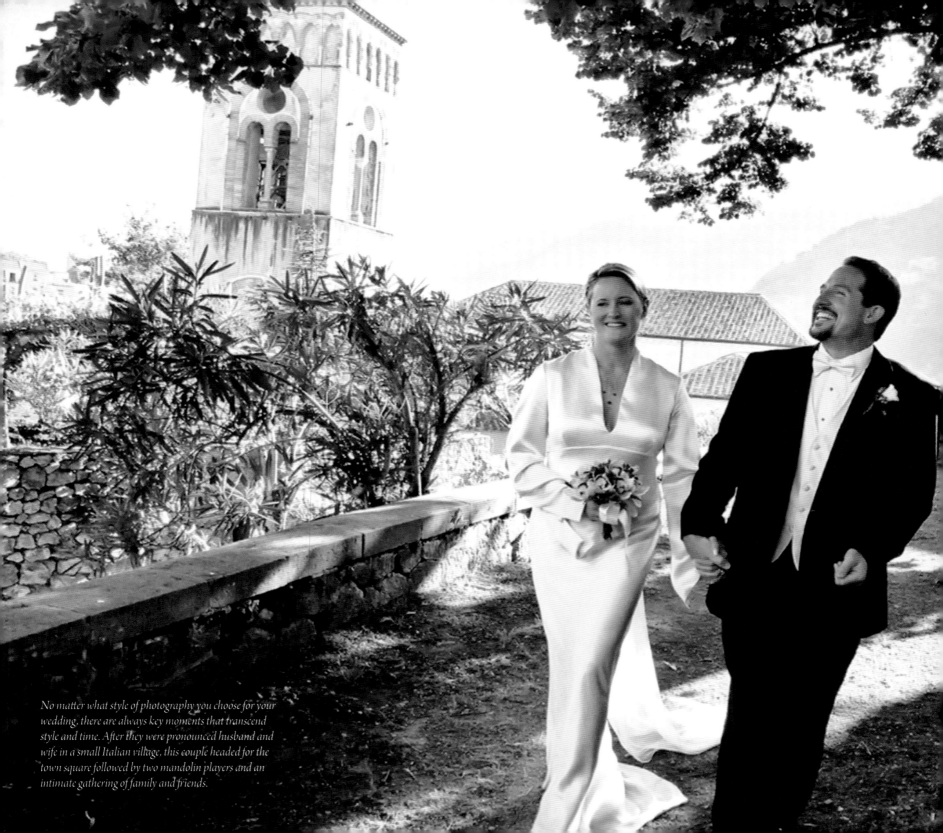

No matter what style of photography you choose for your wedding, there are always key moments that transcend style and time. After they were pronounced husband and wife in a small Italian village, this couple headed for the town square followed by two mandolin players and an intimate gathering of family and friends.

STYLES OF WEDDING

Photography

Even though you've done your homework, made a vision book, hired a wedding planner, and are ready to visit photographers, there are a few photography phrases you need to know to be able to communicate more effectively during the interview process. A picture speaks a thousand words; I can hold up three photos without saying anything

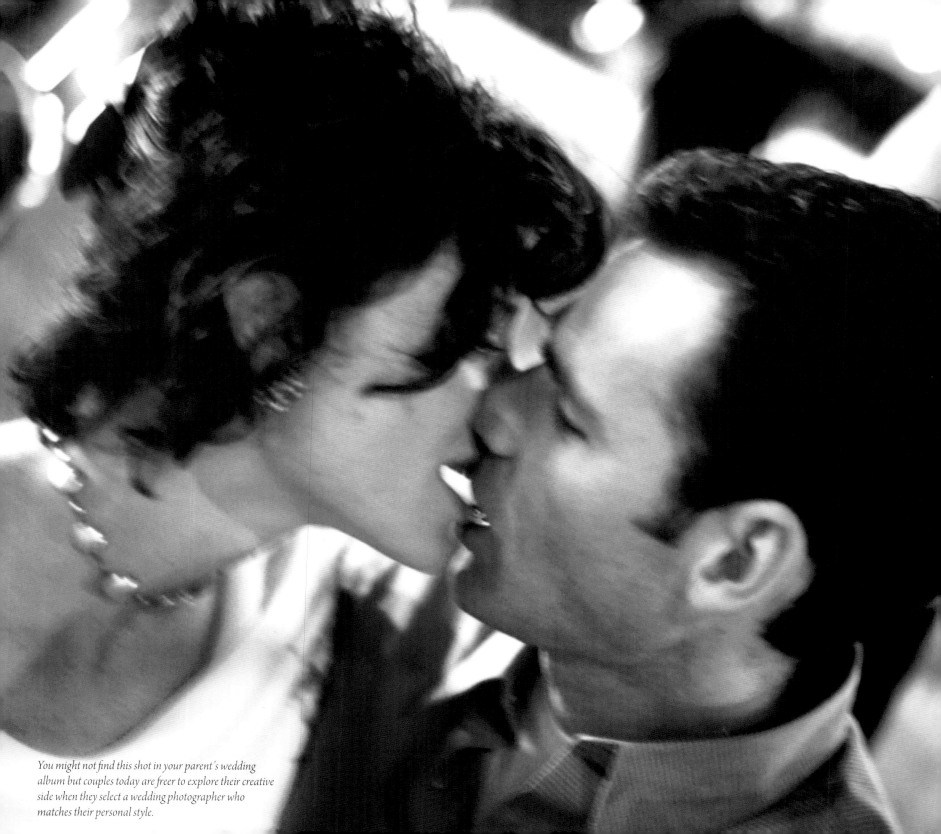

You might not find this shot in your parent's wedding album but couples today are freer to explore their creative side when they select a wedding photographer who matches their personal style.

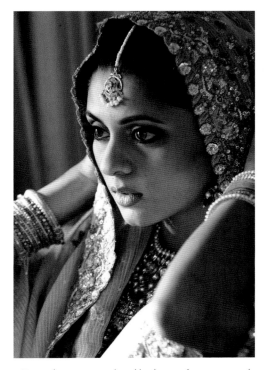

Depending on your cultural background, you may need
more preparation time to assemble your ceremonial attire.

and you will have an instinctive reaction to each. You may love one, like one, and hate one. But what do you call the one you love? How do you express to a visual artist the style you prefer, or the mood you're going for? From a photographer's point of view, it's easy to show without telling; look at the photographer's website, slide show, portfolio, or albums. What you see is what you get. If you enjoy what you see and your personalities are a good match, a bunch of words trying to explain what you see in the photographs won't make much difference in the end. But you can more easily navigate through the selection process and more efficiently sort through certain key phrases by learning to classify and label the different styles of wedding photography. In any category, there are degrees of style that every photographer employs. Most use an amalgamation of styles, as I do. What helps is to know how a photographer defines him- or herself so that you can make sure this person is a match for your desires.

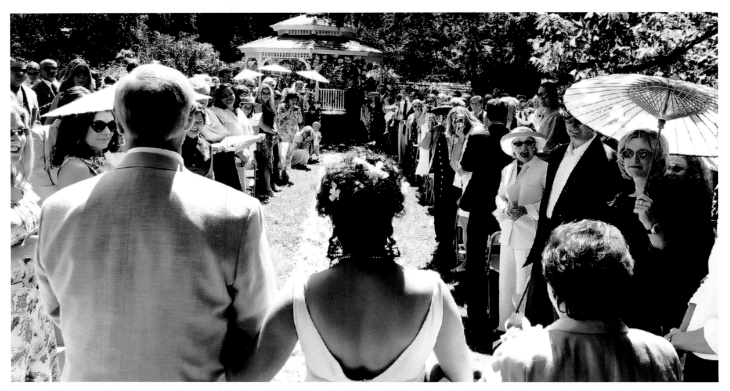

A bride, escorted by her father and her mother, pauses for a moment before walking down the aisle. Sometimes a different angle is all it takes to document your guests' expressions as you remember them and tell a whole story in a single image.

Photojournalism (Documentary Style)

This style revolutionized the wedding industry by instilling much-needed talent and creativity into a very story-rich event that had grown stale with tradition. In truth, you can't refer to a hired wedding photographer as a photojournalist unless he or she works for *The New York Times* or some other publication and was sent out to document your wedding in the newspaper or magazine. In the wedding industry, however, the photojournalist is loosely defined as a documentary storyteller. Although he or she will spend a short amount of time taking a few requested family portraits, the main emphasis is on hanging in the shadows to document the story that unfolds during your wedding. He or she follows the action, looking for emotional moments between the main players. This type of photographer is unobtrusive and elusive, but always in the right place at the right time. The photojournalist carries minimal equipment and may have an assistant or second shooter who is also seldom seen. Reviewing photos later, family and guests will remark that they didn't realize a photographer was even there. This photographer may use more black and white than color, and refrain from adding effects to the images in post-production. Your album will be a

Sitting down without a bouquet gives a casual feel to a traditional portrait and allows the viewer to see the beautiful detail of the dress and sash.

A traditional portrait with the body at a 45-degree angle, the train in front, the head and eyes into camera, and the bouquet held in the classic position. A lower than normal camera position allows for more of the interesting background to be included in the shot.

unique document of your day, without posing and with very few formal portraits. The photographer is focused on shooting what's really happening, the story of the day, without any preconceived, set-up shots. You may pay more to have a good photographer capture your wedding this way and deliver a well-rounded album, but you're less likely to experience any pressure to purchase large wall prints later on. Enlargements rarely go bigger than 8x10 for this type of photographer. Once the photographer's all-inclusive fee is paid, capturing the story is more important than print sales.

Traditional Portrait

At the opposite extreme is the traditional portrait artist. Portrait artists pride themselves on creating large-scale portraits suitable for printing on canvas and hanging above your mantel. They're experts with their gear and usually have a team of assistants to help them carry and set up their equipment. They're good with people and will take the time to position you just so. A portrait artist's shot list

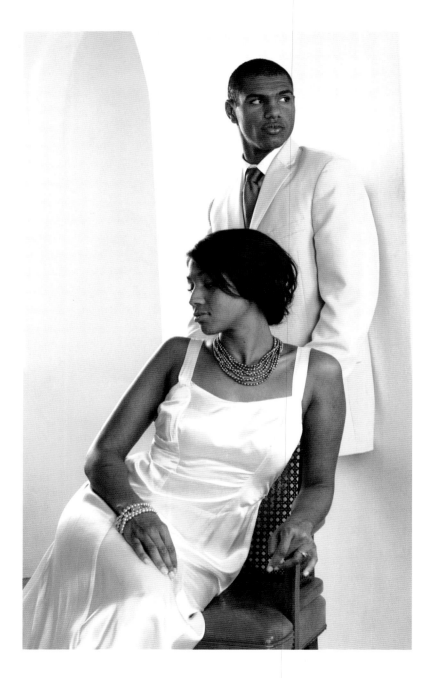

is filled with items to check off: bride at staircase, bride and groom on bluff, bride with grandma in hotel suite. Each shot is a portrait, not a candid. The photographer will capture images behind the scenes, but the main emphasis is the dozen or so iconic shots that will be the foundation of your album and the potential for selling prints later. The portrait photographer is traditional only because portraits have played such an important role in the history of photography. It doesn't mean you'll get your grandmother's album. Portrait artists are doing creative, inspired work, imbuing their photography with their own personal style.

Fashion/Glamour

This one may seem obvious, but you may not see the category Fashion Wedding Photographer when you cruise the Net. It's a wedding photographer with a fashion-forward bent. Most such photographers come from a fashion background, shooting models and clothing. They are used to relying on a team approach to accomplish the shot but don't shy away from their own personal style, which has developed working in another medium where individual fashion sense is the key to their success. A stylist is a big part of this photographer's process. Hair, makeup, and

Attitude is key in fashion photography. Strong positioning and exaggerated poses add to the drama.

wardrobe are fertile ground for a creative stylist. So much can be done to give that fashion look to the final photos. Brides who want that model look, who like to pose, who have a strong sense of self but also like to be directed, will be attracted to this style. Again, it's all a matter of degree. But if you like glamour and want to feel and look glamorous on your wedding day, a fashion-style photographer is for you. Ask to see work these photographers have done other than weddings and what stylists they like to work with. That will give you great insight into their visual process.

Romantic

You know it when you see it—soft focus, ethereal, the subject languishing on a chaise longue, rose in hand. It may border on fairy tale. The look is distinctive, dreamlike, gauzy: lots and lots of bride-and-groom shots in loving poses. Many post-production effects employed in Photoshop give the work the photographer's signature look. A romantic shooter can be a traditionalist or a fashion shooter, but is less likely to be a photojournalist. This kind of photographer creates a world for you through posing, editing, and digital technique to deliver your fantasy wedding pictures.

A dreamy repose adds to the ethereal quality inherent in the romantic style.

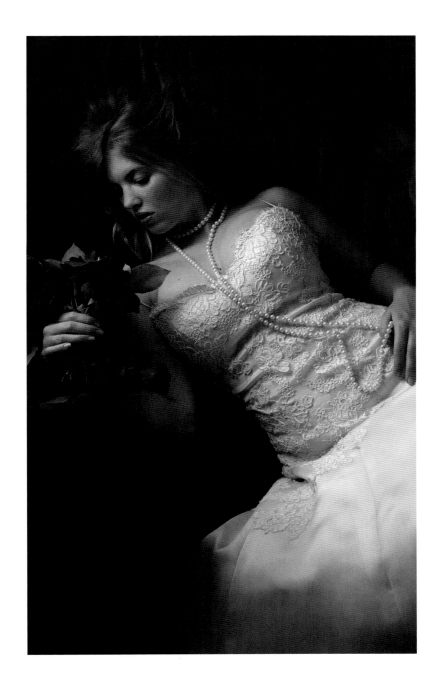

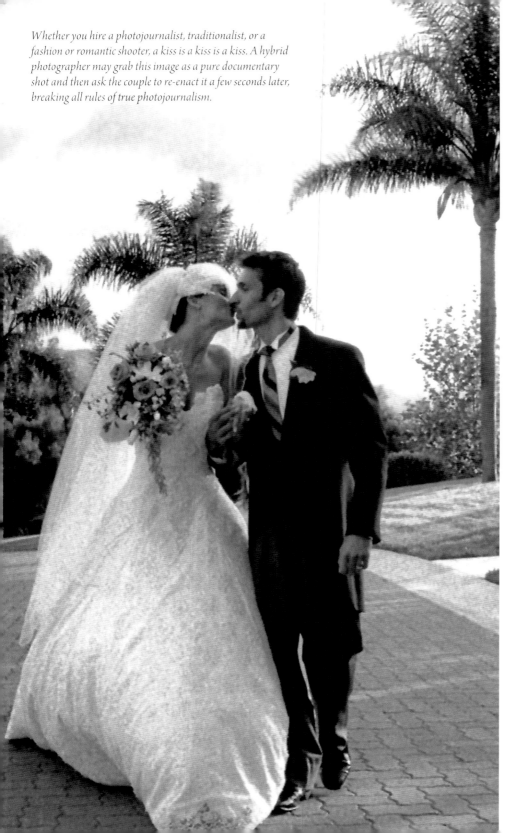

Hybrid

I would say 90 percent of wedding photographers fall into this category, myself included. Every one of us has an emphasis on one of the above categories that may be diluted to some degree by another style. In my case, it's boring to say I'm a generalist. It's more exciting to say I'm a storyteller who documents weddings with a fashion sense and a few portraits thrown in! This is why it's always better to judge a photographer on his or her work, not on a written description of the work on the photographer's web page. I've seen many photographers advertise themselves as photojournalists, yet who may describe only a small percentage of the images they deliver; the rest are portraits and candids. I've also seen brides say they want a strict photojournalist and then start a list of all the traditional portraits they want. Sorting through your choices with this style of photographer can be confusing, but if you trust your instincts when viewing their work, you can easily cut through the definitions of style and rely on the imagery itself.

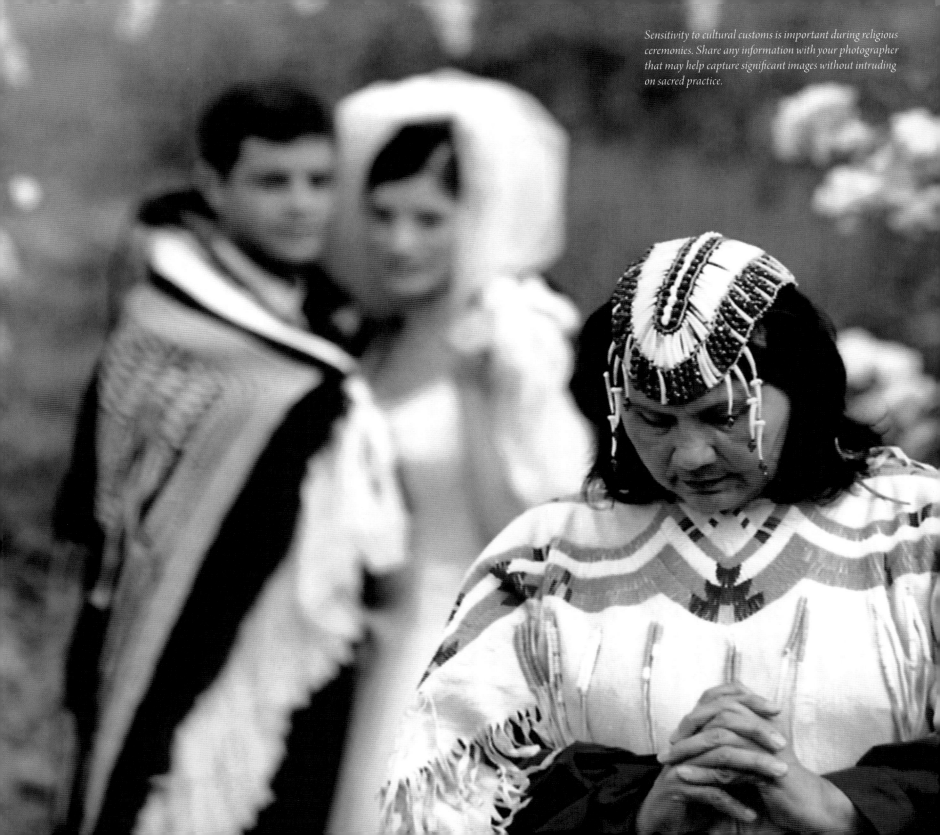

Sensitivity to cultural customs is important during religious ceremonies. Share any information with your photographer that may help capture significant images without intruding on sacred practice.

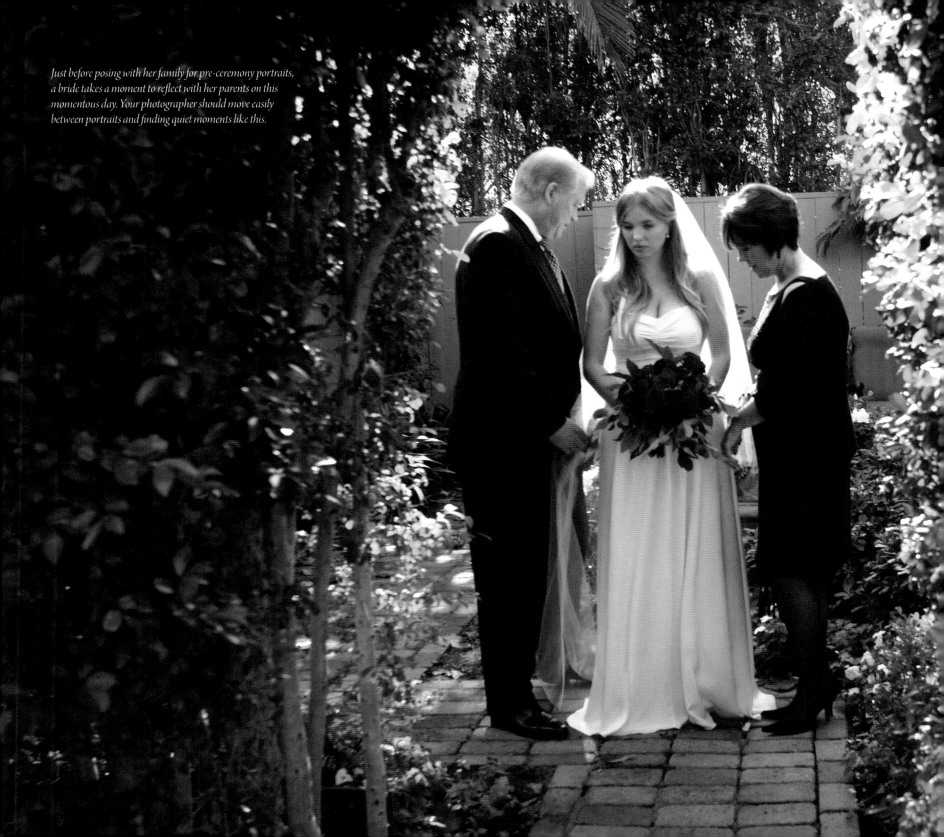

Just before posing with her family for pre-ceremony portraits, a bride takes a moment to reflect with her parents on this momentous day. Your photographer should move easily between portraits and finding quiet moments like this.

What's important is knowledge and communication. Know what you want and communicate that to your planner or photographer: "I want 50 percent black-and-white documentary-style shots with enough portraits to please my future in-laws, and one stellar portrait of the wedding party for my mom's wall." So long as the emphasis is still the photographer's strong point, most photographers will adjust the amount of time they spend shooting a particular style to fit a client's needs.

One more point before I move on: The tear sheets you pull for your wedding book to help you visualize and define your style are for you. It's not necessary to share these with a potential photographer unless you are asked to clarify your thoughts with a picture. Photographers are visual artists who take pride in the work they create. You are paying them to photograph your wedding, not to parrot someone else's work. The first step in building trust with your photographer is showing a true appreciation of his or her work. A photographer who feels valued will go the extra mile to get the wedding shots you want.

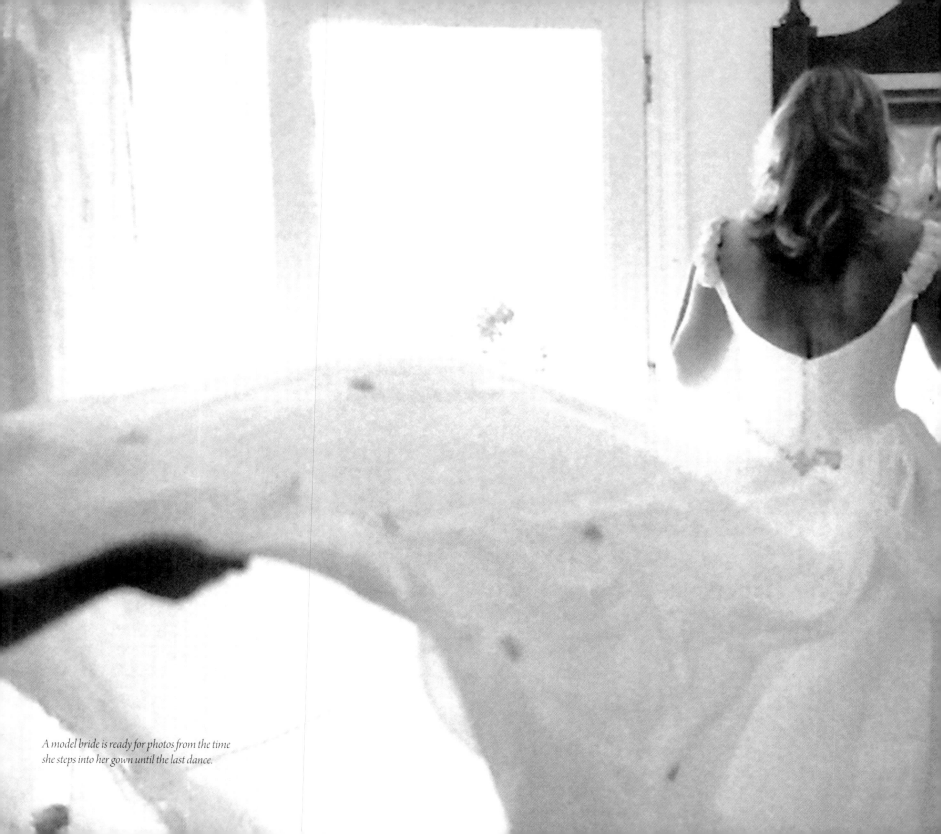

A model bride is ready for photos from the time
she steps into her gown until the last dance.

PREPARING TO BE
the Model Bride

When you close your eyes and visualize

your wedding, what do you see? Is it your groom's reaction

when you walk down the aisle? Is it the first dance? Do you

see in slow motion, in black and white? Maybe you focus on

a particular location at the venue you've chosen: walking

down the grand staircase with your gown and veil trailing

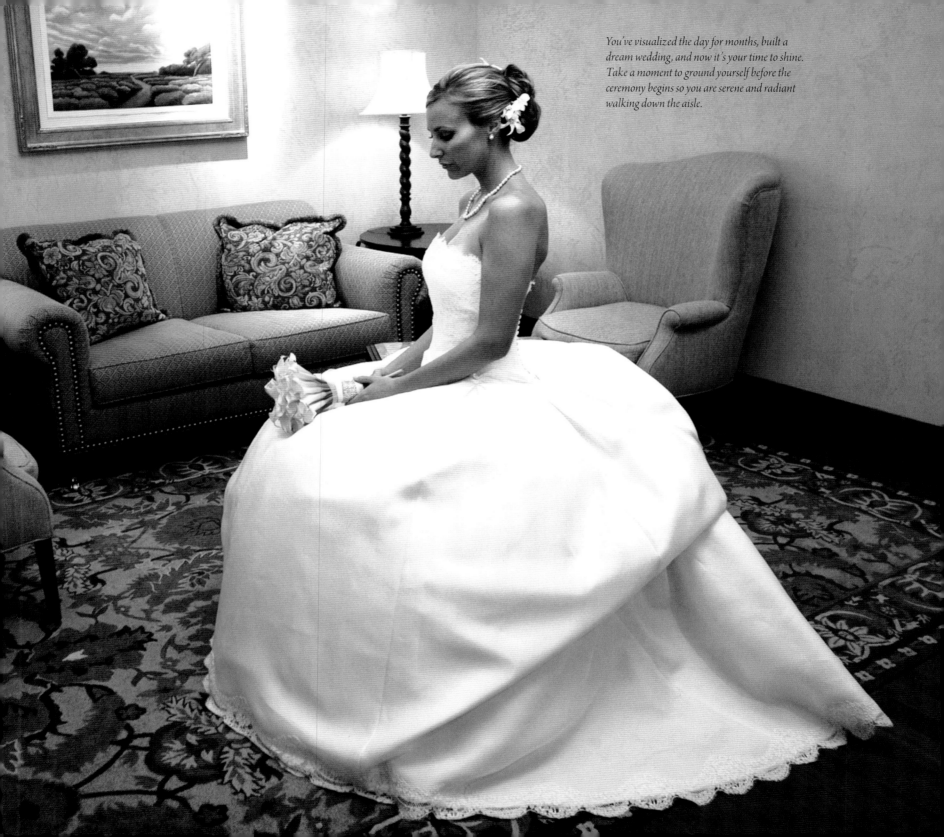

You've visualized the day for months, built a
dream wedding, and now it's your time to shine.
Take a moment to ground yourself before the
ceremony begins so you are serene and radiant
walking down the aisle.

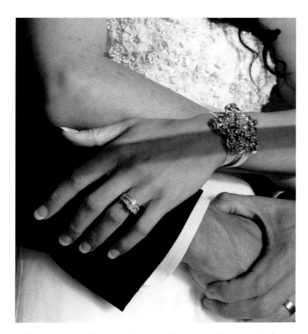

The not-so-small details, like the wedding rings, always make for a nice photo to be used later as an accent shot in your album.

artfully behind, or standing under the rose-covered arbor in an intimate moment just after the ceremony. We all have great potential to visualize the things we want in life. To some degree we all do it naturally, but some of us need a kick-start to use the creative part of our brains to help us see what we want to be or how we want an event to happen. Start now to calm you mind, open up to your creativity, and spend dedicated time visualizing your entire day. This includes the taking of hundreds or thousands of photographs in which you know you will look fabulous. Start posing in your mind. See it happen. You'll get in the flow, without even thinking about it,

when the photographer arrives on the scene on your wedding day.

To help you define the kind of photo style you like, you need to add a section on photography to your wedding planning book. Annie has suggested pulling pages out of magazines for different makeup and hairstyles to emulate, and that's a good idea for your dream photography as well. Cut out images that speak to you, ones that cause a gut reaction. Realize that many images you find in bridal magazines for gown fashions are highly produced and retouched. Use these images as ideas, directions; less so for creating a direct knockoff. These

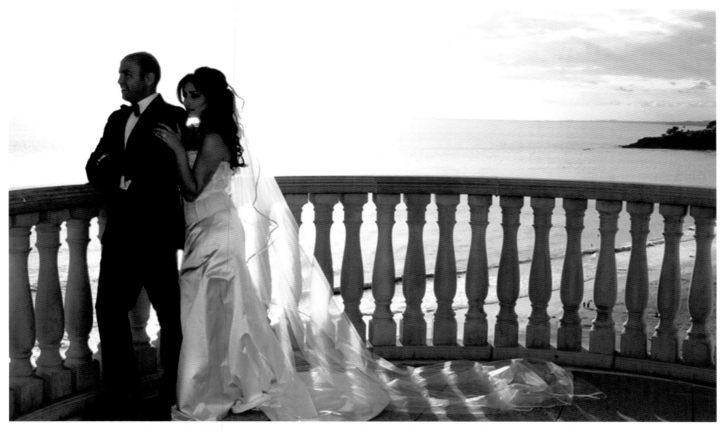

Posing profile and behind the groom without a bouquet allows this bride to perfectly place her hand on his arm to make the shot work.

editorial spreads are meant to inspire, just like couture fashions on the Paris catwalks. Most women wouldn't wear—let alone could they afford—these inspired fashions from the world's top designers. They offer only a breath of an idea that filters down to what's really wearable—prêt-à-porter or off-the-rack fashion.

Look for magazines that highlight real weddings. These are great for showing real people captured during a real event. Don't think too hard about it right now; just cut and paste to your heart's content. You can edit later as

you define the style you're looking for. Soon a picture will emerge of what you love. Is it romantic and soft? Straight journalistic moments captured in grainy black and white? Maybe more traditional, yet with a bit of fashion sense? Or a modern interpretation of a vintage gown? As Barbara and Annie have written, the creative sky is the limit. Don't hold back! There's plenty of time for that later when you are realistic with your budget. For now, just dream as if you're viewing your wedding through a golden lens and everything is possible.

Grabbing her gown with her hand and putting weight on her right leg gives a slight shift to this bride's hips to soften her stance and create a nice draping on the front of the dress.

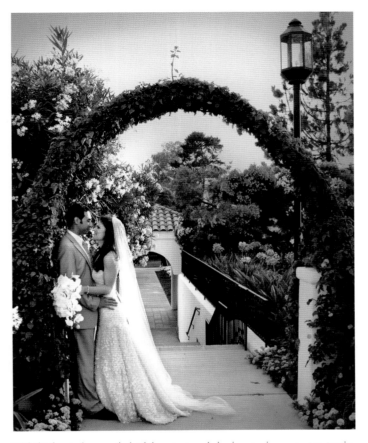

With this face-to-face pose the bride leans in strongly, her hanging bouquet mirroring the line of her draping veil. Seeing the groom's hand on her hip helps bring the shot together.

Finding Your Photographer

Now that you have an idea of what style of photography you like, you can begin the process of hiring the perfect shooter for you. There are a number of ways to do this. Rely on your wedding planner to find the perfect match for you through his or her carefully screened vendors,

rely on a referral from friends or family, or hire on your own. The "hire on your own" method takes detective work on your part. You may need to spend hours on the Internet perusing sites, narrowing your choices, setting up your own appointments, asking the photographers for references, and relying on your intuition. There is nothing wrong with this approach. You may even like browsing for hours through websites, discovering all kinds of ideas and meeting photographers to view their albums. You may be

A junior bridesmaid became the go-to gown wrangler for this bride. With large gowns and trains, you'll need someone at the ready to help you maneuver around your wedding site during pictures.

the first person in your family or group of friends to get married and so you're breaking new ground. If you find a winner through patient persistence, you'll become part of the second method of discovery—referral.

Photographers live or die on referrals. If they do a great job on your wedding, your sister, cousin, and best friend may give them a call when they tie the knot. If you receive a referral from someone you trust, you know you're cutting to the chase and putting your mind at ease. You have many decisions to make while planning your wedding, and every time you can cross one item off your to-do list, you will

feel a great sense of accomplishment. Booking your preferred photographer because you love his or her work is wonderful. Booking a photographer because he shot your friend's wedding and delivered beautiful images and got a glowing review for his people skills during the wedding day—that's a home run.

Or finally, you can rely on the professional you hired—your wedding planner—to plan and run your wedding. You've already taken the time to interview a number of planners. You've seen their work, sized up their personalities and working styles, and made a decision that one of them is the best partner for you. By looking on your planner's web page and albums, you've probably already seen some of the work of photographers to whom you'll be referred. Planners spend years cultivating the best vendors they can find. They take pride in their referrals. The team of vendors they assemble can help give a look to a planner's signature style. A good planner has a list of photographers he or she has worked with and trusts, and will match you and your style and personality with a photographer the planner feels will be a perfect fit. These are only suggestions. You have the final say. But with the

homework you've done with your visualization and the tear sheets you've pulled for your planning/idea book, you'll know quickly who is right for you.

Being a beautiful bride from every angle isn't only about choosing the right photographer, but it's a solid foundation to build on. When you're comfortable and confident with your choice, you'll be relaxed and willing to engage during shooting—a scenario that always, always makes for better pictures.

The Stylist-Photographer Collaboration

Regardless of your favorite photo style, whether journalistic, portrait, glamour, romantic, or a hybrid, every bride can benefit from a great stylist. I love stylists; they make me a better photographer. But I'm partial. Annie is my wife and a stylist. I can't do what I do without her. She'll argue that I can't do a good many things without her.

After reading Annie's section, you know by now how the makeup, hair, gown, and veil choices you make can help you look great in every photo. Even if you do your own makeup and hair based on Annie's

techniques, you'll have a strong understanding of how important that is to the final images. And your photographer will love you for putting the care and energy into making every aspect of the picture-taking experience a cohesive one.

Ask your photographer if he or she recommends a stylist. Some will even offer a stylist as part of your photo package. If you have a wedding planner, she'll have a list of preferred makeup and hairstylists and even gown wranglers or professional bridal dressers. Some hotels have stylists on staff, in the salon for wedding services. The important thing is to have the photographer, the stylist, and you all on the same page. You may hire a photojournalist to shoot your wedding in a very natural way, while someone refers you to a glamour stylist who lays the makeup on thick and piles your hair up like a cake. Not a good combination. It helps if the photographer and stylist have worked together before, but it's not essential. I've worked weddings with other stylists when Annie wasn't available or the client had her own person, and as long as the bride loved her makeup and hair and it translated beautifully to the style I shoot, everyone was happy.

From a photographer's point of view, anything a bride can do to minimize her stress level, such as having her hair and makeup done, makes for a more relaxed bride

and better photos. Having a pre-wedding run-through with your hair and makeup stylist is the single most important thing you can do to reduce the potential for disaster during your preparation. You wake up on your wedding day knowing you're going to look great, because you've already seen the outcome. This confidence spreads to your bridesmaids and everyone else in the bridal room. The photographer walks into a situation with everyone ready to go.

Another concern of photographers is what happens once you leave the room and begin the ceremony. Most stylists will complete the bride, then pack up and leave. Some might stay for the initial bridal portraits, or until the start of the ceremony, or even for touch-ups after the ceremony—there's lots of kissing, you know. A few, like Annie, will stay with the bride and photographer until the grand entrance to make sure she stays put together for the camera and for her guests. A critical period for photographers is the summer, when the heat can cause shine. There's nothing like a great makeup job that melts off during the ceremony, leaving you without a face for post-ceremony photos. If you don't have a stylist standing by, make sure your maid of honor

A bride watches in the mirror as her stylist makes last-minute adjustments to her hair.

or one of your bridesmaids has a compact of powder. Shine can be the ruin of a great photo.

A good stylist will anticipate what the bride and the photographer need. You may be ready for photos but dying of thirst. The stylist pulls out a straw so that you won't mess up your lipstick. You may have your veil securely fastened, then someone steps on it, loosening the veil and mussing your hair. The stylist places a few hairpins and you are on your way in seconds. There will be countless times you'll need little things like this during your wedding. A stylist can be a photographer's best friend and make a good shot into a great shot.

The Photographer/ Bride Collaboration

The teamwork between photographer and stylist is essential, but the most important collaboration is between photographer and bride. Even if you choose a documentary- style photographer for your wedding and plan on doing fewer posed photos, you still have an important

After your stylist has you ready to go, he or she can help place and secure floral pieces on the flower girls. Depending on the size of your bridal party you may need more than one makeup and hairstylist to have you ready in time.

role in this relationship. The choices you make during your day can yield amazing images even without posing. You know your photographer is following your every move. Be aware of where he or she is. If you have a small moment with the flower girl by bending down to talk with her, know you're creating a nice opportunity for an image. Know whether you're facing the best way, if you're in good light. Have the flower girl talk to you by asking her questions so she keeps her head up. Engage with your family and guests. Children and grandparents are always a magnet for a good photograph. Adjust the boutonniere on your grandfather's lapel. Adjust your father's tie. Kiss your grandmother on her check. You know your photographer is looking for moments, so keep the moments coming. Keep the moments real, of course; just be conscious of the flow and help the shots come into focus.

If you're doing longer portrait sessions, be prepared to play. All photographers love it when their subject meets them halfway with equal energy. This doesn't mean you have to start moving like an aspiring model on a reality television show. Be subtle and intelligent about it. If you've had an engagement portrait done, you'll have a head start on how your photographer works (more on that later). If you haven't, you need to come out ready to participate even if you're nervous, anxious, or your bouquet feels like it weighs twenty pounds and is throwing you off-balance. With all the work you've done preparing for this moment, you're anxious only because you're so excited to get to the picture-taking stage.

Practice

Stand in front of a full-length mirror. Put weight on each leg equally. Now break your weight onto one leg and let your hips sink onto the straight, weight-bearing leg. Bend the other knee slightly, shift your feet and body to a 45-degree angle, lower your front shoulder slightly, and then look straight into the mirror. Try subtly shifting your weight, angle your shoulders differently, drop your weight to the other leg, hold a fake bouquet, and see how it changes your arms. Try to mimic poses you like in the images you see here, even if it feels unnatural at first. The idea is to try to see the architecture of your body, your skeletal frame as articulating timbers balancing your weight in a graceful way. Think of a dancer and how he or she uses the body as art. Everything is clearly defined, accentuated so as to be seen from a distance on a stage. You can over-accentuate posing when you practice. Over time it will become more natural, you won't have to think so much. The posing repetition will help you to find a more natural awareness of your body, of subtle degrees of angles that add interest to the body position.

Start today to have an awareness of your body, and this simple act of consciousness will do more for you than anything else. You'll care more about yourself. You'll begin to feel and recognize when your body is sluggish and when you feel languid, regardless of your body

A normal stance can seem fine in person but caught on camera you can look flat and one dimensional (top left). A shift in weight to the back foot with the front leg slightly bent and the shoulders and hips turned creates a flattering shape (top middle). Turned even more with the hands dropped you can see how the back leg is carrying the weight (top right). What to do with your hands? In the bottom three photos our model demonstrates different hand positions and how they affect the pose. Notice how flattering the hips are in bottom middle. Practice different variations in the mirror while wearing form-fitting clothing and look for differences in your body.

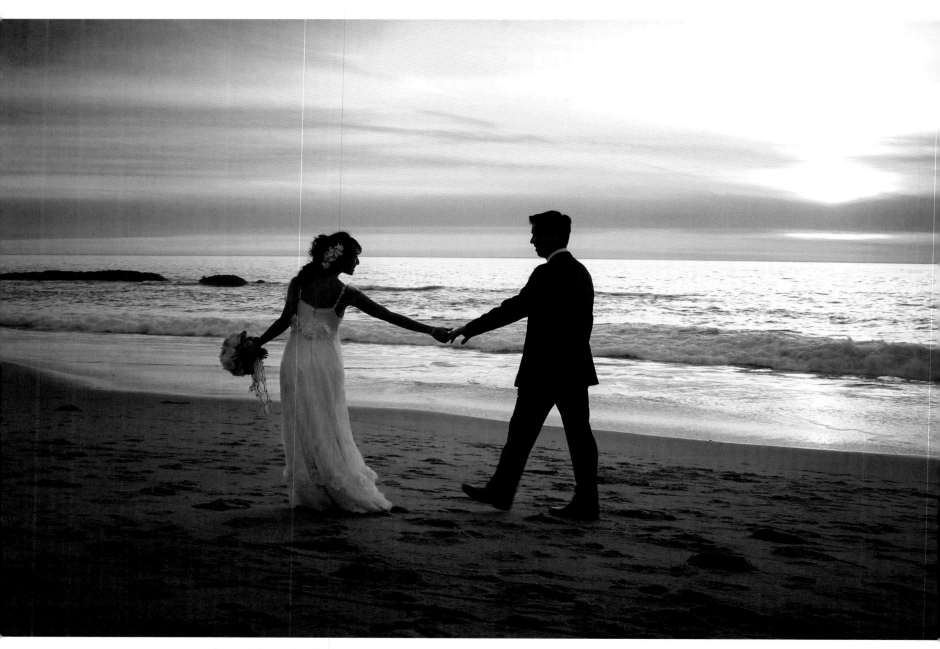

With a simple direction from the photographer to create some space between them and then connect again, this couple created a beautiful scene as they walked on the beach. Be ready to be playful and interact with each other. Your photographer will love you for it.

weight. You'll eat healthier and exercise more because it feels great to have energy in your cells and glowing skin and easy movement in your joints. The mind-body connection will grow stronger, your posing acumen will improve, and your emotional strength will be more accepting of any past limitations you may have held onto about your image captured in photographs.

If you have your dress, wear it, walk in it, move in it. Some gowns can be very heavy. Two hours into your event, you may start to drag, tired from the weight and terrified that more and more people will step on your train. Moving with your dress can take a village. You have to rely on people to carry your train, hold your bouquet, get you into elevators or down stairways, and position your gown when standing. If you're used to moving fast on your own, you'll have to slow down. That's why it's a good idea to feel your gown on you as you move your body through different positions. The same goes for your shoes. They may be seen only once or twice during the day—perhaps when you're walking down stairs and when you're seated if you choose to do the garter removal—by observant, fashion-conscious guests. Otherwise, it's only how you move in them that leaves an impression. Walk in them at home, turn, pivot, and stand for fifteen minutes (the average length of a ceremony). You might as well know what you're up against. It's hard to smile if you're grimacing in pain.

With the help of her bridesmaids, a bride lifts her gown to avoid any water on the ground on the way to the ceremony.

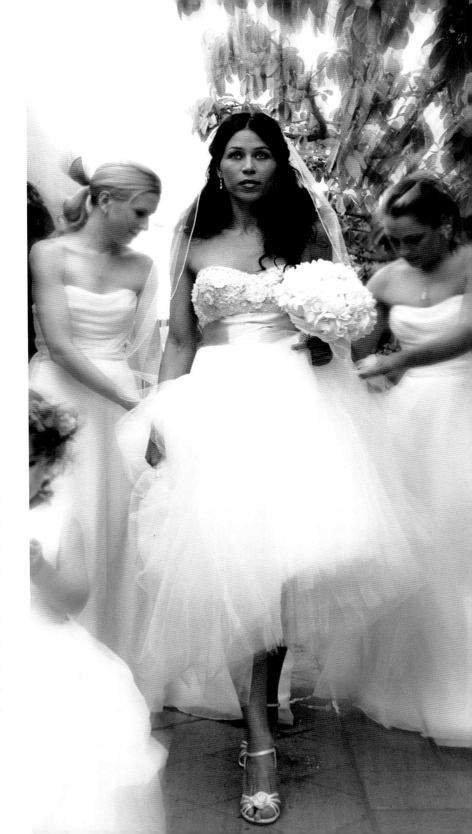

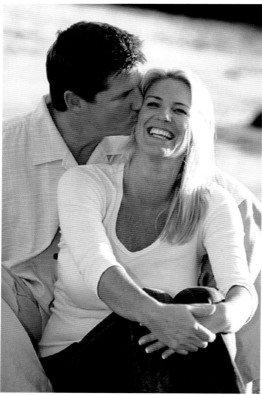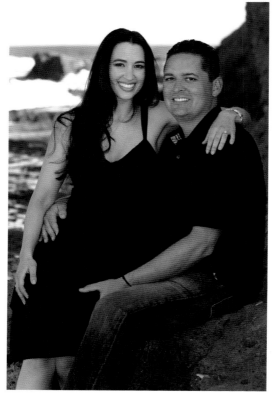

A pre-wedding shoot can be so much more than a traditionally posed photo. The sky is the limit when considering your engagement session. The bride on the far left grew up with a vintage carousel horse in her home. She decided to incorporate the visual by convincing her groom to shoot on a merry-go-round.

Practice what you've learned with some trusted friends. Why not have them over for some food and spirits and have some fun with a camera? You don't need to be in a gown. Try Annie's makeup and hair suggestions and take some head shots. Start with a nude face and build your look. See how your eyes change as you go heavier with mascara and liner. Try your hair in different ways. Snap photos with a digital camera and load them on your computer right away. In a safe environment, you can afford to snap and erase. You may be surprised by what you see. Start to pull back and get more of your body in the shot. Work your angles. Over-exaggerate your positions. Pay attention to your shoulders and your hips. After you overdo it, try bringing it way down. Make it subtle. Compare the images, especially the

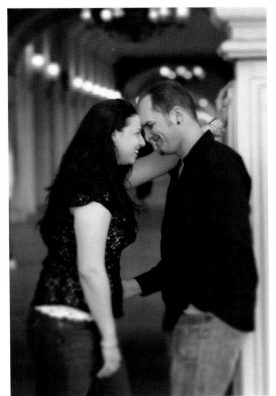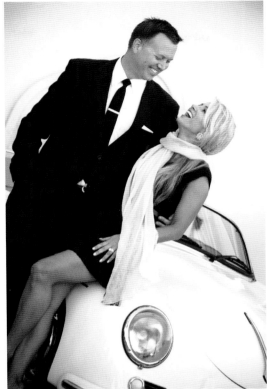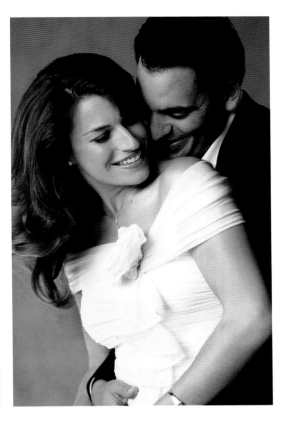

Your photographer may suggest poses to get you started but don't be afraid to improvise and try something on your own. One subtle angle of your shoulder and face while you interact with each other (right) can make all the difference.

look in your eyes. You'll find that you settle into a comfortable place when you go from big to small. You can erase everything at the end. The point is to create an atmosphere to practice, however simple it may be, so that—whether it's your best friend taking the picture or a hired photographer you're working with for the first time—the space you create in front of the camera is a safe place for you.

The next step to consider is a pre-wedding photo shoot with your wedding photographer. This is also known as the engagement shoot. The difference is defined by only you and your photographer's style. The image that might come to mind when you think of an engagement photo is a couple standing cheek to cheek, hand over hand, beaming into the camera. But it can be so much more. Don't think of it as a means to an end (a matted

Our cover bride and her groom had their ceremony in a modern art gallery and wanted to display vintage-themed photos from the fifties and sixties in the entry way. Here is one sample with a sixties cocktail theme. This couple was able to express their personalities with a tongue-in-cheek style that set the tone for their upbeat wedding.

enlargement for display at your ceremony where guests can sign along the edges of the mat board). Think of it as expressing your personal style. Think of it as rehearsal with your groom.

Think of it with dozens of end uses—prints, little books, a slide show on the web, sharing on social networks. It's not that the traditional engagement shoot is dead; it just has so many more possibilities. I've shot couples jumping on the bed, riding Harleys, including their dogs in the shoot, going totally retro with vintage clothes and makeup, with their surfboards—the sky is the limit. You want your and your groom's personality to shine. You'll have plenty of time to be traditional on your wedding day. Let loose for your pre-wedding shoot. It's just like going big with a posing party with your friends. The experience of being in front of the camera with your groom is like taking dozens of dance lessons for your first dance. Come wedding day, you'll be excited to start the photo process. When you and your groom take your pictures together, you'll start where you left off and be fully engaged in the process, relaxed enough with your photographer to allow intuitive creativity to take over as though you've been modeling for years.

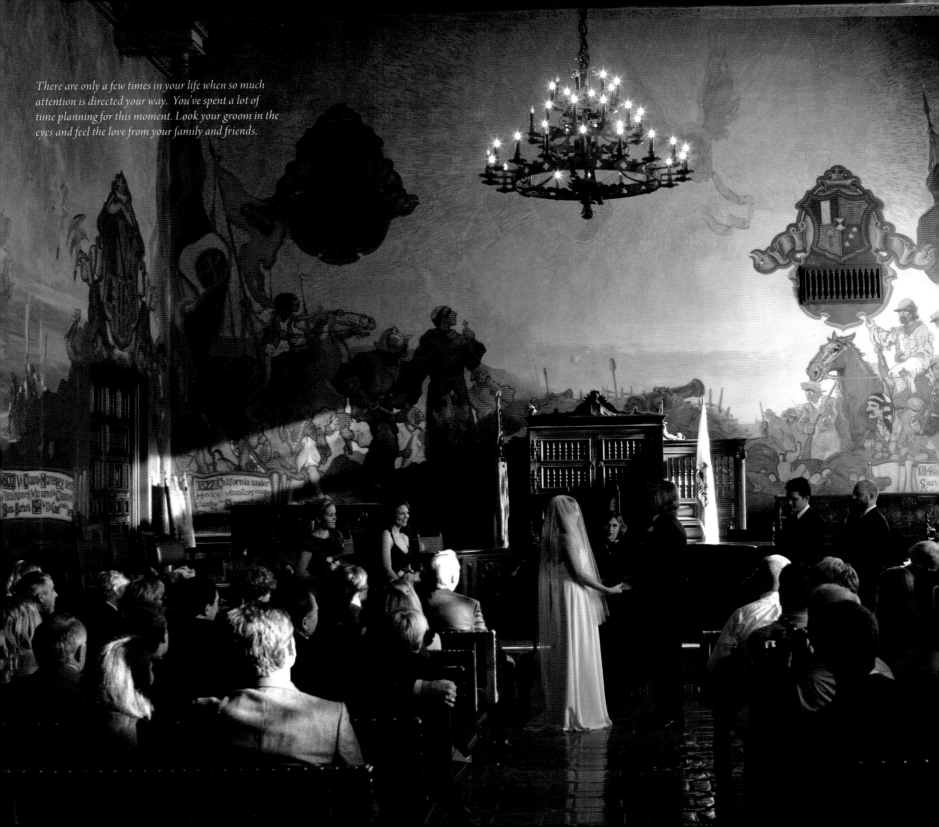

There are only a few times in your life when so much attention is directed your way. You've spent a lot of time planning for this moment. Look your groom in the eyes and feel the love from your family and friends.

THE BIG *Day*

The biggest decision you'll be asked to make

during the photography planning stage is, "Do you wish

to see each other before the ceremony for photographs?"

Your wedding planner will pose this question when she

begins to put together your timeline. There are many pros

and cons to this decision. The main reason for couples

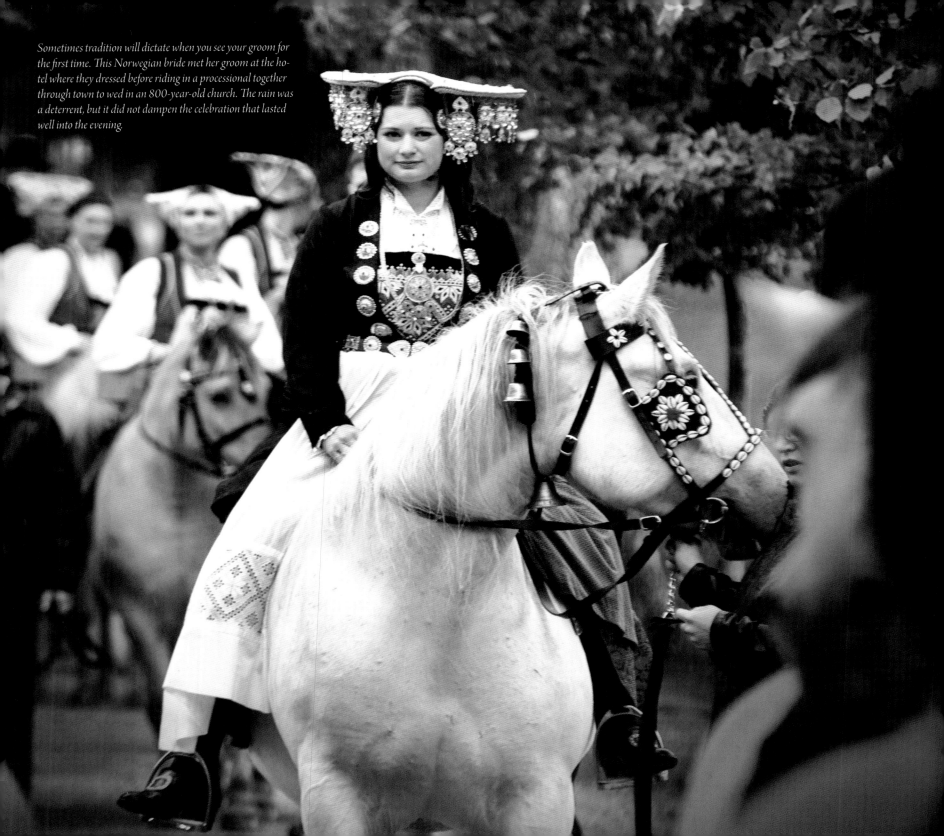

Sometimes tradition will dictate when you see your groom for the first time. This Norwegian bride met her groom at the hotel where they dressed before riding in a processional together through town to wed in an 800-year-old church. The rain was a deterrent, but it did not dampen the celebration that lasted well into the evening.

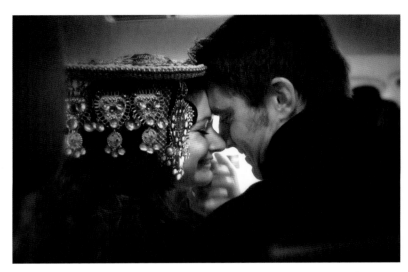

On the way to the reception after the ceremony, this couple share a smile and a kiss.
"We did it!," you may state out loud but it is the expression that says it all.

to see each other beforehand is to get through 90 percent of the photography so they can have more time to enjoy themselves with their guests after the ceremony. This may mean getting dressed earlier and having all family and wedding party members ready for group shots, but it does give the bride and groom a free pass to celebrate as soon as they walk up the aisle.

On the other hand, you take the anticipation out of the processional and of seeing each other for the first time as you walk down the aisle. Also, depending on the time of day of the ceremony, you may want to wait for the best light—the golden hour just before sunset—to have your portraits taken instead of the harsher midday light before the ceremony. Or you can work with your planner and photographer to set up a "first glimpse" between you and your groom where just the two of you—and your photographer, of course—see each other for the first time in a dramatic, photogenic location.

The rehearsal is the perfect time to practice your walk, the exchange from your father to your groom, the hand off of your bouquet to your maid of honor, and the pace of your recessional. Stay focused. You'll have time to socialize later at the rehearsal dinner.

Rehearsal and Rehearsal Dinner

Before getting too deep into the wedding-day events from the photographer's perspective, let's discuss the rehearsal dinner. Not everyone will have a rehearsal event, but most will have some kind of informal practice to rehearse the ceremony staging. Significantly, this may be the first time the entire wedding party is together, and it can quickly turn into a social hour if your wedding planner isn't on top of the crowd and directing their attention. Use

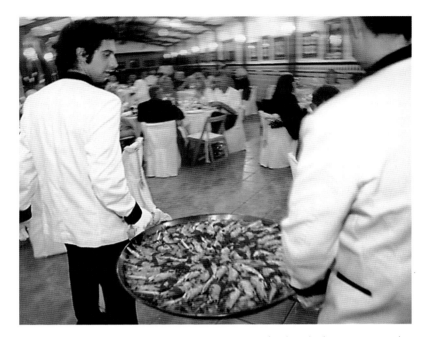

Many families take the opportunity to dine intimately with only close family while others find
hosting a large dinner with friends and family a wonderful way to extend the celebration.
(Paella is served, left, and dining al fresco with flamenco guitars, right.)

your rehearsal time to your best advantage. Greet your wedding party and family and get down to business. You'll have plenty of time later to catch up with everyone. It's a good idea for you and your groom to enlist the help of your maid of honor and best man to keep those in your wedding party on their toes. I've been to many rehearsals and can safely note that it's always the guys who tend to drift off and lose their concentration. Instead of the bride and groom playing taskmaster here, your maid of honor and best

man will get their first taste of the day ahead. It's also good practice for them to help you manage your wedding by taking the stress off of you and assuming their roles as your main assistants. You will not have much to remember—your cue to start walking, to hand off your bouquet to your maid of honor, the vow exchange, and your cue to recess after your kiss. Use every minute to bank some great visuals so that when you're falling asleep you can still rerun the images in your head and see everything going perfectly.

It is very smart to practice your walking pace, your posture, and your expression during your rehearsal. Try to wear shoes similar to your wedding shoes. It's pointless to rehearse in sandals and then realize during your processional that your heels are sinking into the grass you have to cross. It also helps with your pacing. As we've already advised, practicing at home in your shoes so that you can strike a pose is great. Now you have a chance to actually walk down the aisle as gracefully as you can. Use everything you've learned from practice and your visualization exercises to strut your stuff. Work with your father or your escort to slow down or speed up your pace. It can feel awkward to slow it down, like you're going way too slow, but it looks real and gives everyone, including your photographer, plenty of time to see you. Look ahead to your groom. He'll be beaming, crying, exultant, or all of the above. You might get distracted by your guests wanting to catch your eye, but keep your focus on the prize. Walk tall, like a dancer. Know that your posture is the hanger for your beautiful gown and that how you move will dictate how great your dress looks. Your expression during your processional may surprise you later when you see your photos. If you're truly in the moment, it will translate well through the lens. If you're trying to hurry down the aisle, nervous and unsure of your walk, it will show in your pictures.

Be present, and let your photographer catch your true emotion in motion.

The rehearsal dinner is usually planned for just after the rehearsal so that everyone is in a great mood and ready to celebrate. This may be one of your favorite occasions of the wedding weekend, a memorable event: the informal atmosphere, a smaller crowd, fewer people pulling on you, and sharing the anticipation of the wedding day with those you love. It's a great time for photos, too. If you don't hire your wedding photographer to shoot your rehearsal dinner, be sure to have your family and friends snap pictures. I've heard some of my favorite speeches occur spontaneously during these dinners, and the facial expressions of guests are priceless.

One word of caution worth emphasizing: watch the drinking! There's nothing like having a great time the night before your wedding and being awakened the next morning by your photographer knocking on the door. As for the groom and his groomsmen, there's not enough space in this book to discuss the merits of drinking in moderation. That's best left to a conversation between you and your fiancé. Some couples have the rehearsal dinner two nights before the wedding, say, on a Thursday followed by a Saturday wedding. Friday can be left for manicures and a spa—and recovery.

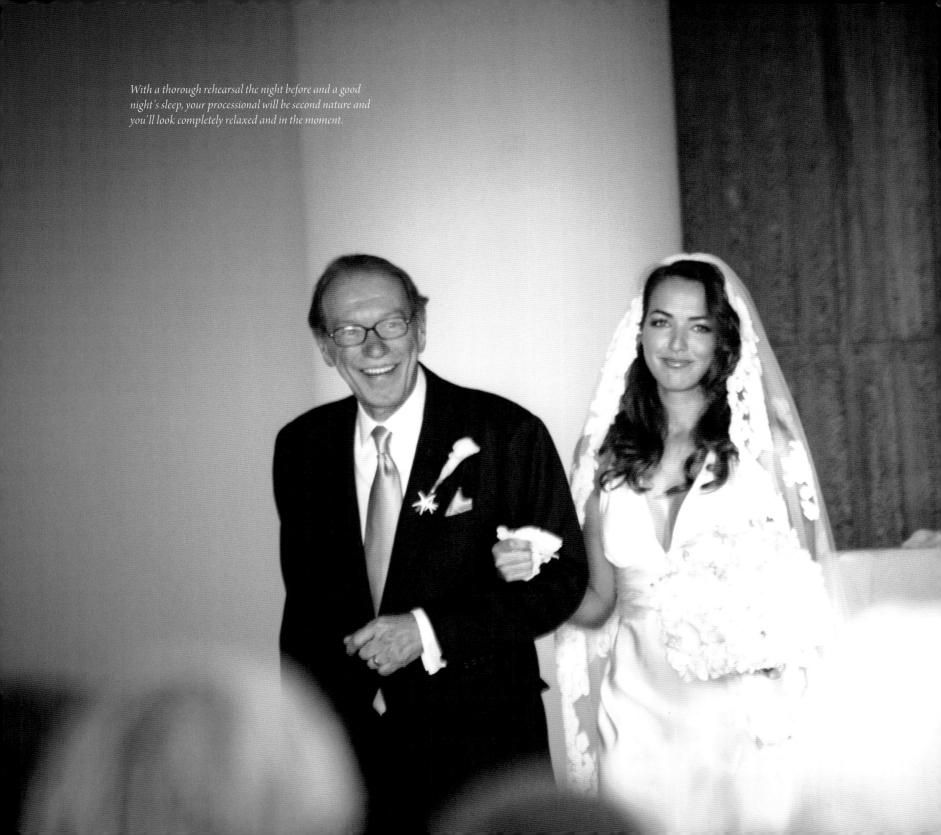

With a thorough rehearsal the night before and a good night's sleep, your processional will be second nature and you'll look completely relaxed and in the moment.

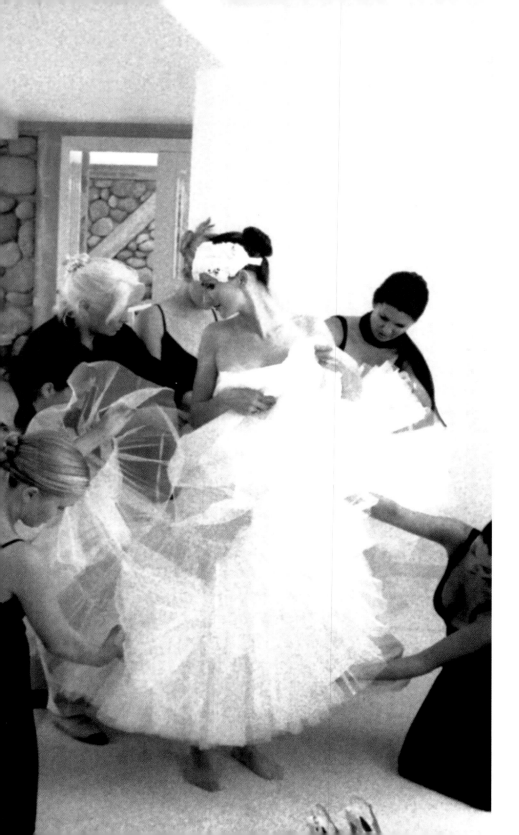

Getting Ready

Regardless of what your official timeline says, you should prepare your own timeline for everything you want or need to do before the official timeline starts. If you're starting makeup at 11:00 A.M., what are your plans from 9:00 to 11:00? Do you like to work out, take a bath, have breakfast with your mom and sisters? Unless you have a morning wedding and need to get up at 6:00 A.M. so that you're ready by 10:00 A.M, you should make time to relax. Let go for a few hours, because once things get rolling you may not have time to think. You've done all the pre-wedding visualization. You know exactly how it's going to go, so you can trust in the decisions you've made and the vendors you've chosen.

The first person you should see on your wedding day is your maid or matron of honor. Unless you have a full-time personal assistant, you're going to need her to help you manage the day. You will have already walked through the day with her so that she understands her duties. It's like me working with a good photo assistant. I rarely have to ask for anything; he anticipates everything I need. So, too, with your maid of

Get all your attendants to help so all you need to do is step into your shoes, and grab your bouquet, and you're ready for photos.

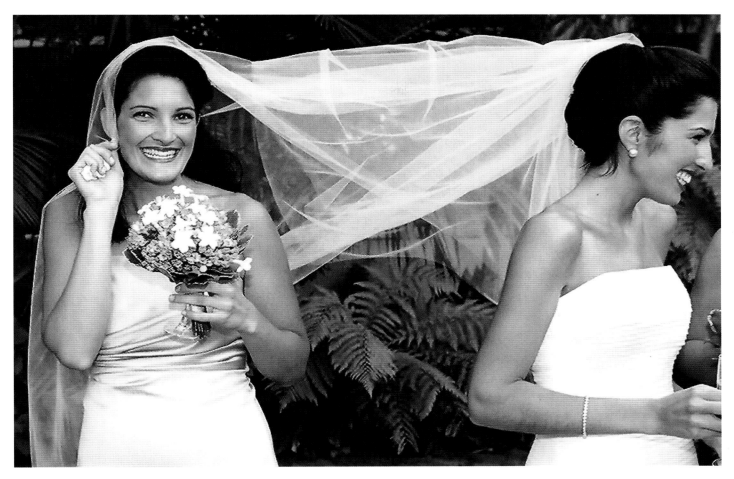

The perfect maid of honor is always at your side, always smiling and ready to help. If she adds humor to your day—and your photos—all the better.

honor. She's honored to stand by you on your wedding day and celebrate your passage into marriage.

Create a list of responsibilities for your maid of honor; it will help you to select the right person. You may consider your close friend, but although she's a loving and talented person, she may be hopelessly disorganized. If you choose her anyway, shift some of her responsibilities to another person you know will rise to the occasion. Don't leave things to chance. It's amazing how fast things can unravel when one person decides she needs to re-do her hair and your perfect timeline is now thirty minutes behind schedule.

One thing to be aware of when planning your preparation time is how many people you want in your room. Are you at home or in a hotel? Do you have a suite large enough to accommodate eight bridesmaids and two flower girls and their mothers? Are they all getting

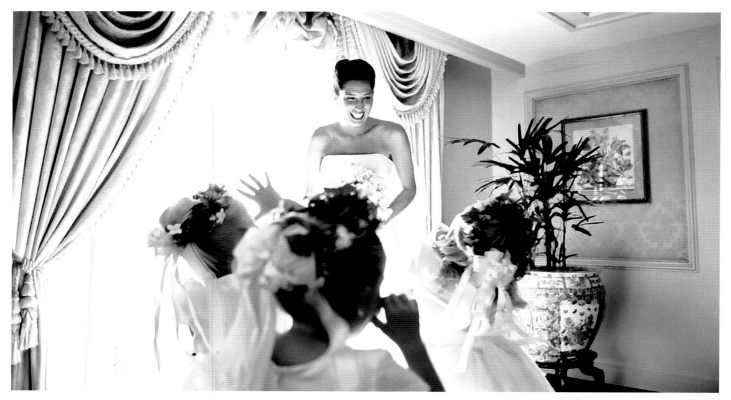

Sometimes your dressing room is a whirlwind of activity. Stepping out to use the light and background of a nearby window allowed these flower girls to release some energy before their important walk down the aisle and brought a smile to the bride's face.

dressed in your room, or should they arrive dressed? Part of the fun is having everyone together prepping for the big day. Just plan your space well so that you're not tripping over each other and the photographer has room to compose shots. I've been in many rooms where there's barely enough space for me even when I'm pinned against the wall. If you are considering a hotel, see if you can work a suite into your budget. The extra room on your wedding day will be well worth it. Some venues have their own bridal suites. Before committing to a venue, ask to see the dressing area and imagine yourself getting dressed there. Will it fit all your bridesmaids and visiting family members? What may look nice in a photo on a website may be much smaller than you think.

More of a concern is garment bags, plastic wrap, and shopping bags strewn about that can clutter the background in a photograph. Real life is cool, but everyone getting dressed in one room can be messy. A beautiful photograph can be ruined by trash in the background. Plan your dressing and that of your bridesmaids and family to be photo friendly and you'll be much happier with the results.

The Photographer Arrives

The first vendor you'll most likely see on your wedding day is your hair and/or makeup artist. Either they will come to you in your home or hotel or you'll visit their salon. In my experience, keeping the bride in one place is always good. You don't have to worry about getting dressed and driving anywhere. It's best to stay in your bathrobe and let everyone come to you. Depending on how you planned your timeline, your photographer may arrive midway through your styling. This gives you a chance to get some makeup on for pictures and still allow enough time for your photographer to document the styling process. Remember, most photographers will shoot your wedding as a story, and the preparation is a big part of the story. The transformation from everyday style to a beautifully styled bride is dramatic. Every story needs drama, so even if you use only a few getting-ready shots in your album, it's great to have the coverage. However, every bride is different. I've had some clients who preferred not to have any preparation shots at all. Others wanted me to arrive early to capture all the bridesmaids getting made up. You'll find your own preferences as you discuss this with your photographer.

While you're in the makeup chair, your photographer will get a few scene-setter shots—wide shots to establish you in the space, some medium shots, and perhaps some extreme close-ups. Don't be alarmed by these close-ups. The camera and lens may feel uncomfortably close to your face, but only a small detail is being captured: the tip of a lip pencil touching the lips, a mascara brush separating your lashes, or a blush brush adding some color. You may never use these images in your album, but it's a great way for your photographer to get started shooting. Finding beauty in your face and the details of the preparation process will get your photographer into the creative mood, feeling as though he or she has captured some great images right out of the gate.

Your photographer will also take the opportunity to shoot details of your gown and accessories while you're having your hair and makeup done. Your maid or matron of honor can help with this by taking your gown from the closet, removing the protective plastic, and either hanging the gown in the dressing room or bedroom near the window or laying it on the bed. It doesn't have to be laid out for a perfect still-life shot. Real is better. Having natural window light nearby will bring out the details in the dress. More often than not, I'm the one pulling the dress out of the closet and finding a place in the room to hang it. If your maid of honor knows her role and wants to be involved, she can be a big help by facilitating the shooting of the details and preparing your dressing space.

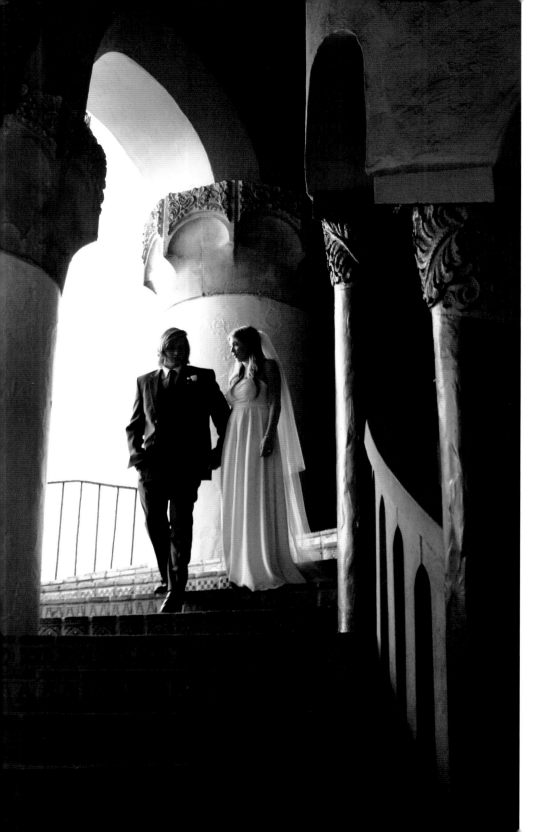

You've completed your makeup and hair, your bridesmaids are all dressed, your bouquet has been delivered, and now you're ready to get dressed. This is a beautiful ceremony to photograph. There is strong action, lyrical arm movement, mirror reflection, the artful design lines of the dress, sweet emotion, and a connection between sisters, friends, and your mother as they help transform you into a beautiful bride. It helps to know who you want dressing you. If your bridal party is small—two or three people—they can all effectively help you. If you have a large party of eight bridesmaids, it's easier to have two or three help while the others remain in the background. You might consider having your mother, grandmother, or sister put on any jewelry you might be wearing. This is an intimate moment and certainly worth capturing, especially if the jewelry has family significance and is being passed on to you for this occasion.

I will usually wait outside the room until the bride has stepped into her dress and is ready to be buttoned up the back. If Annie is on the shoot with me, she'll stay

The bride's bouquet was waiting for her at the bottom of the stairs for the start of formal portraits, but this shot had more magic. Always be aware that you may be photographed at any time during the day, from any angle.

in the room and document the more intimate moments. Ambient room lighting can help capture getting dressed in a beautiful way. Wedding photographers love shooting with natural light whenever possible. If your dressing area is appealing to your photographer, he or she will find the right angles to create beautiful images. But don't worry if it's not. Any good photographer can work magic in a dimly lit, cramped room; it's just more challenging.

Your bouquet will be delivered shortly before you get dressed. Your planner will make sure that your florist has the exact time on the timeline for delivery. Often the photographer will have enough time to take still-life shots of your bouquet while it's still very fresh and before it's handled too much. About fifteen minutes before you need the bouquet for portraits, it's a good idea to have your maid of honor take the bouquet out of water and let the stems dry before you have to hold it close to your gown. She can either stand it upright in an empty vase or use a dry washcloth to wrap the bottom to absorb the water. In the rush to stay on schedule, I've seen many brides grab the bouquet as they head out the door for photos, only to be surprised by water spots on their gowns. Not the kind of stress you need as you prepare for photos!

I always like to start shooting portraits as soon as the bride has her dress on. First, there's no time like the present. We have to stay on schedule and if you wander

A flower girl takes her job very seriously, but it can be a long day for her. If her parents are not in the wedding party, make sure they are near by if she needs reassurance.

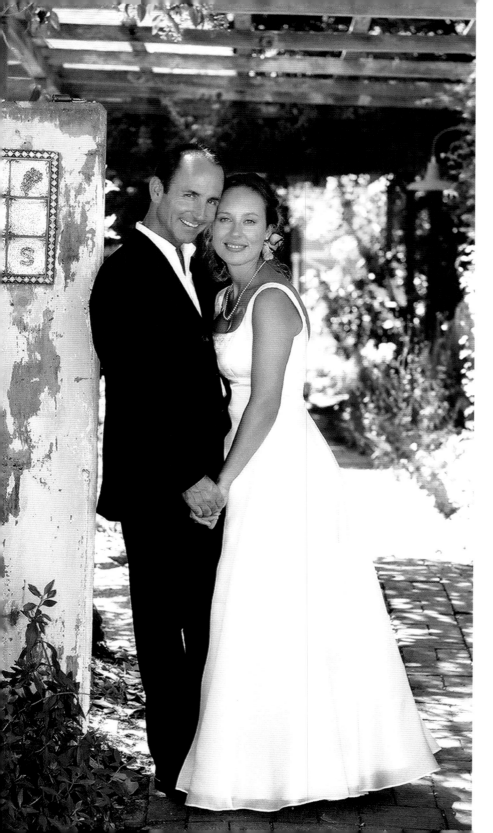

about chatting with everyone, it's hard to get you back. Second, soft window light is very flattering, and some of the nicest close-up shots come from this time. Your makeup and hair are fresh; you've just dressed and have seen yourself in the mirror. Your eyes are full of anticipation and emotion. Everyone is telling you how beautiful you are. Now is the time to look straight into the lens and be a beautiful bride. This is an easy and subtle process. Unless the dressing room is very large, the distance from photographer to bride is close, so it's like having a quiet conversation. I will suggest a few head positions to capture various angles, but the emotion comes from you.

Since the emotion is already there and you've visualized this moment many times, it will feel like a very natural process. Just as in the movies when an actor is in close-up, very subtle movements can come across as big. Raising the chin slightly, angling your shoulder toward the lens, bringing your eyes down, then slowly up to the lens—all these small physical shifts create variety in your shots and the chance for magic to happen.

Before you walk out the door, it's always good to get a few casual shots with the family at hand—usually your mother and father, and perhaps siblings and grandparents. If your dressing room is small,

Although taking pictures before the ceremony can mean more time to mingle with your guests after the ceremony, this couple waited to see each other and it's clear in their expressions how relieved and happy they are.

you may elect to meet your family at a specified location for family portraits. But if your father stops by to see you in your gown for the first time, it's a wonderful moment to capture in an intimate setting. It's odd, but once families congregate to take portraits, everyone assumes the "formal" portrait position—standing lock-kneed, looking straight into camera, and mustering a smile that's been worn before in hundreds of photographs. Why not take advantage of any opportunity to capture authentic moments and work them into your timeline? Will grandma stop by to give you "something old"? Will your niece, the cute-as-a-button flower girl, be nearby when your veil is placed so she can give a sense of proportion and wonderment to the shot? Your photographer will capture amazing moments happening all around you, but having all the right players in the right place at the right time will keep the action within shooting distance of the bride and give you more than you can hope for in your photographer's edits.

Showtime!

Now you're out the door with your bouquet for your bridal portraits. This is the point where your pre-planning comes into play. If you've decided to see your groom before the ceremony, you'll be directed to a perfect spot at your venue for your first glimpse. This is all about you and your groom. Your photographer will take plenty of shots of the two of you together as well as solo shots. This can be a lot of fun. Not only will you release all the nerves once you see each other, but you've been practicing ahead of time so you'll really be able to let go. Remember to have some tissues or your makeup artist at hand in case the tears flow when you first see your husband-to-be. You have a lot more photos to take! And make sure you're using waterproof mascara! Once you've finished these shots, you'll meet the rest of your wedding party and families at a predetermined spot for the rest of your portraits. With most of these pictures out of the way before the ceremony, after the recessional you're free to enjoy the cocktail party.

If you're not seeing your groom until the processional, you still have plenty of images to take pre-ceremony. The mood may be a little different. The anticipation could be higher, with some nerves on the surface. These shots are of you and your bridesmaids and, if you choose, your close family. The shots of you and your groom come later, as well as the combined family and wedding party shots. But don't be afraid to work those poses, even if you feel alone out there in the middle of nowhere. Your practice and your instincts will take over, and you'll nail some beautiful images before you even see your groom.

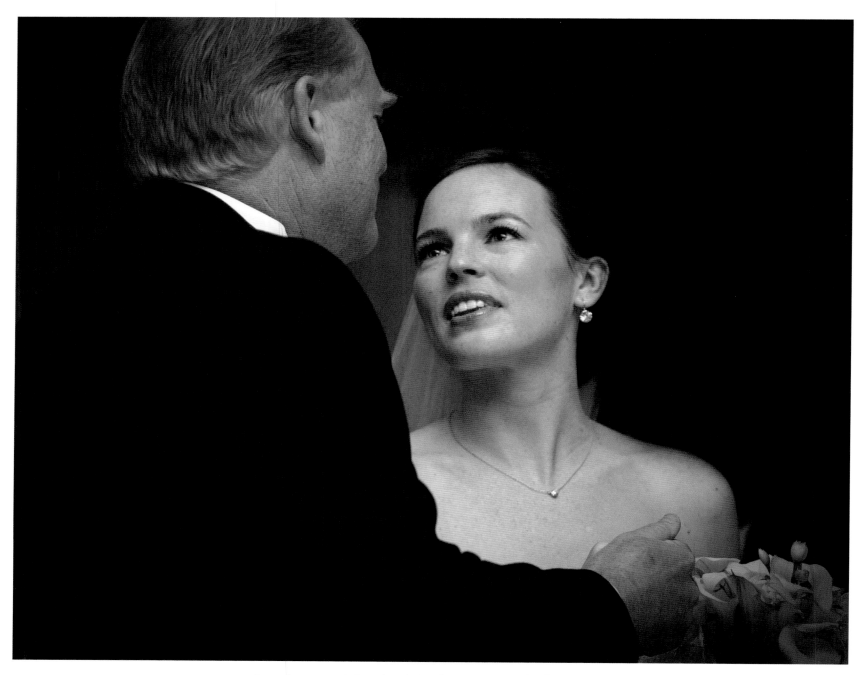

Remember not to rush down the aisle. It took your parents two decades to raise you.
Take a slow walk with your father and give him a moment to know how you feel.

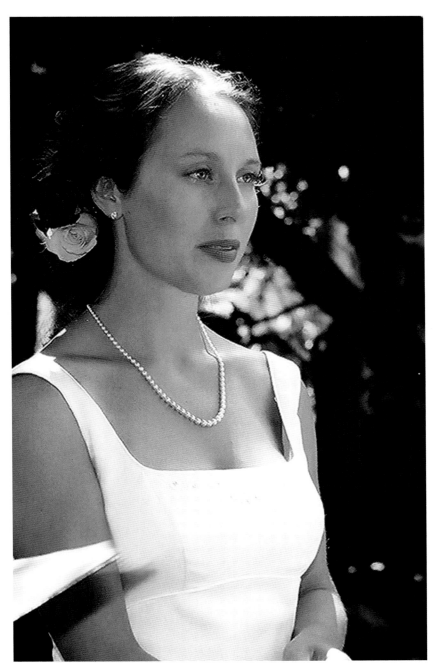

When your planner has everything under control, you'll be able to let go of any nerves and really listen to your groom during the vows.

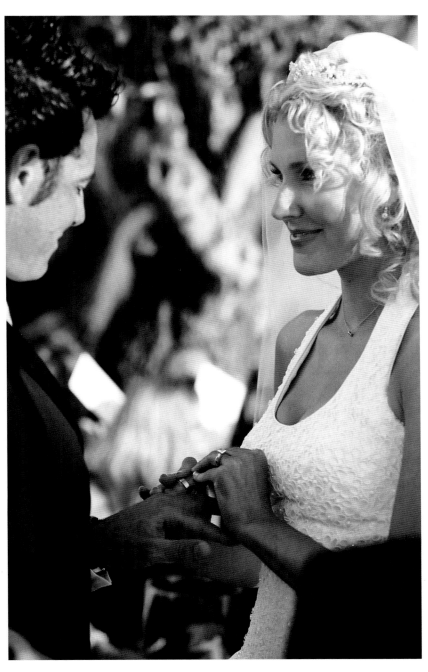

Looking beautiful during such a peak moment in your life as the ring exchange comes from within and is expressed with your eyes and smile.

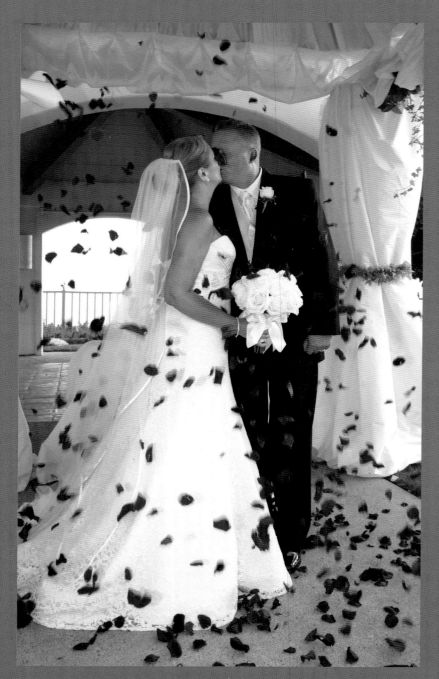
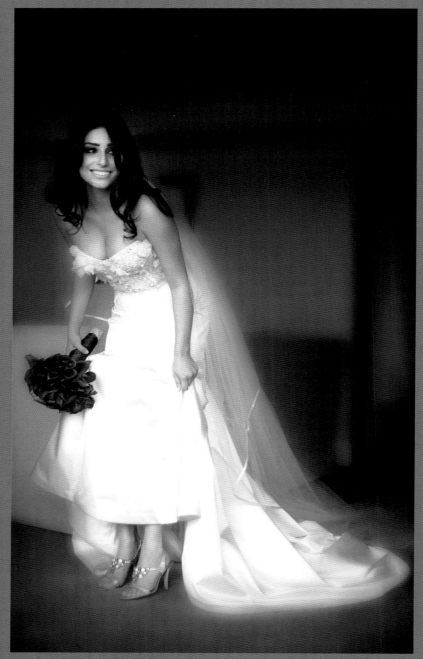

A rose petal drop (left) surprised the guests at the end of the ceremony during the moment of the kiss. The bride's white bouquet against the red rose petals created a dramatic effect. A bride shows her shoes (right) and still manages to hold her bouquet gracefully.

Photographing Your Bouquet

No matter if you're sitting or standing, try placing your bouquet in different positions to find the right spot (left). Holding the flowers high (right) is always nice for a shot or two, especially if the color of the flowers complements your eye shadow, as it does for this bride.

A word about your bouquet: As you can see in the photos, your bouquet can play a very important part in your portraits. Or not. Many of the images in this book are of brides without their bouquets. Remember, traditionally it's important to walk down the aisle with your bouquet. Whether you want it present in all your photos or just a few traditional shots is up to you. Annie spoke about the size of your bouquet and how to best tie it together with your whole look. If your gown is large and has a long train, a large bouquet will help complement your dress. If your gown is light and airy, a large bouquet can overwhelm it. Especially when you're posing with your groom, you may want to shoot a high percentage of shots without your bouquet so you can use both hands to interact with him. Just remember to practice holding something the same size and weight as your ordered bouquet. I've seen many brides surprised by the weight and literally fatigued by the oversized arrangement. This is why it's important to have your maid of honor nearby to act as your bouquet wrangler. She just may hold it longer than you do.

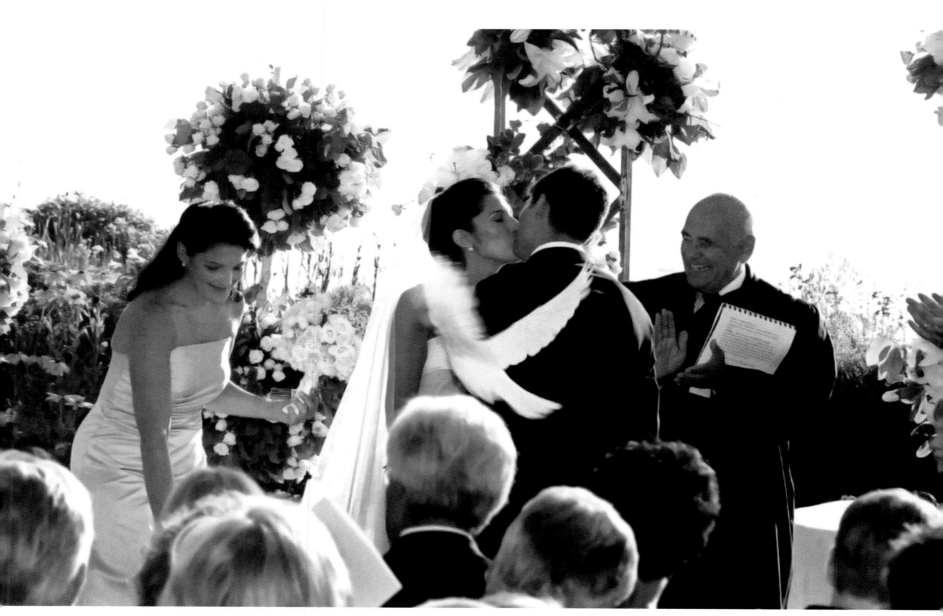

The wings of a white dove nicely frame a kiss. Notice how the maid of honor is adjusting the bride's veil and has her bouquet ready to hand her for the recessional.

In the rehearsal segment, I mentioned the processional. There's no mystery about it on your wedding day. You've had a chance to walk it before, so now just be present. There is no posing involved. This is all about taking your time to walk. You've practiced your walk and pace, so your photographer can capture you in motion naturally. Throughout your ceremony you are in a peaceful, loving state of mind, focusing on the officiant's words, your groom, and the actions of the ceremony. Your photographer will capture your expressions. Even though you have worked hard at being a model, this is all about connecting with your partner and being in the moment. After the kiss and recessional, you'll have plenty of time to work the camera.

Ah, yes, the kiss—might as well make it a good one, and long. Nothing like a quick peck to make a photographer start thumbing through his shots, praying he got it!

Turn and face your family and friends. Take a moment to take it all in before you and your now-husband walk up the aisle. Let them admire you and applaud you. You've worked hard for this moment. Remember to collect your bouquet from your maid of honor. Hand-in-hand, walk a slow walk.

If your ceremony is outdoors, you may have planned for your guests to throw flower petals, blow bubbles, or toss rice, or you may have a dove release. All of these add to the drama and the potential for a spectacular photograph. Be aware of your positioning and your posture and the speed of your gait. If flower petals are raining down on you, lift your chin and feel the love; don't bury your face in your husband's chest. Natural reactions truly are the best, but since you've had so long to plan your wedding, you might as well make your recessional a centerpiece of your album and preserve it as the peak moment that it is.

Long after the ceremony, there will be plenty of kissing in your post-ceremony photographs.

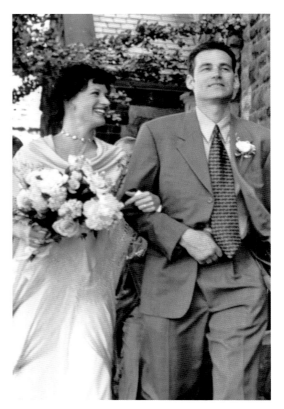

Your recessional is participatory. Your guests may throw rose petals (far left), applaud, try and catch your eye or your hand on your way up the aisle. Even when you're out of guests' view, your photographer may capture a spontaneous moment (middle) in a hotel hallway or on a brisk walk (right) from the church to the reception hall as in this vintage-themed wedding.. Be ready for anything!

Married at Last!

Immediately after your recessional you'll be whisked away to a private spot where you and your husband can have a quick moment alone. I usually keep my distance at this point, grabbing a few shots with a long lens so I don't intrude on the moment. Your wedding party and closest family usually will join you in congratulations. If you're at a hotel that hosts a lot of weddings, you may have an attendant at the ready with champagne and hors d'oeuvres. This is a beautiful moment for you and your closest friends and family, where you are not "on" and don't have to perform. Enjoy yourself before the rush of photos and posing that will follow.

If you elected to see each other before the ceremony and checked off the wedding-party and family

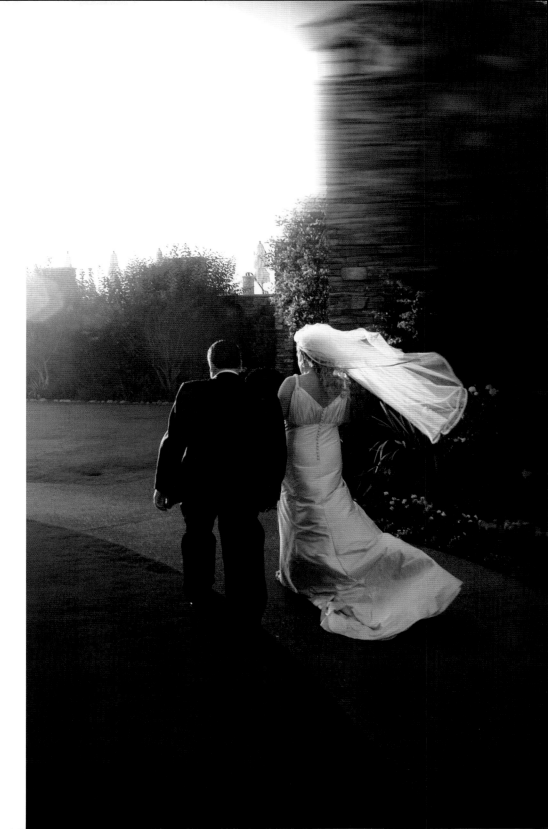

shot list, congratulations, you may proceed directly to the cocktail party. If you still have portraits to do, gather yourself and get ready for fifteen to thirty minutes of fast and furious portraits. A calm yet assertive photographer can make this process go smoothly. If you've prepared ahead of time with a shot list and your requested family members know where to be, all you will have to do is stand with your husband while your photographer moves different people in and out of the shots. Even if you've hired your photographer based on his or her documentary style, nearly everyone expects these kinds of group portraits. You may edit these out of your final picks for your album because you like the more spontaneous and "real life" images your photographer captured, but they are still important historical images. This process will go much more smoothly if each side of the family has a "wrangler" to round up the family members needed for the portraits. With large families and wedding parties, you

With formal family portraits complete, a bride and groom walk to the bluff for sunset shots. It's been a long day already, so you need to take a breath and prepare for the last of your formal bridal portraits before heading to your reception.

would be amazed at how many people are lost to the lure of the bar at the cocktail hour. Discussing the importance of the post-ceremony portraits and where everyone needs to be at the rehearsal dinner is a very good idea.

Once the wedding party and families have been photographed and released, it is the bride and groom's prime time for photographs. Depending on your venue, your photographer will have some spots picked out for your portraits. Where I do most of my work, on the coast of Southern California, the beach is always a popular destination. In other areas, hotels and other wedding venues usually have a garden or photogenic area to shoot in. This is the time for you and your groom to really come alive. The tension has melted away, everyone is happy and ready to celebrate, and you have another fifteen to thirty minutes to immortalize the moment. A lot has happened since you started your day in a bathrobe ready for hair and makeup. Here you are, and it's time to pose.

After what seems like hundreds of photographs, this groom has had enough! He jokingly called me paparazzi as we headed back to the cocktail hour.

Hair and Makeup from the Photographer's Perspective

Makeup touch-ups is just part of refreshing your look for photos, your guests, and especially your groom.

One note on your makeup and hair: Even though you may have touched up before the processional, there is a lot of kissing and hugging that goes on post-ceremony. If you don't have a stylist or haven't retained one to stay through the grand entrance as Annie recommends, have a bridesmaid be in control of a small stash of makeup and hair products: lip pencil, powder, hairpins, compact hair spray. If you are having an outdoor ceremony during the summer, the heat could create quite a bit of shine on your skin. You will need to touch up before you begin the photos and possibly throughout the portraits. Photoshop is a great resource for photographers to correct images after the fact, but eliminating shine and flyaway hairs at the start goes a long way toward choosing and printing beautiful images without the added frustration and expense of post-production fixes.

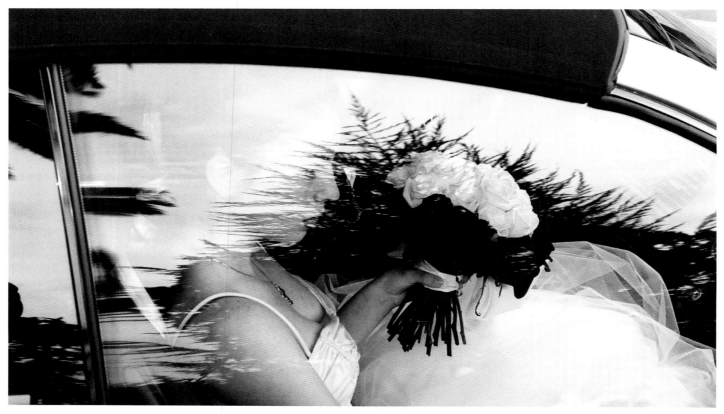

If you are driving to your reception, make sure all you have to worry about is holding your bouquet.
Let your planner worry about getting you there on time.

The Reception

Your photographer will complete your bride-and-groom shots as soon as possible so you can enjoy visiting with your guests. If the wedding is on time, this normally isn't a problem. If you're fifteen minutes behind, your photographer will begin to sweat, trying to fit in your shot requests in the abbreviated time left. It's important to decide ahead of time what means more to you: attending your cocktail hour or devoting all your attention to your portraits. Those of you who decide to complete your portraits before the ceremony won't have to worry about this. Most of my clients who choose to see each other for the first time at the ceremony remain open to the whims of the day. If we stay on schedule from the beginning, the timeline will flow as you and your planner envisioned. But if your ceremony starts late, family members wander off and are missing when needed, and new family group shots happen spontaneously because Aunt Jane invites over all your third cousins, all of this will affect the amount of time you

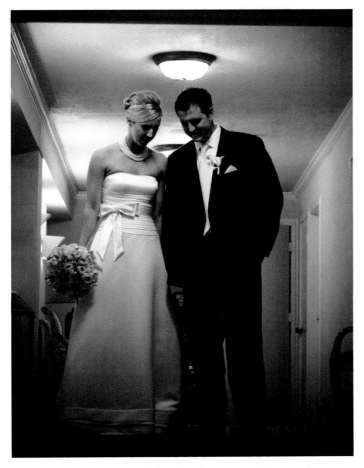

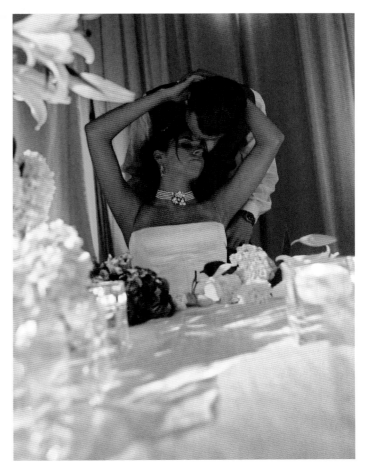

After a beautiful ceremony and all of their photos are complete, a couple waits to hear their names announced as husband and wife for their grand entrance.

Near the end of the reception, a couple takes a minute at the head table to reflect—and to rest the brides feet!

have to get your artful bride-and-groom portraits. Be adaptable and stay positive. Many couples plan from the beginning to miss cocktails and make a dramatic grand entrance at the reception. If time allows, they can decide to attend cocktails or to take the time to relax before the reception begins.

Even though you're done posing, you're not done performing. The key events of your reception will make up the last third of your album. It's important to be aware of your presence and posture as these events are photographed. You can and probably have practiced your first dance. It's harder to practice your cake cutting and bouquet toss. Not that every event needs rehearsing; spontaneity and emotion will make these shots work. But understanding your position in relation to the camera, knowing where your photographer is, knowing how to engage your husband to be in the moment when he's thinking about his two left feet instead of

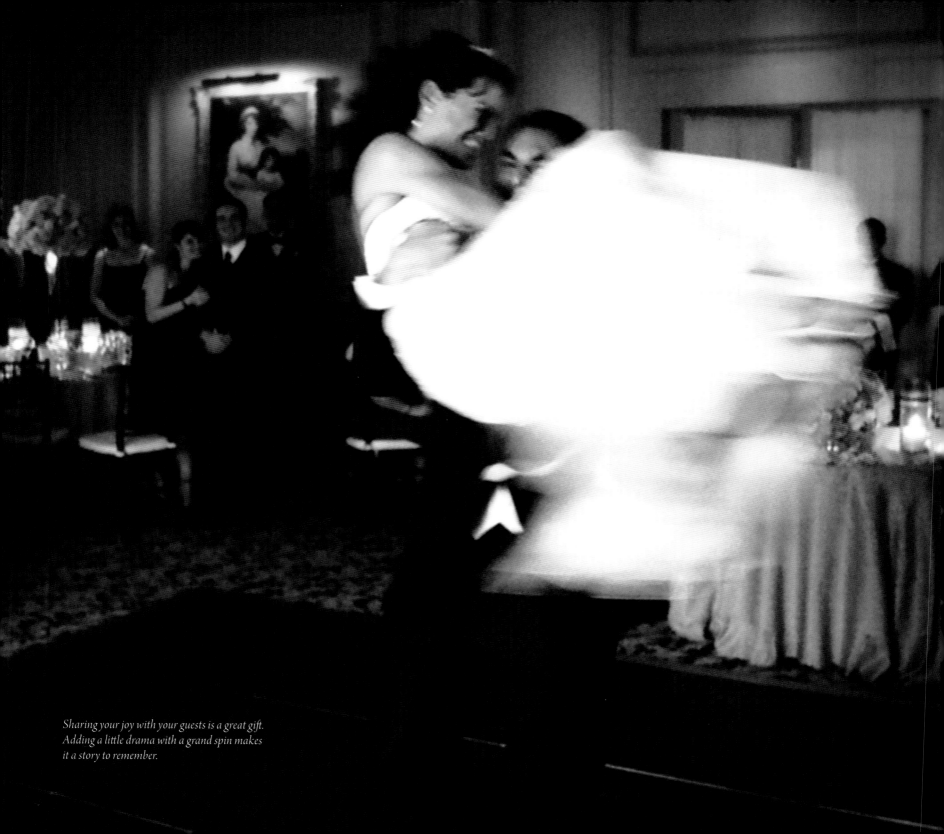

Sharing your joy with your guests is a great gift.
Adding a little drama with a grand spin makes
it a story to remember.

looking you in the eye, and drinking responsibly to enjoy yourself but also to have your wits about you all contribute to the photo story being captured. Much like the director of a movie has her vision laid out on a storyboard, you need to keep your storyboard—your album—in mind as you move effortlessly through your reception events.

You may have a few informal portraits with guests and extended family on your shot list for the reception. If you have a dress change, you may want to plan some time for a solo portrait and one with your groom. You'll also be faced with dozens of requests from your guests to pose for photographs with their cameras. Everyone with a cell phone or pocket camera will be snapping away. Expect to touch up your makeup during the evening, especially after eating, so you'll look fresh in these candids. You want everyone to marvel at how beautiful you look, whether it's in the chosen professional portrait you've enlarged for your wall or a grainy, dimly lit camera-phone shot taken by a guest and posted on Facebook.

In the end, you've worked very hard to bring this day into reality. You've produced your own play that has one showing. As any great actress can tell you, you learn your lines and your stage blocking so well that you don't have to think about it during the performance. You just react and let the emotion happen. On your wedding day you hope to be both in the performance and entirely in the moment, so when you look at your wedding pictures in the years to come, you see the best of you as a beautiful bride.

Transportation Gallery

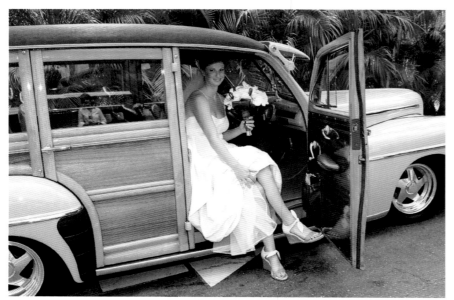

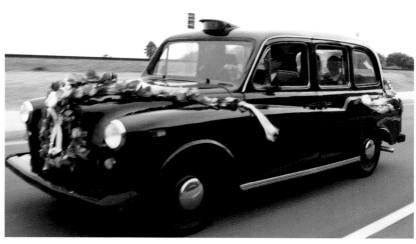

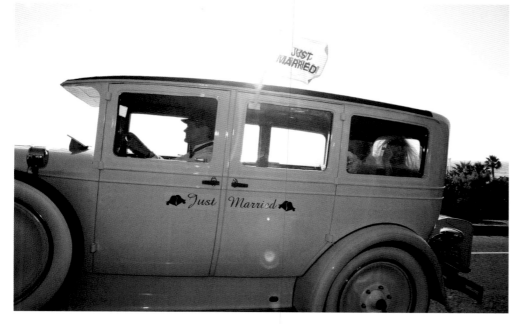

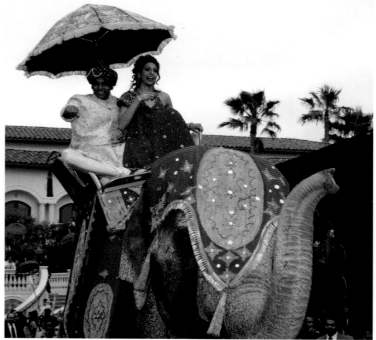

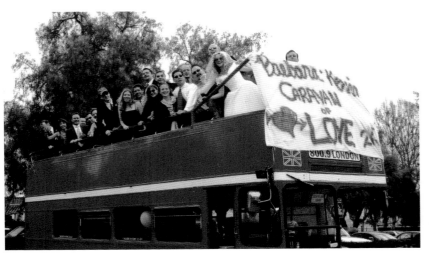

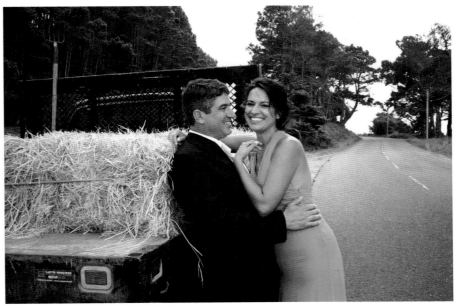

There are many ways to get from here to there on your wedding day. Whether it's to the ceremony venue or from the ceremony to the reception, you can ride in something as unconventional as a truck filled with straw bales (above) to an extravagant mode of transportation, such as the horse drawn carriage (lower right) or the elephant (facing page, lower right). Vintage cars, such as the Woody Wagon (facing page, upper left), the London taxi (facing page, upper right), or the elegant 1927 Packard (facing page, lower left) may fit your wedding theme. A car for just the two of you is a good way to get that precious time alone after the ceremony. However, a bus that holds the entire wedding party—and then some—(upper right) can be loads of fun.

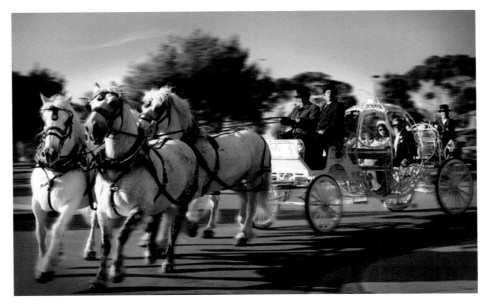

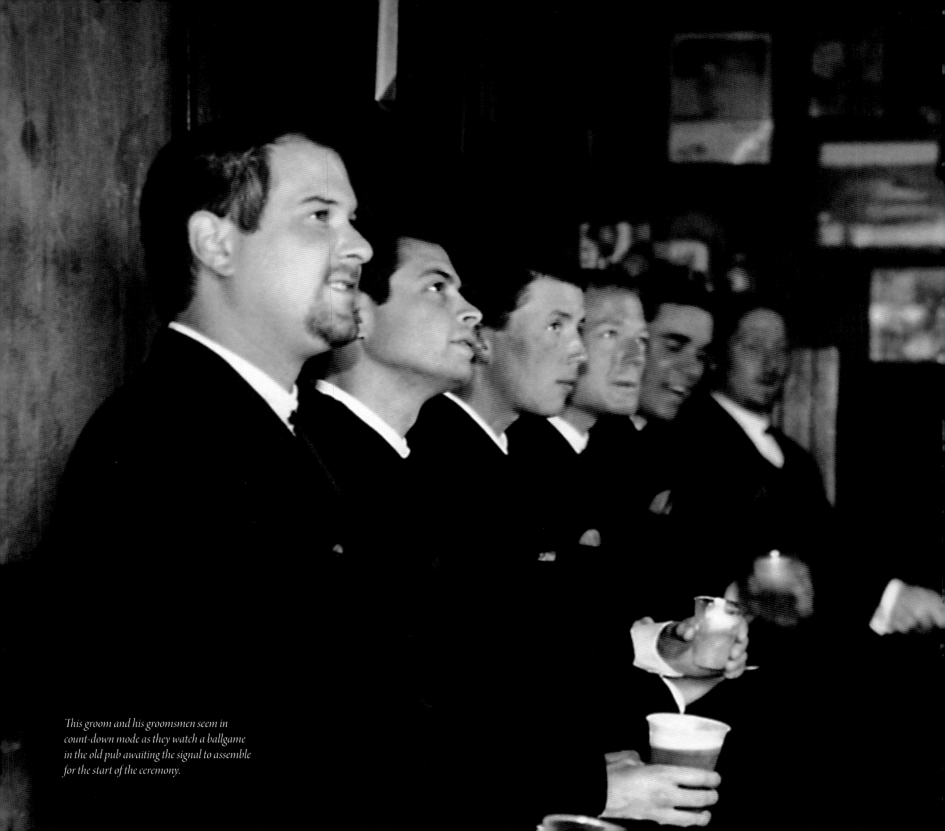

This groom and his groomsmen seem in count-down mode as they watch a ballgame in the old pub awaiting the signal to assemble for the start of the ceremony.

Tips for the GROOM

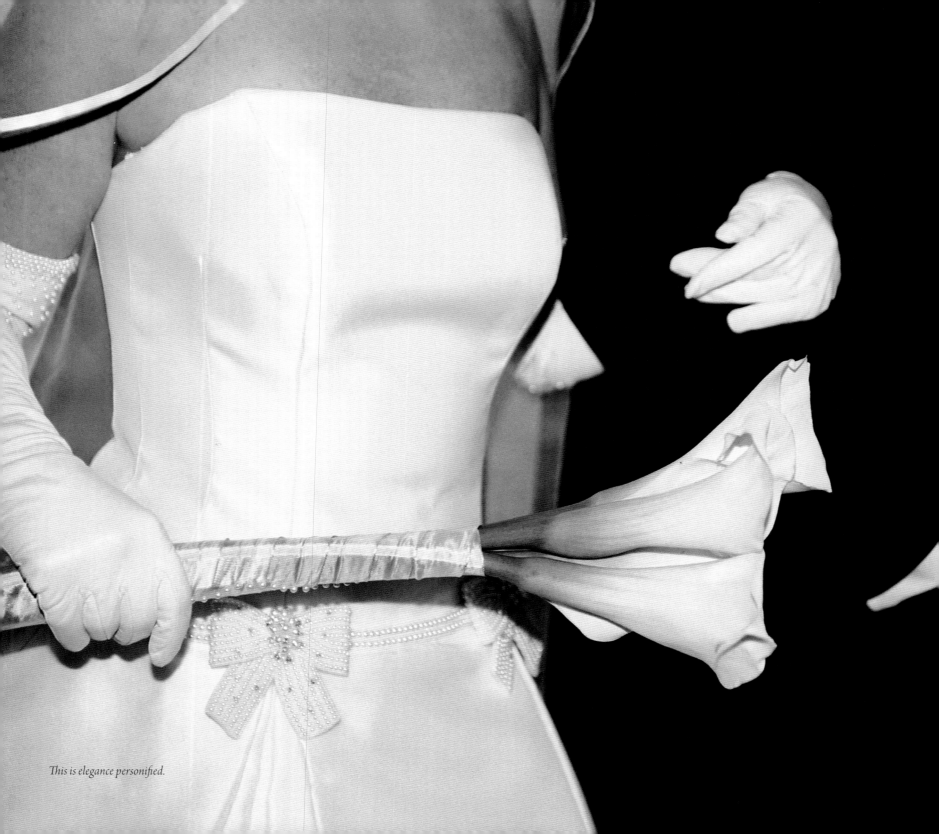

This is elegance personified.

THE PLANNER
Speaks

Many times we hear that a wedding day is

the bride's day, but it's certainly also the groom's day—and

should be. After all, you need a couple to have a wedding.

So, guys, you can own that day, too! And now, more than

ever, the groom and/or his family are chipping in to pay

for all or part of the wedding, so there should certainly be

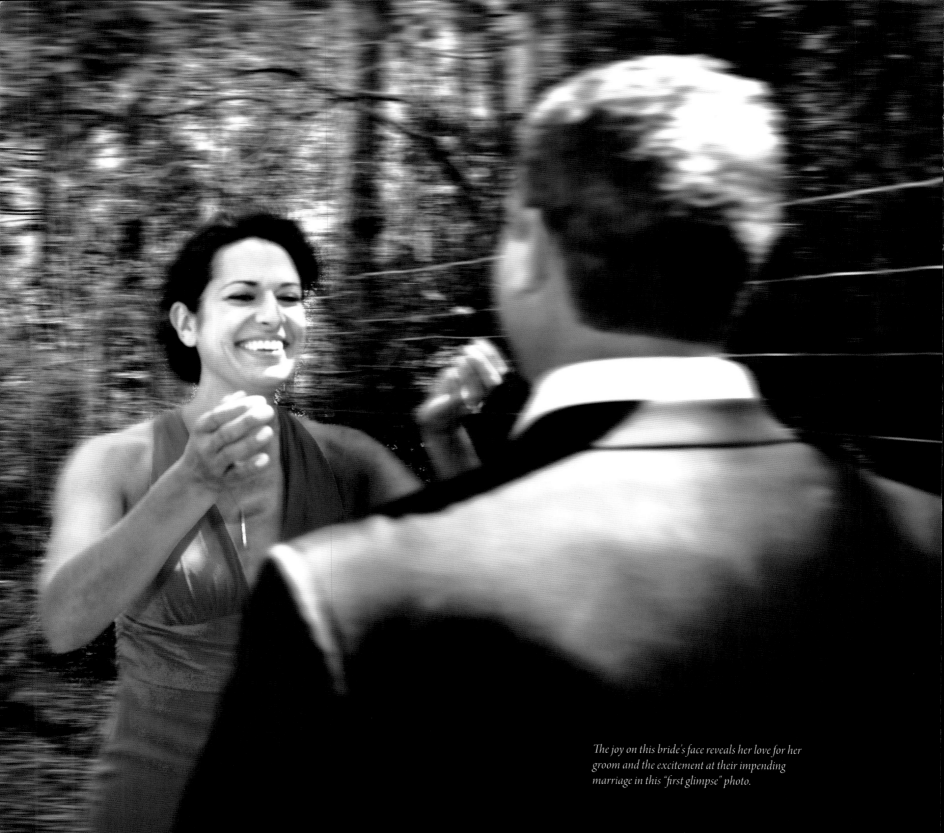

The joy on this bride's face reveals her love for her groom and the excitement at their impending marriage in this "first glimpse" photo.

These men know how to make an entrance. They have purpose in their step and it's so engaging, they've captured our attention! Your involvement in the wedding planning process can make your wedding that much more memorable and a way for you to leave your mark, too!

input, from and credit given to, the other half of the equation.

In the past half decade I've noticed a huge increase in grooms' involvement with the wedding planning. In the past, I'd seen them at the food and cake tasting meetings, but now the guys are coming to the meetings for flowers, linens, or invitations—and giving great input. This tells me that the grooms really are interested in making the wedding day a couple's day.

They want to put their thumbprint on the wedding as much as their bride does.

So here are some hints for you men to help make your wedding experience great. Many of them will give you some amazing press that will last for months (maybe years) after the wedding day. They are ways that will endear you to the principal people of the wedding—the bride (very important!), her mom (almost as important!), and your mom (also important, but she is usually more forgiving!).

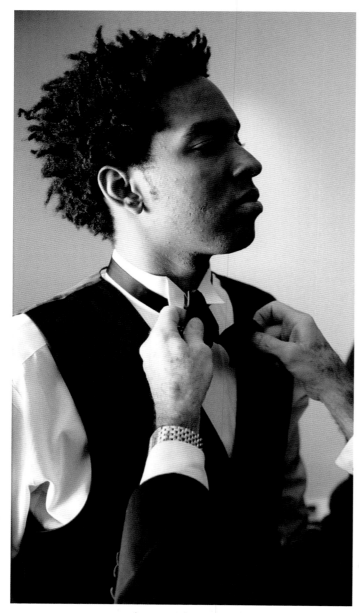

Such a handsome and regal posturing deserves a perfectly knotted bow tie.

Everyday Manners to Practice—for Your Wedding and for Life

Ever wonder why James Bond has such a way with the ladies? Part of it is his suave and gentlemanly manners. Even in the tightest situations he is courteous, well groomed, and the perfect gentleman. Emulating him just 50 percent of the time puts you in a class by yourself.

- Stand when a lady enters the room or you are being introduced to a woman or to an older man or one who outranks you, such as your boss.

- Pull out the chair of female dining partners and make sure they are seated before you take your seat.

- Open doors for ladies or for any people whose arms are full or who are just steps behind you as you pass through a door.

- Take a glance at the section of this book called "Mind Your Manners" for hints on table manners if you need a refresher on them for the wedding day.

Question: What is more romantic than writing and singing a song to your bride on your wedding day? Answer: Having it be a surprise! The bride was in tears as she watched this performance. What a way to endear yourself to your bride on your wedding day!

How to Endear Yourself to Your Bride on Your Wedding Day

- Send her a bouquet of her favorite flowers first thing on the morning of your wedding day.

- Write her a love letter to be hand delivered (maybe by your best man) as she is getting ready. Tell her what she means to you and how much you are looking forward to marrying her. Depending on the circumstances, you might consider sending a gift of jewelry or another lovely keepsake.

- Tell her she looks gorgeous (this should be done more than once) during the wedding day.

- Toast her at the reception. This works nicely around the time the wedding cake is being cut. The two of you can then thank all your guests

Clinking bottles. Since "drink" seems to be the root of many a blunder or faux pas, we thought we'd remind you with a list.

for coming and your family for the support they have given you in life.

- Do NOT, I repeat, do NOT, do anything stupid the night before the wedding or at your bachelor party (or ever, actually). Showing off for the guys might be a laugh, but it can cause irreparable harm to your relationship with your bride. Surround yourself with men (note, I said men, as this implies maturity) who will help you have a great wedding experience and not sabotage you in any way.

- Drink lightly, if at all, prior to the ceremony. Inebriated grooms are not particularly attractive to others. Plus, it's not even legal to make a contract, such as marriage vows, while under the influence.

- Carry breath mints and use them throughout the day.

- If you've taken off your jacket to be more comfortable during the reception, be sure to put it back on for the first dance, groom/mom dance, cake cutting, and other "formal" photos that are likely to become part of your wedding album.

- Be complimentary to the bridesmaids and your bride's sisters and friends, but make sure you do not pay so much attention to them that your bride feels left out. This is a good policy for every day, actually.

How to Endear Yourself to Your Mother-in-Law on Your Wedding Day

- Tell her she looks lovely.

- Thank her and your bride's dad for raising a daughter as beautiful as your bride.

- Ask her to dance at least once during the evening—the earlier, the better. Be sure you escort her back to her table—never leave a lady standing alone on the dance floor.

- This also goes for grandmothers. If they are not comfortable or physically able to dance, they'll decline, but you'll get lots of points just for asking. This also goes for special aunts or other important ladies in the bride's life.

- Thank her and your bride's dad for the lovely wedding if they paid for any part of it.

Your bride's parents want more than anything to see her happy,
and knowing that you adore their daughter will most certainly endear you to them.
You can see the love in this groom's eyes as he tells his bride how excited he is to share her life.

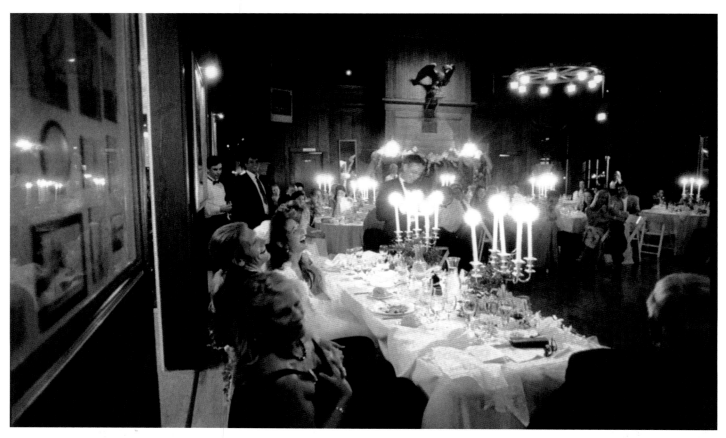

Laughter and harmony is the goal for any union. Extending heartfelt gestures and thoughtful expressions of gratitude and love for your mother and father is a beautiful way to begin a new chapter in your life. Thanking them for all that they have imbued you with is such a small thing but leaves such a big impression.

How to Endear Yourself to Your Mother on Your Wedding Day

- Tell her she looks beautiful.

- Dance with her to a song that means something to the two of you—she might have taught you to dance as a teen.

- Thank your parents (either privately or publicly) for all they have done for you and for inspiring you to be the man you are.

- Send your mom flowers or a gift thanking her for bringing you into the world. Hint: This is also appropriate on her birthday. Another cool idea: On *your* birthday, send her a bouquet of her favorite flowers—one for each year of your age—and a note thanking her for giving you life.

If he behaves like the title of this song, a groom will never go wrong!

During the Planning Process

Wedding planning can be a stressful time for your fiancée, so you might have to lend your shoulder for her to cry on occasionally. When things get to that point, she might be asking for your input on certain elements of the wedding, but perhaps she needs comforting more than another opinion, so be alert to her moods and needs and act accordingly. Suggest an evening out, a walk along the beach, or a nice bottle of wine by the fireplace to take her mind off the wedding for a short time. Sometimes a bride gets so focused on the wedding planning that she forgets how important her relationship is with the groom, so you can put yourself in charge of some of the planning even if you are not otherwise a very involved groom.

You will probably be asked many times for an opinion on things that you aren't very experienced with or have only a mild interest in, such as the color of the bridesmaids' gowns or some element of the tabletop décor. Never say you don't care or act disinterested. Your bride wants to include you in the decision-making as much as she wants input from her bridesmaids or her mom, so give your opinion. Don't be offended, though, if she picks something other than your choice.

If there is something you have a strong opinion on, such as what your groomsmen will wear or the song for your first dance, be specific about it. It might help in the beginning to figure out what elements of the wedding are most important to you and state them in such a way that they become the decisions in which you will have a major part. I suspect that your bride will be relieved to have fewer decisions facing her. Just make sure they fit well with the other wedding plans. It's important for both of you to be flexible and make compromises during the wedding planning—it's something that you'll have to practice during your entire life together, so it's a good idea to start off on the right foot and work as a team.

I send all my best wishes for a wonderful wedding!

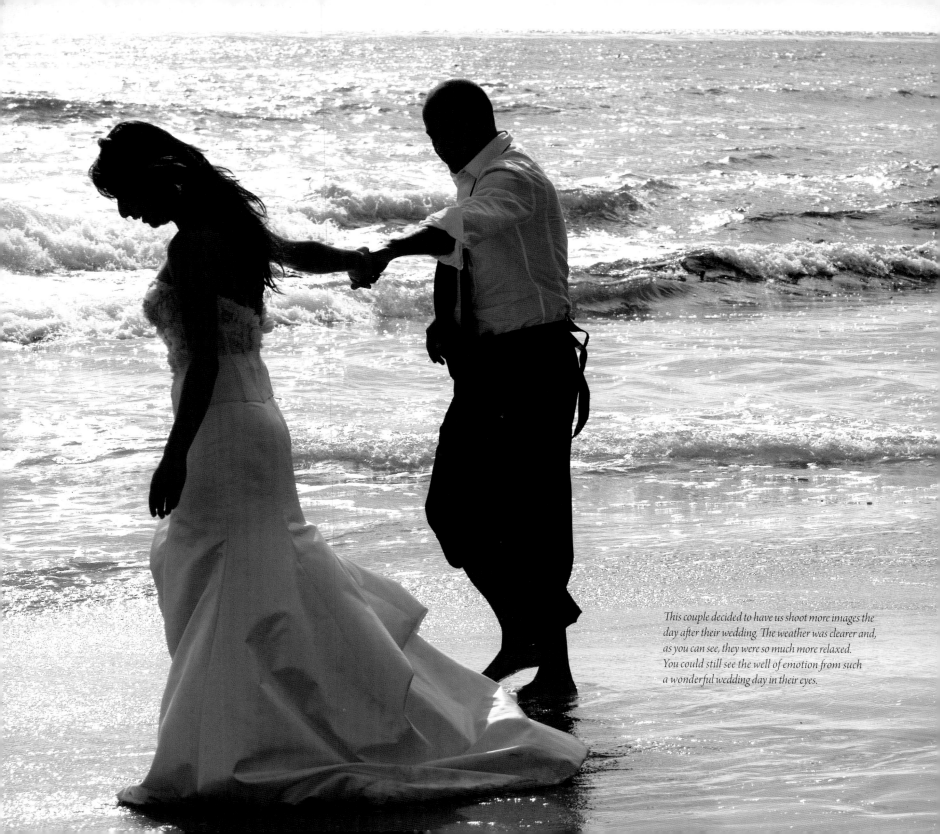

This couple decided to have us shoot more images the day after their wedding. The weather was clearer and, as you can see, they were so much more relaxed. You could still see the well of emotion from such a wonderful wedding day in their eyes.

THE STYLIST
Speaks

Every groom has his own ideas on how involved

he really wants to be in the wedding planning process. When it comes right down to it, there are only a handful of things that are R-E-A-L-L-Y important for you to remember throughout this process. As Barbara has said, respecting and considering the in-laws is key—her parents, siblings, the whole family.

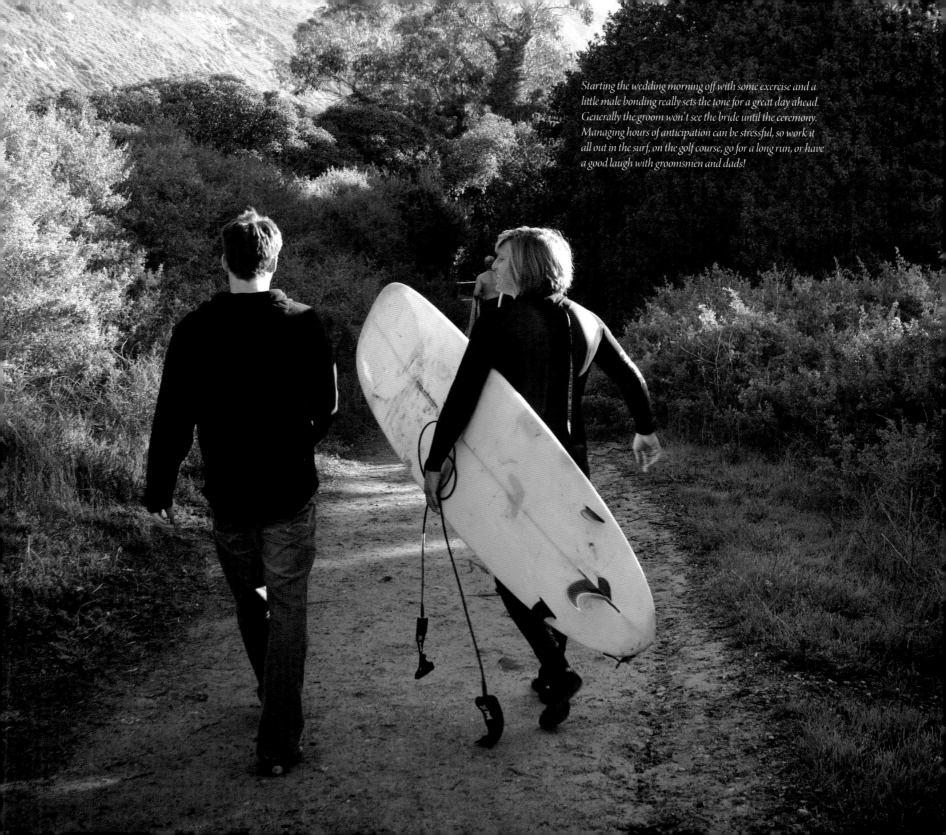

Starting the wedding morning off with some exercise and a little male bonding really sets the tone for a great day ahead. Generally the groom won't see the bride until the ceremony. Managing hours of anticipation can be stressful, so work it all out in the surf, on the golf course, go for a long run, or have a good laugh with groomsmen and dads!

A good sense of humor is key; try to keep things light and bright.
No one wants to see a grumpy groom!

Extending gestures to involve them in any way can be very important to them, and ultimately you carry some of that responsibility. Discussing this subject with your bride sooner rather than later is a good idea. We've found that planning an activity, such as an early-morning surf or a golf game with all of the groomsmen and fathers and brothers of the bride and groom, is a fantastic way to get in a little male bonding before it all begins. That helps everyone feel a part of the day and leaves you all with a nice sense of camaraderie and fun. The key is to create a climate of fun, have a laugh, and not let the inevitable stress overwhelm you.

You can help to keep the bride in check, too! Sometimes she'll be bugged by a family member or feel overwhelmed by the stress. You can reassure her that "this too shall pass." Families have established dynamics and that can be a slippery slope for a newbie husband, so starting out by being supportive and the voice of reason can help to keep you in the families' good graces—and hers!

So many options, so little time! Try to find a design style for a suit or tuxedo, dress shirt, cuffs or cufflinks, color, fabric, and tie that complement your own personal style and the "whole idea" of the wedding. In a perfect world, try to augment the bride's gown (if she'll let you know what that is!).

You might not really "get" fashion, or even care "who" you're wearing. But if you're gonna do it, go big or stay home! I understand that grooms often just allow the bride to choose the suit, but that doesn't mean you can't have some input and trust your own instincts. If you don't really know what you want, find a suit in a magazine that you like and ask questions at the store or rental place about the style and design options they have. Paint a picture with words or ask for help. If you identify with an actor or someone else you can use as an example of the look you're going for, do it—a specific era, a magazine tear sheet, a film analogy (like the Godfather suit Pacino wore, or like Bond—James Bond).

If you're too embarrassed, seek help from someone you trust. A female friend, a sister, your mom—it's a surefire bet they can guide you with a little insight that they may already have from having seen your fiancée's dress. Often the groom doesn't have the full picture of the dress design or genre the bride will

be wearing (it's a big secret), so this leaves you at a disadvantage.

How can you complement her look with your choice if you don't know what she's wearing? At least prompt her to give you a genre, a reference, an analogy—any hint for the feeling or direction of the style. If you have a friend, father, or work associate who has a good style sense or is known for his hip attire, ask him to help you out. It can be very liberating to surprise your bride, too. I think it's wonderful to care about the way you look on your wedding day.

Let's get down to details. Collar options abound. Cuffs and cuff links? Color of suit or tux? Single-breasted or double-breasted? Tails? Tie, bow tie, silk tie, or a fabulous Italian suit with an amazing classic tie (à la John F. Kennedy Jr.)? Cummerbund, vest, suspenders? Shoes—shiny or matte? Whatever it is, it's out there—go for it. With any luck, you've got many months to figure it out! Above are a few examples of distinctive styles that might help to inspire you. Does your style resemble any of these?

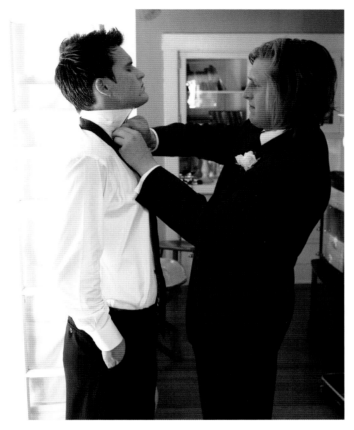

Hey guys, put as much effort into pulling it all together for her as she does for you! Give all of the details and accents some thought and extra effort. Gift your men with the same tie, cufflinks, an engraved tie clip, or something unique that will be meaningful to them in the future.

Things to Do on Your Wedding Day

Think about creating a special gesture for your bride on your wedding day. Don't ask her what she wants or tell her what you are planning. Keep it a special surprise that demonstrates how happy you are to be joining your life with hers. Be original, or at the very least, heartsy.

We've seen some really fun and touching ideas play out in front of our camera's eye. One of our grooms, who knew he would be kneeling during the ceremony, wrote a love note in white on the soles of his shoes. The guests all sighed when they saw it. It was sweet, fun, and heartfelt.

Another groom wrote his bride a note, rolled it up, and placed it with sand in a bottle. It was delivered to the bride's room just before the ceremony. The sand was from the beach where he had proposed to her. (A replica of this same bottle, with the special sand, was placed at all of the table settings as a gift for guests, with the bride and groom's initials printed on a vintage tag.) He really thought this one through!

Another groom wrote a song especially for his bride, rehearsed and choreographed it over some weeks with the band, and busted it out as a surprise for her at the reception. She cried! [See page 273 for a photo.]

We've seen other members of the wedding party with great ideas for special gestures. A father of the bride presented his daughter with a locket that was her deceased mother's. The bride wore it as she walked down the aisle. Very beautiful and sentimental.

One of our brides brought a small container filled with her father's ashes to the wedding site on the beach, and together she and her groom sprinkled them about just before the ceremony. She wanted him to be a part of her special day.

Another bride created a beautiful coffee table book documenting her groom's family heritage, in which he was very interested. She used vintage photos, letters, heirloom documents, images, and artifacts of his family to create a historically accurate story through imagery. She included a tribute, telling him how thrilled she was to marry him and become a part of his amazing family story.

These are unique expressions that leave a lasting impression. Planning something together for family, or for each other secretly, can be very special when you really put thought and effort into something so personal. Whatever it is, if it's from the heart, she'll/he'll love it! Wouldn't you?

THE GROOM MAKING HIS MARK . . . NO, NOT "MAKER'S MARK"!

Depending on the personality of the groom, sometimes he may get lost in all of the planning and excitement. We have had some unique ideas from the groom and/or a male perspective that really took the bride by surprise. Not only were they fabulous in the photos, but they also set the tone or brought more whimsy to the day. It doesn't always have to be so serious!

One groom told all of his groomsmen to wear a unique pair of socks—striped, multicolored, polka-dotted, something fun. We took a really fun photo with all of them putting their shoes together and lifting their pant legs. At the reception, the socks became ties, and they were a party hit!

Sunglasses are cool, too, when the groom and groomsmen wear the same or similar shades (a little Risky Business) in the pics,

I love this! This groom chose these wild and colorful socks as his style statement on his wedding day. To top it off, the groom wore black and white Converse tennis shoes with a vintage style suit—brilliant idea . . . and so him!

and sometimes the groomsmen—though not the groom—have worn them during the ceremony.

Rain threatened one wedding. Of course everyone was stressing, and the bride was concerned about the photos. The groom and father-in-law ran and bought everyone large umbrellas, all black umbrellas—to match their suits. It did rain, but they brought them out and it made for such fun. The bride was so relieved and excited that they had prepared for this. They just went with it and incorporated the umbrellas into the photos.

One father of the bride surprised the new couple at their reception with the USC Marching Band and USC Cheerleaders—at no small expense! They burst through the reception doors, playing their fight song, in full regalia. The couple was over the moon! You'll have to call in your favors for this kind of thing.

Another father of the bride set up a fireworks display without the couple's knowledge. At the reception, he subtly lured them out onto the balcony, and the fireworks went off like clockwork. The couple was stunned and felt wonderfully overindulged by such a dramatic gesture!

Many times the rehearsal dinner can be the best time to make fun or kitschy gestures. Often, friends and family feel more relaxed in a more casual setting. My advice is to spread apart the rehearsal dinner and the wedding day by at least a few days, in case people

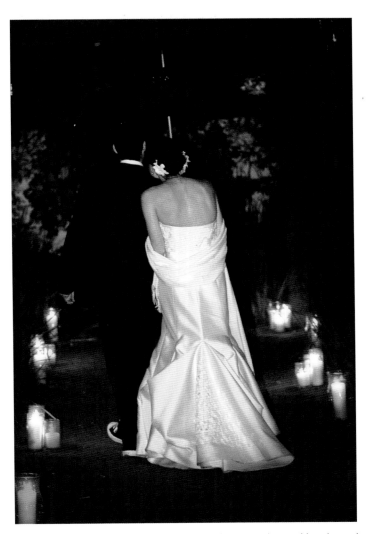

I love that this bride and groom just rolled with the rain on their wedding day and incorporated the umbrellas into the imagery. It brought a unique quality to the mood and tone of the photos.

really want to let their hair down. Everyone wants to look nice for the big day, so recovery time is essential.

This groom had ten groomsmen and they all wore black sunglasses throughout the day, even in portraits. It was perfect for a bright, sunny California day. The effect with all 10 groomsmen in a line with their Wayfarers on was a little Risky Business *to be sure!*

ADVICE TO THE GROOMSMEN: USE SUNSCREEN!

Wedding festivities often include outdoor activities, such as a golf game. Please use sunscreen! Any outdoor activity can be the cause of sunburned cheeks (even blisters) and sunglass marks that show up all too well in the photos. Of course, not only the men fall victim; I've seen brides and bridesmaids with bathing-suit lines clearly defined on their bodies while showcasing their very expensive strapless gowns. Ouch!

A Few More Words from the Wise

Most guys know who the loose cannon is in their friend/family lineup. This is something you should consider when inviting friends to be in your wedding. If you can get through to him before the event, great! But if your trust in him to behave responsibly is iffy, make him the bachelor party planner instead of the guy in charge of the rings!

Pace yourself with alcohol. There is nothing worse than that flush of pink that blushes your cheeks for the rest of your life when you revisit the reception memories.

By this point, you and your bride probably have arranged honeymoon plans. If you've arranged to surprise your bride with a trip, please, oh please, cross your t's and dot your i's! (If you are not going away right after the wedding, then pack a basket of goodies and bubbly for a late-night picnic in bed at your favorite B&B.) Or better yet, have your parents take care of it all. I know this seems like a no-brainer, but travel plans can go awry. Recommendations are so important, and season can be pivotal, too. Don't take for granted that Tahiti will be fabulous all year round. They've got bugs the size of small cars there, and it's seasonal and very expensive. You don't want to be caught off guard by financial issues in a foreign country. And don't forget

We refer to this image as Reservoir Dogs *after the Quentin Tarantino movie poster. It has a cinematic quality.*
The way the groom's jacket falls open as he walks and the gestures and movements of the groomsmen, it's just so cool!

passports, visas, and luggage packing—for her, too, if it's a surprise. It's no small feat to remember everything. Involve a best friend, or ask your bride's mom to help with packing. Plot your course with good information and run it by someone whose judgment you trust. Everyone's got a great friend who's brilliant with

details, or better yet, a friend or relative who's a travel agent. It's key for having a stress-free, amazing, relaxing break after a year or more of planning. Your bride will love you for this!

Finally, do be charming and amazing—the man she'll be so happy she married!

A groom and father dress for the wedding. Plan ahead and decide where you'll prepare and who will be in the room with you. Some grooms may prefer a quiet atmosphere, while others may want all groomsmen and family members present. Let your best man know your wishes and he can help you keep order.

Chapter Fifteen

THE PHOTOGRAPHER
Speaks

Your first experience with your bride and the

camera will most likely be your engagement session. Not

every couple chooses to do an engagement photo, but

there are a number of reasons why you, the groom, should

convince your bride to do one. Many photographers

will add the engagement session to a wedding package

Groomsmen come in all shapes and sizes, with personalities to match. Wrangling this party into a formal portrait was a challenge, but in the end the bride and groom preferred the candid shot taken just before the posed portrait.

Talk about making an entrance! This groom, in traditional attire, rode in a processional on a white horse to meet his bride and her family. Your entrance may not be as dramatic but it's just as important to command the stage when your guests—and your bride—see you for the first time.

as an incentive to book. Use that to your advantage. If your bride feels she's getting more for the dollar and one more opportunity to have you participate with her in the wedding planning and events, it will set the right tone for your wedding photography experience. Use the shoot as a chance to "rehearse" your wedding photography. You may be in casual clothing in a relaxed atmosphere, without the pressures or timeline of the wedding day, but it's still you and your bride inhabiting the space before the lens. Use the shoot as if you're practicing for your first dance. You wouldn't take to the dance floor in front of all your guests and just wing it. Even the most skilled dancers would do a run-through.

If you think you have "two left feet" as a model, you'll benefit the most from an engagement shoot. If you're comfortable in front of the camera, maybe even a ham, you will still learn something from shooting dozens if not hundreds of photos in an hour-or-two photo session. You'll see what works and what doesn't as you pose with your bride. You'll get a good feeling of how the photographer will work during your wedding. If the shoot is outside instead of within the confines of a studio, you'll have the added benefit of working with the freedom to move and enjoy the fresh air. Schedule your shoot in the late afternoon

Grooms have less of a chance to make a statement with their wardrobe than the bride. Your choice in tie, shirt collar, and suit or tux cut is where you can express your personal style.

or early evening to take advantage of the beautiful, golden light. Take your bride out to dinner afterward as part of the whole experience. When you participate and find mutual pleasure in these early wedding planning events, your bride will be much happier throughout the planning process, and it will lead to creative and beautiful wedding photography.

Tux/Suit

Be involved in your wardrobe selection. Your bride may be going for a certain look or style, but you're the man who has to wear the clothes on one of the most important days of your life. Don't you want to look and feel great? Don't let the salesperson at the tux rental shop work it out for you at the last minute, or you might end up with a collar that's an inch too big. There's nothing worse in photos than an ill-fitting shirt, and it's a dead giveaway years later when you look at

your photos and realize you fell down on the job. If you're dieting or working out, know that you might need an adjustment in your suit or tux a few days before the wedding. Make sure you have enough cuff showing—at least a half inch. Make sure your accessories—cuff links, cummerbund or vest, belt or suspenders, bow tie or straight tie—are present and accounted for. If you were a model on a clothing shoot you'd have a wardrobe stylist steaming, prepping, pinning, and straightening every little wrinkle. You need to be your own stylist, at least in thought, to match the level of sophistication your bride is bringing to the day with her gown.

Drinking

Some guys pride themselves on how much they and their buddies can drink and still maintain a sense of decorum. Or at least they think they can. Others know their limit and stay

Taking the time to shine his shoes, this groom knows the importance of a well-dressed groom standing by his beautiful bride.

Celebrating responsibly is key to enjoying a great wedding. Know your groomsmen and when to say when to pre-ceremony drinking.

within it. There's a fine line between celebration and embarrassment. Know yourself and your groomsmen, and know when to say when. It's a long day. It's one thing to let loose once the dancing starts and all the speeches have been made; it's another to down shots while you're trying to figure out how to put on cuff links for the first time.

Use your bachelor party to exercise your male drinking prowess as a single guy; use your wedding day as a celebration of your new life as a married man.

Managing Your Groomsmen

What can I say here? These are the guys you grew up with, went to high school or college with, spent countless hours watching and playing sports with. If you're the first of your buddies to get married, you may be in trouble. "PARTY" may be the only word in their wedding vocabulary. If you're the last to be married, you're in luck. Your friends have already been trained by previous wedding planners and brides. They have built up some wedding experience and will behave. They know that if they listen and do what they're told, there's a light at the end of the tunnel—food and drink. You know your friends the best. Just make sure they know where to be at the right time. And have their cell phone numbers at the ready. Someone always wanders off or shows up late.

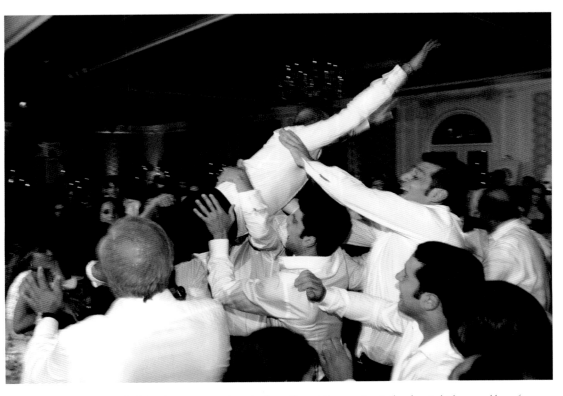

Once the ceremony and all the photos are complete, the dance floor at the reception is the place to let loose and have fun.

Keeping Family on the Same Page

Just as for the groomsmen, it's a good idea for you or a sibling to have all wedding party and family numbers programmed in your phone. It's inevitable that Uncle Joe will wander off when he's supposed to be in the photos. Your wedding coordinator will have the family portraits scheduled in the timeline. Talk it over with

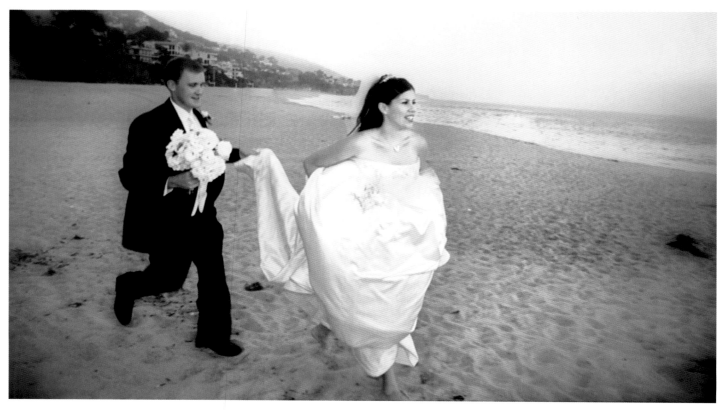

You may not be prepared for all that wedding dress, so watch your step.
You'll probably end up being the gown wrangler to help your bride from one location to another during portraits.

your family during the rehearsal. Make sure all of them know where they are supposed to be. The sooner you get through family photos, the happier everyone will be.

Watch the Dress!

No matter how much you prepare for your photos on your wedding day, you may be surprised by the diameter of your bride's gown and the length of her veil. Theatrical productions always have a dress rehearsal to resolve any issues before the performance. No such luck in weddings. Your bride wants you to see her in all her glory for the first time on your wedding day. No matter how hard you try, there is a strong chance you will step on either the gown or the veil, especially when you're focused on the camera during your bride-and-groom shots. All you can do is be aware. Just reading this section will help you become aware, so when you're being spontaneous in your post-ceremony shooting, you'll be mindful of the challenges you face working with the only dress your wife will wear only once in her life.

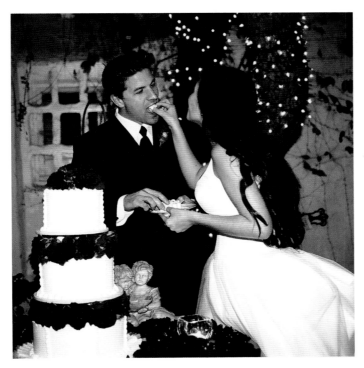

A bride respectfully feeds her groom a piece of cake. You may need to discuss in advance your intentions of how you feed her—no surprise attack in the face!

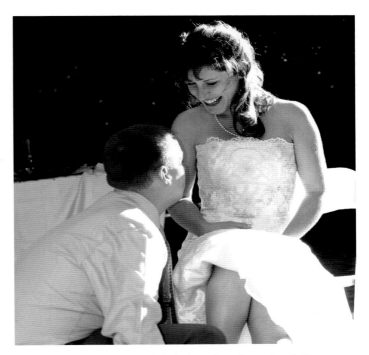

The garter toss is one reason to watch the drinking. It's usually near the end of the reception, you're in front of all your guests and asked to perform a delicate maneuver to remove the garter. Don't give your family a reason to recount an embarrassing story on your anniversary.

Time for Cake

Of the many weddings I've photographed, there have been only a handful of couples who pushed cake into each other's face. Most couples discuss cake etiquette beforehand with an agreement to remain civilized. Then alcohol takes over. Only you know what will serve you and your bride best in the end. If you're a wild and crazy couple and your friends expect it of you, go for it. Just keep it clean and around the mouth. She can always reapply her lipstick but if you unleash an all-out assault, she can't wash and style her hair over again.

Garter Toss

As the night wears on, the more peculiar wedding customs appear. The bouquet toss with the bridesmaids and the garter toss with the groomsmen are always photogenic events if you and your bride decide to do them Things can happen very fast, though, so try to move slowly. Instead of winging the garter over your shoulder without notice, either wait for the DJ to count you down, 3-2-1, or simulate with the hand that's holding the garter a 3-2-1 motion, then release. Your photographer may be in position but could easily miss the action shot if you throw too fast.

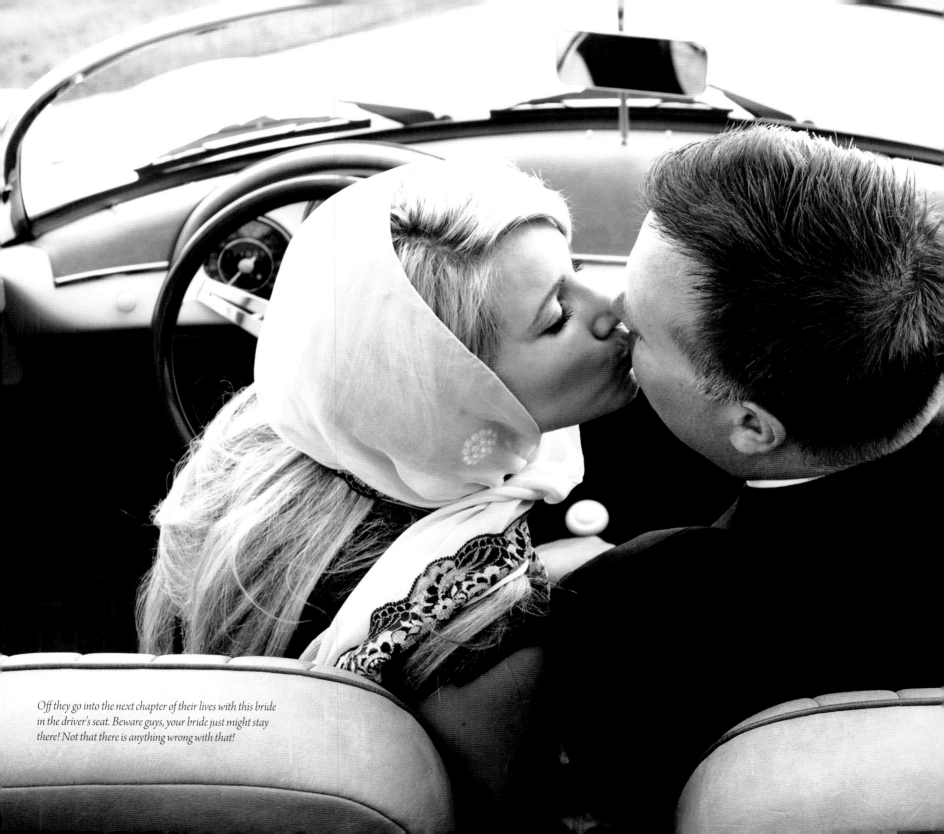

Off they go into the next chapter of their lives with this bride in the driver's seat. Beware guys, your bride just might stay there! Not that there is anything wrong with that!

Congratulations!

You've done it! Now you two can go off on your honeymoon and rest in the knowledge that every choice and decision you made for your wedding was authentic and carried your thumbprint. You can take credit for handling the scope and grandeur and hours of mulling over details and familial orchestrations that have led you to succeed in accomplishing your goal, an unforgettably beautiful wedding! You have created cherished memories for you and your family and friends to revel in for years to come through extraordinary photographs. That's no small feat!

We hope that this book has helped you to find the confidence, given you the knowledge, and offered the tools that will continue to inspire you today—*and in life!*

INDEX

ACKNOWLEDGMENTS

It seems that, at some time (if just for a fleeting moment), most people dream of becoming authors. Some go a bit further and actually write things but stick them away in a drawer or on a hard drive and don't do any more with it. But we three slightly crazy people decided to go for it and actually publish a book, and you are now holding it in your hand. That is not to say that it was easy or fast. It was actually neither—but it was probably easier than faster. But it's done and we're very happy to present it to all brides and grooms and, in fact, to the entire wedding industry. We hope you like it and, more importantly, we hope you learn something that will make a difference in your wedding ... and your life.

While in the process of putting this book together we realized just how many people were integral to the process. What is so wonderful is that all of them were so willing to help and go out of their way to do it. It's hard to know just where to start with our heartfelt thanks and genuine gratitude at the love and support we've had during the process. But here goes:

To all of our awesome brides and grooms, who so graciously consented to the use of their photos in the book. We would not have this book without you—in fact without you we would not have had our wonderful careers in weddings. Special thanks to Kelly Gallette Carter for being our cover bride.

To Nils Wanberg, who has contributed his creativity, his eye for capturing beautiful imagery, and his commitment to excellence. He grew up around cameras and is an instinctual shooter, but above all he is an exceptional man.

To the superb group of wedding vendors—including decor designers, florists, lighting designers, rental companies, hotels, caterers, musicians, and on and on—without whom these amazing weddings would not have happened. We wish we could list each of you here.

While the vast majority of the images in the book are real brides and grooms at their weddings or engagement shoots, we had one photo shoot to capture a few images that illustrate points that our real brides could not. We appreciate those who helped us that day and offer sincere thanks to: Our friends and relatives who willingly acted as models (in alphabetical order): Kimberly Currin, India Dupré, Fernanda Jaime, Dominic Jones, Amberly Crouse Knox, Clara Ross, Allison Wanberg, Katja Wanberg, Katrin Wanberg, and Brooke Yarborough. We only paid in food—so it's clear how generous they were with their time; Felicity Couture of Corona del Mar, California, for the gracious use of her lovely custom gowns; Friar Tux Shops of Southern California for the generous use of groom's attire; Amy and Erich Riedl for their hospitality and use of their lovely, antique-filled home.

Thanks also go to Karla Olson for her knowledge and insights as she shepherded us through the winding road of getting three authors and a myriad of photos into a form that is actually readable—not to mention printed; and to Charles McStravick, for his invaluable design expertise, cheerful patience, and multitudinous versions of the layout. At times we wondered if our computers would go on strike in retaliation for being used practically around the clock.

Barbara, Annie, and Lars

SOUTHERN CALIFORNIA
AUGUST 9, 2010